LANCHESTER LIBRARY

3 8001 00320 4405

The Nude

in Western art

106 reproductions
selected & introduced
by Malcolm Cormack

Phaidon

Lanchester Library

WITHDRAWN

The author and publishers are grateful to all museum authorities and private owners who have given permission for works in their possession to be reproduced. Plates 10, 37 and 44 are reproduced by gracious permission of Her Majesty The Queen. The works of Bonnard, Chagall, Duchamp and Modigliani are © by ADAGP Paris 1976, and those by Gervex, Léger, Matisse and Picasso are © by SPADEM Paris 1976. Photographs for Plates 1, 13, 17, 20, 32, 50, 78, 84, 86 and 92 have been supplied by Scala, Florence; those for Plates 33, 38, 45, 46, 51, 54, 55, 58 and 67 by Giraudon, Paris. P. & D. Colnaghi and Co. Ltd supplied the photograph for Plate 19; Fischer Fine Art that for Plate 73 *top*; Allan Frumkin Gallery Inc., New York, that for Plate 94 and Marlborough Fine Art (London) Ltd that for Plate 95.

Phaidon Press Limited, Littlegate House, St Ebbe's Street, Oxford

First published 1976
© 1976 by Phaidon Press Limited
All rights reserved

ISBN 0 7148 1668 X

No part of this publication may be reproduced, stored in a retrieval system or transmitted in any form or by any means, electronic, mechanical, photocopying, recording or otherwise, without the prior permission of the Copyright owner

Printed in Italy by Amilcare Pizzi SpA, Milan

Author: CORMACK
Class: E.708.14 COR

The Nude

Ever since man began to paint, the representation of the nude figure has held a special place in the world of art. It is always an exciting subject for spectator and artist alike, for a variety of reasons. The artist can create a magical world related to his gods by representing ideal figures and ignoring all imperfections, so that, for example, the supreme female beauty becomes Venus, the goddess of love.

The human body, however, can also be seen as something loathsome, to be covered and hidden. When this happens the painting of nudes goes into abeyance and there has to be a revolutionary change in taste before they become once again acceptable.

In this book the examples chosen are all from the Renaissance and later, that is to say, from a time when the painting of the nude had long been established and frequent classical precedents could be found. Nevertheless, the nude was not immediately acceptable and we can trace during the Renaissance an increasing awareness of the potentialities of the nude figure, from being merely a crude attempt to imitate the ancient tradition to something capable of intense and dramatic expression. Masaccio, in his *Adam and Eve* (Plate 1), quickly realized the emotional potential of the nude human figure.

During the early Renaissance the increasing awareness of the Antique, and the example it could provide, can be felt, for instance, in Ghiberti's enthusiasm for the classical statues and objects which he had seen excavated and which he describes in his *Commentaries*. In Rome he had seen a hermaphrodite, 'a work of marvellous skill', and in Florence an engraved gem of *Diomedes stealing the Palladium*. It was 'a marvellous thing observing all the measure and proportion necessary in a sculpture or carving.'

From the desire to see what made classical figures ideal, there arose a system of measurement, proportion and selection which culminated in Alberti's treatise on sculpture *De Statua* of c. 1464: 'We have chosen a number of bodies considered by the skilful to be the most beautiful and have taken the dimensions of each of these. These we compared together, and leaving aside the extreme measurements which were below or above certain limits we chose those which the agreement of many cases showed to be the average.'

The measuring of human figures for their ideal proportions, like the measuring of Roman architecture, was to become something of an obsession during the Renaissance and, indeed, was eventually embodied in an academic ideal which lasted for at least three centuries and survived in old-fashioned art schools until fairly recently. Briefly, the ideal human figure was to be nine face-lengths long, the 'Apollo' type, or, exceptionally, ten face-lengths long, the 'Jupiter' type. Occasionally the proportions were changed to a little over eight face-lengths, or measured in terms of nose-lengths, which would result in about twenty-seven units to a figure.

This approach may nowadays seem dry and excessively formal, but to the artists of the Renaissance it was an exciting and necessary task to lay down the rules from which the study of the nude could proceed. In the examples chosen here, we can see Leonardo concerned with relating his practical knowledge of the human figure to a theoretical framework in his '*Vitruvian Man*' (Plate 14), and thereby linking him with the noble and ideal proportions of classical architecture. The image, incidentally, was later to be used by Blake in his *Glad Day* (Plate 60) for a very different purpose.

North of the Alps, Dürer, with his *Apollo and Diana* (Plate 3 bottom), shows an interest in the same problems, as well as an indebtedness to Italian ideas. A drawing of the nude with a scale of proportions shows that Michelangelo, too, was interested in this intellectual approach. From such great heights, the art-school precept to make the figures about eight face-lengths long can be seen as the ill-remembered echo of a once startling philosophical idea: that perfect man could be represented in art by diligent study.

Not all artists of the Renaissance, however, approached the classical past or the nude figure in such a theoretical manner. The richness and variety of the nude in art come from the differences in treatment which the subject allows, even within the work of one artist. It is, perhaps a commonplace which needs repeating, that artists do not fit neatly into prearranged schemes, producing only one sort of picture or one sort of nude, whether the type of 'Venus' or 'Apollo' is represented, or whether a mood of pathos or ecstasy is created in the painting. They may be concerned with all of these things together or at various times, as we can see, for example, in the works of Primaticcio (see Plate 29) and, above all, in those of Michelangelo. The subjective qualities of nude painting obviously could not be ignored. During the Middle Ages the erotic aspects had been suppressed. With the Renaissance the revival of interest in the human figure brought with it the opportunity to exploit those subjects from Greek and Roman mythology where such figures can occur. Ovid's *Metamorphoses* and the loves of the gods and mortals provided endless subject-matter. In time the elusive flavour of a classical allegory could be answered by the poetical treatment of the nude in a pastoral setting. Botticelli's *Venus and Mars* (Plate 8) is one such example of the erotic languor which the combination of classical legend and the nude could convey.

In Venice during the sixteenth century a whole series of paintings explore the sensuousness of the nude figure in a classical setting. With Giovanni Bellini, Giorgione, Palma Vecchio and Titian (see Plates 12, 20, 9, 28) we find the glorification of the nude female figure and its fleshly delights, increased by a richness of colour and handling of paint, but all, in the end, justified by a classical subject. Titian was to call such paintings '*poesie*', and some were to become complicated poetical allegories of love, enriched by the interaction of music and the female form. Bronzino's *Allegory* (Plate 24) is just such a painting, but finished in the Florentine manner with greater emphasis on outline and overall design.

Drawing the nude became a common practice for the Florentines and by the twentieth century the study and drawing of the nude human figure was a perfectly respectable activity engaged in from Academy schools to amateur art classes all over the world. The reason behind this is, of course, the realization that one of the best ways of coordinating the hand and eye of an artist is by the difficult task of rendering the most subtle of forms, the human figure. This requires in turn a detailed knowledge of anatomy and it was for such an end that we find Leonardo producing his seemingly endless and justly famous drawings of aspects of the human figure. In Florence, as we have seen, drawing the nude was a certain way of realizing its ideal form, but such drawing in the spirit of scientific accuracy could become an end in itself.

In Italy, the accurate draughtsmanship that nude studies required became a prerequisite and the underlying basis for a greater range of expression. For Titian and the other Venetians the direct painting of nudes was perhaps their most important interest, and we find in X-rays of Titian's paintings and, indeed, on the surface, evidence of many changes of mind about the poses of his figures. For a Florentine, on the other hand, the essential qualities of grace and a powerful design would all have to be worked out at an earlier stage by direct and realistic studies. This was also to be the method of the Carracci (Plate 32) in the foundation of their Bolognese Academy, and lies at the heart of the extension of the range of emotions expressed in the Baroque period in Italy. Only by a greater and more systematic realism could the means be found to realize this amplitude of religious and poetic feeling. Artists such as Rubens (see Plates 35, 36) and Van Dyck (see Plate 37) could, of course, draw on their experience of the giants of the Renaissance and the monuments of classical antiquity, but they also needed the discipline of realistic studies from the nude (see Plate 23).

If, then, greater realism could lead to grander displays of the human figure, the reverse was also true, particularly north of the Alps. Greater realism could also lead to an earthiness and directness which would bring the spectator closer to the subject of the picture. The greatest examples of this attitude in the seventeenth century are perhaps Caravaggio (see Plate 34) and Rembrandt (see Plate 38). Their paintings are very different in feeling and execution, but both are based on a more direct realization of the nude.

It is only a short step to involve the spectator more closely. In the eighteenth century the Rococo style, with its aim of exciting the senses with a flurry of decorative detail, also takes the spectator to within a hand's touch of the model. Watteau's *A Lady at her Toilet* (Plate 42), based on careful and exquisite studies from the life, brings us to the keyhole of the dressing room, and Boucher's portrait of the famous courtesan Mlle O'Murphy (Plate 40) brings us to the foot of the couch. Reynolds, however, criticized Boucher for working without drawings or models of any kind; to which Boucher replied that when he was young, studying his art, he found it necessary to use models; but he had left off them for many years.

We can be grateful that Mlle O'Murphy supplied such a fresh and charming model, but his other nude confections are perhaps justifiably censured by Reynolds. Fragonard, for a time Boucher's pupil, exploits this vein of lightweight gallantry (see Plate 45), but not without a certain tongue-in-cheek glance at the whole range of decorative and mildly suggestive nudes which such a style demanded.

The heroic nature of Neo-Classical nudes, with their stern ideals and return to the stricter virtues of Roman *mores*, is in strong contrast to the seemingly artless and wholly delightful world of, say, Gainsborough's *Diana and Actaeon* (Plate 44). David in his *Death of Barra* (Plate 46) deliberately treats the nude as an excuse for a moral tale of the revolutionary martyr. For such an attitude the energetic stance of the male nude is generally preferred, though on this occasion David allows the swooning pose of the dying boy to be somewhat seductive.

Ingres so refined his line to an ideal vision of the nude, which he thought the academic view required, that he was pilloried as the master of line in a celebrated contemporary cartoon showing him, armed with a pencil, jousting with Delacroix, armed with a brush. 'Line is the probity of art,' he proposed, and there is clearly an enveloping line surrounding his *Grande Odalisque* (Plate 51) and patent refinement in his studies for *The Golden Age* (Plate 56).

Yet it is equally true that, for all his apparent suppression of extraneous matter in his work, Ingres was not able to ignore the erotic charms of the nude. The carefully posed nudes which he painted early in his career recur in his later paintings and culminate in the lush riot of bodies that makes *The Turkish Bath* (Plate 54) such a mad dream. Here we have convincing proof that behind every stern Neo-Classicist there lurked a Romantic.

Paradoxically, for all the exotic eastern daydreams which Delacroix's *Odalisque* (Plate 48) conjures up, his own private attitudes were often austere and in later life he became something of a stoic. Thus, during the nineteenth century, we find a greater mixture of attitudes and a multiplicity of styles available for the painter of the nude, with the examples of the great followed and changed by lesser artists. Turkish and Middle Eastern subjects stemmed from the Romantic movement, yet we have seen how Ingres, the great classicist, romanticizes the subject. Alma-Tadema, the Royal Academician, in his *Tepidarium* (Plate 59) is concerned with very much the same scene, a nude at a bathing place, but he has translated it into an everyday example of Roman genre, with probably unconscious prurient overtones. In this case, it is possibly the lack of balance between the academic ideal and the photographic realism that causes a slight smile. It destroys that hard-won trust between the artist and spectator, whose confidence in the artist's world is so easily betrayed by humour, particularly with paintings of the nude.

If a greater realism in the painting of nudes was a product of the nineteenth century, a realism that was the direct result not only of the new photography but also of the endless life classes which made it all acceptable, then the shock which greeted the realism of Manet's *Olympia* (Plate 62) is hard to understand. Perhaps because the oriental trappings or overtones of classical legend had been deliberately discarded, the spectator was too dangerously close to the artist's world, directly confronted as he was with a modern courtesan. We can now admire that particular painting as a wonderful creation in its own right, with all Manet's felicities of touch and mastery of tonal relationships and colour effects, but to Napoleon III and his subjects at the 1863 Paris *Salon des Refusés* it was an affront and a disgrace. He much preferred the watered-down academicism of Alexandre Cabanel's *Birth of Venus*, which, with its thinly disguised eroticism, makes eclectic references to the great French masters of the eighteenth century.

The revolutionary realism of Manet and Degas in their approach to the nude can be seen in the examples illustrated (see Plates 62, 67, 85). The advent of photography certainly helped the artists to see their subject afresh without too many preconceptions about pose or subject-matter, as if through a keyhole, so that we find an almost complete absence of formal design in the search for correct facts. Yet Degas admired Ingres, whereas Renoir, who more than other Impressionists turned to the nude, attempted to make something classical and lasting out of his painting. The subtle and delicate effects of light and atmosphere in landscape and on flesh had been very much his preoccupation, and yet he too altered his style, as, like Ingres, he found the claims of line irresistible, in his large painting *The Bathers* of 1884–7 (Plate 70). In this we find realism and Impressionism tempered by the example of previous art. The nudes are painted in hard outline as if they were pieces of

sculpture rather than pulsating flesh and blood. This was, in fact, an exception in Renoir's work. In his later nudes the warm golden visions of womanhood seem to embody a lifetime's admiration.

Cézanne, on the other hand, is much less concerned with the warmth of human figures. His paintings, apart from a few early works, use a basically Impressionist technique to render more solid the planes and subtleties of the female figure in large-scale formal masterpieces. His arrangement of *The Bathers* (Plate 66) can be seen now as the high point of 500 years of the western tradition of figure composition, in the same spirit as Masaccio, Michelangelo and Poussin. The arrangement of nudes has become an end in itself with no other subject than formal visual harmony created by a sublime temperament. Its strength and impersonal character is in strong contrast to the highly emotional and other-worldly symbolism of Gustave Moreau's '*L'Apparition*' (Plate 75), or the even more neurotic vision of Munch's *Madonna* (Plate 74). In these we have strayed into a land beyond reason whose 'goddess is the Salome of Moreau'.

Both Moreau and Munch, and even Gauguin with his '*Nevermore*' (Plate 63), approved of Baudelaire's view that 'natural things exist to only a limited degree, reality lies only in dreams.' Female nudes could also represent frightening and dreamlike figures which reached the depths of man's unconscious. This alternative to the visual approach of Degas and Cézanne led to the exotic and equivocal hot-house atmosphere of the Decadents of the 1890s. Aubrey Beardsley (Plate 68) is an example, while the tradition lived on in the frenzied world of Vienna before the First World War in the work of Klimt and Schiele (see Plate 88). This 'mystic nostalgia for the beyond' prefigures the Surrealism of Paul Delvaux (Plate 92) and the enigmatic horrors of Francis Bacon (see Plate 96).

Yadwiga's Dream by Rousseau (Plate 87) and Picasso's haunting *Life* (Plate 82) owe much to this personal feeling for expressive imagery, but both are also influenced by other considerations. Their formal construction is equally important, and for Picasso, who greatly admired Rousseau's innocent simplicity, his invention of Cubism with Georges Braque resulted in subject-matter being almost entirely subordinated for a time. His *Seated Nude* (Plate 83) takes over where Cézanne left off and treats the human figure solely as a matter of realizing three-dimensional planes and facets on a two-dimensional surface. There is no emotion or anguish here, only the frenzy of creating a new form of realism. Léger's *Three Women* (Plate 89) is equally devoid of emotional overtones. He treats his women as so many spare parts, with the cylinders, spheres and rectangles carefully assembled by a master mechanic. When Cézanne advised Emile Bernard to treat nature in terms of the sphere, cylinder and cone, he cannot have imagined he would be taken so literally by his admirers.

In the twentieth century the new forms, new methods, new cultures and new ideals brought to the painting of the nude a multiplicity of styles and attitudes. Bonnard (see Plate 84) looks backward to an ideal of female beauty seen intimately and frankly by the artist in his studio or his home. The nude is recognizable, the flesh is delectable and there is no greater aim than the intense painterly realization of the subject with all its attendant visual problems of light and colour. We have a carefully composed snapshot of a slice of life.

Marcel Duchamp's *Nude descending a Staircase* (Plate 81) is also influenced by photographic effects, but he has thrown away his Kodak Box for the effects of cinematography. Based on simultaneous photographs of figures moving, and influenced by the formal experiments of Picasso and Cubism, he has attempted to represent the break up of forms by movement, and, for the first time in the history of the nude, the model is not at rest. Bacon (see Plate 96) also uses photographs of the nude, but for a very different purpose. He uses the nineteenth-century images of Eadweard Muybridge, who experimented with consecutive photographs of models and horses in movement, taken with a battery of cameras. His results were much used by nineteenth-century artists from Degas to Alma-Tadema as evidence for what happened to the figure in motion, but Bacon transforms the banal facts into an enigmatic and powerful image of his own.

The fascination of the nude figure is no less felt in most recent art. Again the camera is used to provide a hyper-intensive realism, perhaps as an antidote to the mysteries and impenetrability of abstract art (see Pearlstein, Plate 94). Other people's pin-ups can also be used to tempt us once more and make us look again at what painting the nude figure is about. The variations are endless and an anthology such as this can only show so much. I hope it reveals the pleasures and pains of the artist when face to face with the nude.

Masaccio (1401–28)

1 The Expulsion of Adam and Eve

Fresco, 79¼×34½ in. 1427–8. Florence, Santa Maria del Carmine, Brancacci Chapel.

This powerful and dramatic fresco stands at the beginning of the Early Renaissance and immediately provides a masterpiece of the nude. Masaccio worked on it in conjunction with his fellow-Florentine Masolino. 'With this work he has always been held in great esteem and admiration by all artists, both ancient and modern,' as the originator of the 'good style'. By this Vasari meant that Masaccio's naturalism, particularly the expression of Adam, aids his realization of the tragedy and pathos of the pair's expulsion from Paradise. The work is also an example of the Renaissance humanism which enabled Masaccio to adopt the pose of the 'Venus Pudica' from classical sculpture and transform it in an entirely new, Christian context. He has also managed to assimilate the weighty proportions of such sculptural figures in his own grave image of ideal human figures.

North Italian School, late fifteenth century

2 (top) Nude Holding an Arrow

Pen, brown ink, wash on vellum, 8¼×5⁵⁄₁₆ in. About 1490–1510. Cambridge, Fitzwilliam Museum.

At the end of the fifteenth century Botticelli (see Plate 8) had shown the way in which nudes could express a certain sensitive mood towards antiquity. This drawing is by a North Italian, perhaps from the circle of Francia. The delicate placing and drawing on vellum of the nude holding an arrow is an early attempt at representing a celestial as opposed to a terrestrial Venus; that is, one of the two aspects of love, Sacred and Profane, which Titian was to paint so confidently a little later. This ethereal image of Venus probably appeared at a time, about 1500, and place, not far from Mantua, where the Gothic style merged with High Renaissance scholarship and corporeal paganism.

Pisanello (1395–1455)

2 (bottom) Study of Four Nude Women

Pen and ink on parchment, 8¾×6¼ in. About 1425–30. Rotterdam, Museum Boymans-van Beuningen.

During the Middle Ages artists used pattern books to provide useful material for their studio practice. At the beginning of the Renaissance they began to draw from the nude model and this sheet of studies was probably once part of a sketch book. Pisanello had an intense visual curiosity about the world around him, but he was also influenced by the abstract flowing line, decorative effects and insubstantial poses of the International Gothic style, which was very fashionable at the beginning of the fifteenth century. It has been suggested that he might also have seen a Roman sarcophagus with figures of Amazons, and taken his figures from this. If so, this sketch, with its lively yet slightly awkward effects, shows the dilemma for artists at the beginning of the Renaissance: to reconcile what they could see with what impressed them stylistically, whether from the Antique or the still fashionable Gothic Style.

Albrecht Dürer (1471–1528)

3 (top) Nude Self-Portrait

Pen, brush and black chalk, 11½×6 in. About 1503. Weimar, Schlossmuseum.

'What Beauty is I know not, though it adheres to many things,' Dürer later wrote, and this drawing is in strong contrast to his ideal studies of proportion. His interest remains the nude, but here he has drawn himself after an illness, lean and unwell, far from the perfect beauty of his Apollo (Plate 3 bottom). He is concerned with folds, finicky details and a sagging pose, rather than a bold heroic stance, and his careful objective gaze and detailed techniques are very evident. To draw himself, frankly naked, marks a new sensibility towards the art of the nude and towards himself as an individual creator. The combination of idealization and realism is at the heart of the Renaissance in Italy and was developed by Dürer north of the Alps.

Albrecht Dürer (1471–1528)

3 (bottom) Apollo and Diana

Pen and ink, 11¼×8 in. 1501–3. London, British Museum.

Dürer, after his contact with the art of the Italian Renaissance, was obsessed with the idea of the perfection of human form and the ability of the Italians to realize it. Around 1500 he was introduced to practical examples of figure drawing, and, with the theoretical aid of Vitruvius, he set out to construct a series of studies of human proportions. This is one of the earliest, in the pose of the Apollo Belvedere, and probably the most brilliant. Apollo is cast as the sun god, holding the solar disk and Diana is left unfinished at the right. Dürer's technique owes much to his engraver's upbringing, with every muscle and plane finely drawn and insistently outlined; it is very different from the smooth generalization of his contemporary Italians.

Hugo van der Goes (active around 1467–82)

4 The Temptation of Adam and Eve

Panel, 13¼×10¼ in. About 1470. Vienna, Kunsthistorisches Museum.

This small work, painted with a miniaturist's precision, is one half of a diptych. Nothing further from the heroic world of Masaccio can be imagined, though it probably dates from only forty years after his Adam and Eve (Plate 1). The figures are observed very closely and stand in rather awkward poses as if already aware of their nakedness. The type of figure is also different: Eve, with the exaggerated curve of her abdomen, small breasts and even smaller head, represents a northern standard of beauty, which reflects the Gothic attitudes of the Middle Ages and was to remain popular well into the sixteenth century.

Lucas Cranach the Elder (1472–1553)

5 Venus

Panel, 14⅝×9⅞ in. Signed and dated 1532. Frankfurt, Städelsches Kunstinstitut.

For the Court of the Electors of Saxony Cranach developed a style of nude painting which became very popular because of its refinement and erotic qualities. Though he had knowledge of the Italian Renaissance, and many of his paintings are of Venus and other pagan subjects, he endows his nudes with a northern quality which looks back to the International Gothic Style, apparent, for example, in the works of Pisanello, a century earlier (see Plate 2 bottom). The scale of his nudes even suggests that they are enlarged manuscript illuminations. They are delicately posed, with great emphasis on the outline of the figure with all its vagaries. The elaborate hairstyle, the insistent detail of the jewellery and the transparent drapery are obvious aids to erotic appeal, and, though Cranach's ideal woman is very different from contemporary Italian models, the figure's appeal as a 'pin-up' remains timeless.

Raphael (1483–1520)

6 (top) Adam

Pen and brown ink, 10½×13 in. About 1507. Oxford, Ashmolean Museum.

This was drawn after Raphael had experienced the masterpieces of figures in action designed by Leonardo and Michelangelo as cartoons and hung in the Palazzo Vecchio in Florence. Raphael's own work, just before his move to Rome, reflects this interest in the varied possibilities of posing the nude figure. That he was successful in assimilating the new style is shown by the fact that the drawing was engraved by Marcantonio Raimondi and then used in a totally different context by Reynolds as the basis for the pose of Mrs Lloyd carving her name on a tree (1776). Adam's graceful pose, assured outline and sensitive modelling contrast with the harshness of Dürer's near-contemporary Apollo (Plate 3 bottom).

Francesco Parmigianino (1503–40)

6 (bottom) Bathing Nymphs

Pen, brown ink, brown wash, with some white heightening, 11⅝×8¼ in. About 1524. Florence, Uffizi.

Parmigianino's figure style was based on a number of sources. He was first trained at Parma, where he was exposed to the influence of Correggio (see Plate 16), whose elegant and sensuous manner he soon adopted. When he moved to Rome in 1523 he also became aware of the stronger disciplines of disegno as practised by the followers of Raphael. In particular he was able to experience at first hand the complicated figure compositions in the newly emerging Mannerist style. To these influences can be added his own nervous and delicate style of drawing, which is apparent in this composition. It is an early example of that obsession with drawing the human figure which almost prevented him from producing any finished works at the end of his career.

Marcantonio Raimondi (*c.* 1480–*c.* 1534)

7 The Judgement of Paris

Engraving, $11\frac{3}{4} \times 17\frac{3}{8}$ in. After 1510. London, British Museum.

Marcantonio Raimondi ran a successful studio reproducing the designs of Raphael and other Italian artists whose work was thus quickly disseminated north of the Alps. In turn, he brought the influence of northern artists such as Dürer to Italy. Raphael, in one of his many capacities as designer, painter, archaeologist and architect, seems to have produced a number of designs specifically to be engraved; they are not known in any other medium. This complex design reveals him in his maturity, elegantly posing his nude figures, which are echoes of Roman sculpture and hint at a trouble-free world. Marcantonio is well able to translate into his print Raphael's subtle arrangement and confident figure composition. The nymphs and river gods at the right were later to be used by Manet for his *Déjeuner sur l'Herbe* (Plate 67).

Sandro Botticelli (*c.* 1445–1510)

8 Venus and Mars

Panel, $27\frac{1}{4} \times 68\frac{1}{4}$ in. About 1483–5. London, National Gallery.

Botticelli probably painted this a little before his better-known masterpiece, *The Birth of Venus*, but he reveals the same approach to the nude. He had just been to Rome, where remnants of classical antiquity lay all around. The reclining poses of the two gods and the playful figures of the fauns carrying away Mars's helmet and lance are taken from a Roman sarcophagus. The subject seems to be a complicated humanist reinterpretation of a classical theme: that Venus, as love, should conquer Mars, the personification of discord and war. Both the visual and literary details are thus part of the revival of interest in the classical past, but Botticelli has created a personal, rather melancholy mood, with what Bernard Berenson praised as a 'linear symphony', suitable for the erotic nature of his subject. The nude, in this case the male figure, is treated with a languor of pose and harmony of flowing line which transformed the subject into a subtle and poetic decoration for a Florentine palace.

Palma Vecchio (*c.* 1480–1528)

9 Venus and Cupid

Canvas, $46\frac{1}{2} \times 82\frac{1}{4}$ in. About 1523–5. Cambridge, Fitzwilliam Museum.

The vision of Venus in a landscape provided Venetian painters with innumerable opportunities to paint the nude. Palma Vecchio was a pupil of Giovanni Bellini (see Plate 12) and it is from his art, as well as from that of Giorgione (see Plate 20), that this masterpiece originates. The reclining pose may have come from a print by Campagnola and even from a classical sculpture of a river god, but the figure has no heroic quality and is softer and more languorous than a piece of sculpture. It is painted with a cool silvery tonality, which contrasts with the green of the foreground and the intense blue of the distant landscape. Venus's reticence and ambiguous gesture—she seems to be disarming Cupid rather than giving him the arrow of desire—are very much part of the mood of early sixteenth-century nudes, which celebrate and humanize the beauty of form and landscape together.

Michelangelo (1475–1564)

10 Archers Shooting at a Herm

Red chalk, $8\frac{5}{8} \times 12\frac{3}{4}$ in. About 1532–3. Windsor, Royal Collection.

Michelangelo's drawings of the nude are intimately connected with the important role he thought the human figure could play in a work of art. Not only are his drawings studies of nudes for his major works (see Plate 15), but in the early 1530s he also produced a series of highly finished drawings which are complete in themselves. He intended them as gifts to his friends. They are drawn in a complicated technique, only completely visible with a magnifying glass, of dense hatchings and stipplings, which gives an unearthly light to the idealized godlike nudes. The subjects are, on one level, straightforward enough, with a display of varied poses and vigorous action reproducing or echoing subjects from the Antique. But at a deeper level, as in this example, they are profound comments on the human condition and his own personal feelings: passionate, blind striving cannot achieve its real aim of love.

Antonio Pollaiuolo (*c.* 1432–98)

11 A Combat of Nude Men

Engraving, $15\frac{1}{2} \times 23\frac{3}{4}$ in. Signed, 1460–80. London, British Museum.

Antonio Pollaiuolo is perhaps less well known than his brother Piero (*c.* 1441–96), but this signed print is his masterpiece. The brothers worked as painters, goldsmiths, engravers and sculptors in a thriving workshop. The variety of their activities looked back to the medieval system, but the depth of their interest in the Antique and the nude human figure belonged in spirit to the Early Renaissance. This carefully composed print owes an obvious debt to nude figures on antique pottery and reliefs, but the new sophistication of the engraving technique has the quality of a drawing. The harsh linear style is reminiscent of the expressiveness of Donatello, but the nudes are closely observed and there is a harmonious balance between the vigour of the action and the pattern of light and dark made by the figures, weapons and background.

Giovanni Bellini (*c.* 1430–1516)

12 Woman at her Toilet

Panel, $24\frac{1}{2} \times 37\frac{1}{4}$ in. Signed and dated 1515. Vienna, Kunsthistorisches Museum.

Just as Bellini created a range of votive Madonnas, so we have here an offering to Beauty. There is no sense of the artifice that occasionally makes Florentine mythologies creak of archaeological reconstruction. Though the painting has suffered with time, the image remains lucid and is suffused with the same clear light as the landscapes which are so important to Bellini's pictures. Female beauty is carefully placed in a rich setting against an ideal landscape, to create an atmospheric Venetian mode, which was to set an example to all his pupils: Giorgione, Palma Vecchio and Titian. The picture may have been begun as a portrait, but the mirror and jewellery, with the exquisite still-life of flowers, combine to present an allegory, perhaps of earthly beauty, or even of vanity. The transitory nature of such a theme is caught in one balanced but sensuous image of light and atmosphere which transcends its pagan origin.

Titian (*c.* 1490–1576)

13 Venus of Urbino

Canvas, $46\frac{1}{2} \times 65\frac{3}{4}$ in. About 1538. Florence, Uffizi.

Venus poses frankly in a sumptuous and colourful palace, with her maidservants about to prepare her toilet. The work was painted for the Duke of Urbino and is obviously indebted to Giorgione's famous *Sleeping Venus* at Dresden of about 1508–10, which Titian may have finished. But whereas Giorgione's Venus is asleep in a carefully arranged landscape, Titian's 'Venus' is very much aware of the spectator and the mood is less ethereal, less reserved, and more realistic and direct. The outline of Giorgione's figure is abstracted and idealized, whereas the curves of Titian's figure are more interrupted and there is a greater sense of the model's weight and individuality. The opulence of the surroundings emphasizes the naturalness of the scene, and the figure is less abstract and ideal than Titian's later *'poesie'*. This Venus is the ancestor of Manet's *Olympia* (Plate 62), even to the detail of the pet at the foot of the bed.

Leonardo da Vinci (1452–1519)

14 Nude Male Figure in a Circle

Pen and brown ink, $8\frac{3}{4} \times 6$ in. About 1485–90. Venice, Academy.

This famous drawing illustrates Vitruvius's system of human proportions and Leonardo has added a translation of Vitruvius's text. It dates from his period at the Court of Milan and is earlier in style than those innumerable anatomical studies which he executed, mainly in Florence, during the next two decades (1490–1510). It may have been intended as a frontispiece for the future publication of his treatise on anatomy. The idea of drawing the perfect man, who would be nine face-lengths long and fit into a square which would be the width of his outstretched arms, obsessed Renaissance artists. There is a drawing by Michelangelo at Windsor which is based on twenty-seven nose-lengths (ten face-lengths) while Dürer (see Plate 3 *bottom*) was also fascinated by this exercise.

Michelangelo (1475–1564)

15 Seated Male Nude

Red and black chalk, $11 \times 8\frac{3}{4}$ in. About 1511. Teylers Museum, Haarlem.

There are a number of surviving nude studies drawn from the life for the greatest creation of Michelangelo's early career: the decoration of the ceiling of the Sistine Chapel. This drawing is for one of the seated nude figures ('ignudi'), which flank the panel representing the creation of the waters. It is on the right above the Persian Sibyl (see Plate 17). Michelangelo began his great work in the winter of 1508–9, halted in 1510 and finished in 1512. The present figure probably dates from the second period of activity. Like other studies of the time, the drawing shows a detailed, even exaggerated, concentration on the musculature of the handsome youth. He is posed as

a reminiscence of the Antique 'Belvedere Torso', but with a more powerful and poised twist to the body. The motif of interspersing the narrative scenes with nude figures, as sculptural adjuncts, probably survived from Michelangelo's earlier ideas for the Tomb of Julius II and was to be extremely influential on the development of decorative art (see Plate 32).

Correggio (1489/94–1534)

16 Jupiter and Io

Canvas, $64\frac{3}{8} \times 27\frac{3}{4}$ in. About 1530. Vienna, Kunsthistorisches Museum.

This ecstatic work is one of a series of four paintings of the loves of Jupiter, commissioned apparently by Federigo Gonzago, possibly for his newly built Palazzo del Té in Mantua. In them Correggio reaches the height of his sensuous figure style, which looks forward in its emotionalism to the Baroque and in its eroticism and in the proportion of its figures to the Rococo world of the eighteenth century. Io, the daughter of Inachus, was taken by Jupiter hidden in a cloud. She sits, with head thrown back, in a soft and sensual pose reminiscent of a classical Nereid or of Psyche.

Michelangelo (1475–1564)

17 'Ignudo'

Fresco (detail). 1510–12. Vatican, Sistine Chapel.

In Michelangelo's masterpiece, the vault of the Sistine Chapel, we find the supreme expression of the nude in painting, both formally and symbolically. The decoration had been commissioned by Pope Julius II just after Michelangelo had been working on designs for the Pope's enormous tomb. The ceiling continues those structural ideas. It is basically an architectural framework with projecting piers and an elaborate cornice, punctuated with figures (the Sibyls and Prophets) seated in niches and, on the next storey, nude men seated on the piers: the 'ignudi'. They act as intermediaries between the Divine Histories and Man below. Thus they have a plastic function, as well as a symbolic one as representatives of perfect human beauty. They were very influential for subsequent decorative schemes and were much admired for their variety of pose and anatomical accuracy.

Perino Buonaccorsi, called del Vaga (1501–47)

18 (top) Vertumnus and Pomona

Red chalk and ink, $7 \times 5\frac{3}{8}$ in. 1527. London, British Museum.

Perino del Vaga, as one of Raphael's principal assistants, was responsible for continuing the gracious style of his master in Florence and Rome. This drawing was done for an engraving as part of a series of Loves of the Gods. It is typical of the Mannerist style of the 1520s, in which the nudes are part of the fantastic world of mythology and are posed deliberately in a complicated yet elegant manner. Vertumnus normally appears as an old woman (see Plate 31) and the substitution of the virile god emphasizes the eroticism of the scene.

Ludovico Carracci (1555–1619)

18 (bottom) Study of a Sleeping Nude Boy

Red chalk, $9\frac{3}{8} \times 8\frac{3}{4}$ in. About 1585. Oxford, Ashmolean Museum.

The Carracci founded an academy in Bologna where drawing from the nude was established as a regular part of the artist's curriculum. The three members of the family, Ludovico and his cousins, the brothers Agostino (1557–1602) and Annibale (1560–1609), used a classicizing style which reached its culmination in Annibale's decorations in the Farnese Palace, Rome, 1595–1604 (see Plate 32). Their art, however, was based on close observation and this drawing shows how realistic they could be. The slightly humorous quality reminds us that they were also in the forefront of the development of caricature. But a comparison with Goltzius's nude (see Plate 19) of 1594, shows that the realism is balanced by a schematization of the internal modelling which gives the drawing an easy grace.

Hendrick Goltzius (1558–1617)

19 Reclining Figure of a Nude Girl

Black chalk, $10\frac{1}{8} \times 11\frac{15}{16}$ in. Signed and dated 1594. Private Collection.

Goltzius was at first known as an engraver. Then at Haarlem he developed into a painter and draughtsman of some power and individuality. Contorted poses and harsh outlines often imbued his works with the exaggerated effects of northern Mannerism. But this example contains less art for art's sake; it is much more direct, depicting a quiet moment in the studio, with the model asleep. It is

the closest a Dutch artist came, before the seventeenth century, to the life studies of the Italians. Its carefully outlined detail, without any scheme of internal modelling, and its casual, inelegant pose, without artifice, add to the obvious realism (compare Carracci's Sleeping Boy, Plate 18 bottom). In this respect this engaging and striking image looks forward to the triumphs of Dutch art in the next century.

Giorgone (c. 1476/8–1510)

20 Concert Champêtre

Canvas, $43\frac{1}{4} \times 54\frac{3}{4}$ in. About 1508–10. Paris, Louvre.

This famous picture embodies the essence of the Giorgionesque. The term came to describe the creation in early sixteenth-century Venice of pictures which express a lyrical Arcadian mood, with nude figures set in an ideal landscape. The aim was to provide a pleasurable and subtle arrangement of figures which contrast, on the one hand, the fleshly delights of the nudes, with, on the other hand, a lush landscape and the sensuous charms of music. They are painted in rich colour and the pictures became poetic compositions of great tenderness. This scene perhaps does not bear serious analysis, with the obviously posed figure at the left not very convincingly drawing water. Yet similar nude figures gracefully and expressively posed, with hints of classical statuary, set against a luminous rural landscape and with Arcadian shepherds in the background, have given Western man a fresh and lasting vision for over 400 years. They provided constant inspiration, from the immediate influence on Titian in his Sacred and Profane Love, to Raphael, Poussin, Manet (see Plate 67) and Picasso.

Tintoretto (1518–94)

21 Susanna and the Elders

Canvas, $57\frac{3}{4} \times 76\frac{1}{4}$ in. About 1550–6. Vienna, Kunsthistorisches Museum.

Tintoretto, of all the Venetian artists of the sixteenth century, was the one most influenced by the contorted poses and heroic stance of the nudes of Michelangelo. The figure of Susanna is a striking example, but Tintoretto has translated Michelangelo's flamboyant male nudes into a softer, more sensual female figure, drying her feet with a natural gesture. Though the painting has something of the warm glow and reflected light of Venetian painting, the figure is painted with longer proportions and a greater interest in the outline than was customary with his great contemporary Titian (see Plate 28), and reminds us that Tintoretto drew more than most Venetians. The background, too, with its tunnel-like distance and almost distracting amount of detail piled into the diagonal space, is less harmonious than the ideal Venetian landscape. The two Elders who spied on Susanna are at first difficult to find; yet another indication of Tintoretto's Mannerist tendencies.

Jacopo Pontormo (1494–1556)

22 Standing Male Nude

Red chalk, $11\frac{3}{16} \times 8$ in. About 1525. London, British Museum.

Pontormo's drawing was based on the Florentine practice of careful studies from the nude for the figures in major pictures. The linear style, with its vigorous cross-hatching and emphasized outline to define the anatomy, is part of the Florentine approach. This drawing was not used for a finished composition and is more in the nature of an exercise. It is, in fact, a nude self-portrait of the artist (compare the one by Dürer, Plate 3 top) pointing at himself in a mirror.

Sir Peter Paul Rubens (1577–1640)

23 Study for the Figure of Christ

Black chalk, heightened with white with some wash on buff paper, $15\frac{3}{4} \times 11\frac{3}{4}$ in. 1609–10. Cambridge, Massachusetts, Fogg Art Museum (Bequest of Meta and Paul J. Sachs).

This is a nude study from the life for the figure of Christ in The Raising of the Cross, a triptych painted between 1609–11 and now in Antwerp Cathedral. The gaze is directed upward towards the figure of God the Father who appears in a niche above. This, and the other nude studies associated with the altarpiece, show how much Rubens had learnt in Italy about the vigorous expression of emotional content through striking poses and a sure line. Its command of anatomy, with rippling touches of light over the surface and sensitive outline, reveals an obvious debt to the Carracci and the Bolognese School (see Plate 18 bottom). Rubens's other nudes of the time are energetic in the manner of Tintoretto or Michelangelo, but this youthful Christ is posed languorously. A comparison with the nude of Goltzius (Plate 19) shows Rubens's increased subtlety, without equal among his northern contemporaries.

Bronzino (1503–72)

24 An Allegory

Panel, $57\frac{1}{2} \times 45\frac{3}{4}$ in. About 1546. London, National Gallery.

The complicated subject is matched by a virtuoso display of contorted nudes. The picture probably represents an allegory of Venus and Cupid locked together by sensual love, encouraged by a *putto* at the right. This can only result in Jealousy, who tears her hair at the left, and Deceit, the figure at the right with a beautiful face and the hindquarters of an animal, while all will be revealed by Time at the top right, and by Truth. The painting, probably sent from the Florentine court of Duke Cosimo I to Francis I of France, is certainly a product of the involved Mannerist style popular at both courts. Though the subject is erotic in its details, the overall impression is of a contrived stylization, with the artist revealing his virtuosity by the unnatural variety of poses, even probably taking his figure of Venus from that of a dead Christ by Michelangelo. The strident colours emphasize the artificiality of the picture, where the nudes are part of the world of art, rather than of life.

Veronese (c. 1528–88)

25 Venus and Mars United by Love

Canvas, $81 \times 63\frac{3}{8}$ in. Signed, 1576–84. New York, Metropolitan Museum.

Veronese's penchant for rich and sumptuous settings is well shown in this allegorical pageant. At one level, it is an obvious restatement of Botticelli's theme (see Plate 8) on the unification of harmony and discord by love, but whereas Botticelli's picture has a fragile humanist maiden as its heroine, the Venus of Veronese is robust and mature, the embodiment of Venetian earthly delights. Her creamy flesh is contrasted with the colourful display of Mars's dandified antique armour. The horse, a symbol of animal passion, is also subjugated by love. It further provides another tonal area to balance the herm in the background and the colours of Mars in the foreground against the flesh tints of Venus. The whole is a riot of the senses where the sensuous mode of expression emphasizes the theme. Even the gesture of Venus reinforces the physical aspects of the allegory.

Pierre Milan (active 1542–65) and René Boyvin (c. 1525–after 1580)

26 The Nymph of Fontainebleau

Engraving, $12 \times 20\frac{1}{8}$ in. About 1554. Paris, Bibliothèque Nationale, Cabinet d'Estampes.

Pierre Milan was a professional engraver working in Paris. He has been included to show how engravers, when their work was sensitive and competent, had an important role to play in the dissemination across Europe of styles of drawing the nude. The work done at Fontainebleau by artists such as Primaticcio (see Plate 29) and Rosso developed into an elegant Mannerism which this print successfully captures. Rosso, who signed the print, designed the characteristically elaborate background with its riot of ornament, caryatids and *putti*, though the central image of Diana may have come from a relief. Diana was particularly associated with Fontainebleau because Diane de Poitiers was patron of much of the work. The figure style of small head, elaborate *coiffure*, classical profile and elongated body is typical of the school, though the reclining pose comes ultimately from the same classical source as Palma Vecchio's *Venus* (Plate 9).

Rembrandt (1606–69)

27 (top) Woman with Arrow

Etching, $8 \times 4\frac{3}{4}$ in. 1661. London, British Museum.

As well as drawings of nudes, Rembrandt also made a number of prints. His female nudes were deliberately not glamourized and did not fulfil the canons of classical form. A later Dutch critic complained that there were 'flabby breasts', 'the marks of corsets', 'garters on the legs' and 'no principles of proportion in the human body'. The realism hinted at in Goltzius's drawing (Plate 19) is now given full expression and a classical Venus is transformed by Rembrandt's dry-point needle into a mysterious image of a modern goddess. The symbolism remains the same as it was in Palma Vecchio's painting (Plate 9), but the debt to Antiquity has been assimilated and is less obvious. The weight and bulk of the figure, the subtleties of light on her back and flank, the dark recesses of the bed, show how direct observation of the nude, or the 'alternative convention', as it has been described, provided an equally valid way of looking at form and one which dominated art schools, almost to the present day.

Rembrandt (1606–69)

27 (bottom) Standing Male Nude

Pen, brown ink, brown wash, black chalk, $7\frac{3}{4} \times 5\frac{1}{4}$ in. About 1646. Vienna, Albertina.

Rembrandt's drawings of female models, which he made throughout his life, but especially in the 1650s while he was working on his *Bathsheba* (Plate 38), are perhaps best known. Around 1646, however, he produced a number of drawings and prints of male nudes, of which this is one. We know that he ran a flourishing studio and there are pupils' drawings showing him teaching his young class in front of the life model. This drawing gives the light and air of such a scene. It is very much an exercise in modelling, in light and space, with no thought of an elegant pose for subsequent use. The plasticity and boldness of the drawing, with the reed pen and brush, should convince those who have suggested that this is a pupil's work retouched by the master.

Titian (c. 1490–1576)

28 Danaë

Canvas, $50\frac{1}{2} \times 70$ in. 1553–4. Madrid, Prado.

Titian painted 'Danaë', one of the finest and most voluptuous of his late nudes, more than once. This version was sent to Philip II of Spain, who commissioned a number of similar erotic allegories. Danaë was imprisoned by her father after an oracle had foretold that he would be killed by his daughter's son. However Jupiter visited her in prison in a shower of gold. Titian has chosen the moment of conception, and, like a scene from a grand opera of the gods, he has given full expression to the expectant gaze of Danaë and her easy receptive pose. He has completely assimilated not only a classical prototype ('Leda') for the pose, but also the powerful figure of 'Night' from Michelangelo's Medici tombs in Florence. The painting of the flesh, the draperies, the old servant and the sleeping dog, is done with all the colouristic skills of his late manner, with, as Vasari says, 'bold strokes and blobs to obtain the effect at a distance'.

Primaticcio (1504–70)

29 Ulysses and Penelope

Canvas, $44\frac{3}{4} \times 48\frac{3}{4}$ in. About 1545. Toledo, Ohio, Museum of Art (Gift of Edward Drummond Libbey).

Primaticcio and Rosso Fiorentino created a style of decoration for Francis I which was a French variant of Italian Mannerism and known as the School of Fontainebleau. This charming painting was probably based on one of the panels which Primaticcio designed at Fontainebleau for the Galerie d'Ulysse. Ulysses's gesture under Penelope's chin, as he recounts his adventures, is typical of Primaticcio's refined drawing and delight in the by-play of hands. Ulysses is seen as a handsome river god, but Penelope has an individual beauty, with very small breasts, elaborate hair-do and long features. The two figures, their delicate eroticism and the elongated silhouettes in the background seen through the high archway, show that Primaticcio was influenced by Parmigianino's sensitive art (see Plate 6 bottom).

Guercino (1591–1666)

30 Female Nude

Pen, brown ink and wash, $10\frac{1}{8} \times 8\frac{1}{8}$ in. London, British Museum.

A tradition of studying from the life had grown up in Bologna with the Carracci Academy (see Plate 18 bottom). Guercino followed in this tradition and constantly made drawings from the life, sometimes as preparatory studies for his paintings and sometimes as ends in themselves. He produced a whole series of 'academies', as such nudes came to be called, on a large scale in black chalk, many of which have only recently come to light. This drawing, however, is small, spontaneous and delightful. The model is posed with arms held above her head and drawn in Guercino's characteristic rapid pen style, with subtle accents of wash to accentuate the movement of light across the flesh. Its freshness and lack of earnestness look forward to the Rococo and the attractive world of Boucher (see Plates 40 and 43).

Jan Saenredam (c. 1565–1607)

31 Vertumnus and Pomona, after Abraham Bloemaert

Engraving, $18\frac{15}{16} \times 10\frac{1}{8}$ in. 1605. London, British Museum.

Saenredam was one of those leading print makers of Haarlem who, at the end of the sixteenth century, produced a range of technically

skilful prints after the leading artists of the day. They were influenced by the prints and designs of Goltzius (see Plate 19) and were thus largely concerned with the late flowering of Mannerism in the north, based on the Italians and the School of Fontainebleau. Bloemaert, from Utrecht, was a prolific artist working in a variety of Mannerist and academic styles. In this example Saenredam competently handles the profusion of vegetation which Bloemaert, following Ovid, had placed in Pomona's garden. Vertumnus, disguised as an old woman, pleads his case to the reluctant nymph, who is posed gracefully among the interlocking trees. Such an art, with nude and clothed figures from classical mythology, elegantly placed out of doors, presupposes a courtly interest in a refined and sensuous world that never was.

Annibale Carracci (1560–1609)
32 Venus and Anchises
Fresco. 1597–1604. Rome, Palazzo Farnese.

The whole ceiling decoration, of which this is part, is devoted to the loves of the gods. There is a triumph of Bacchus in the centre and here, Venus and Anchises, from whose union Aeneas was born. It is one of the greatest and happiest achievements in the history of western decorative art, to be ranked with Raphael's *Cupid and Psyche* in the Villa Farnesina and Michelangelo's ceiling of the Sistine Chapel. From the one Annibale has adopted an exuberant pagan world and from the other, the motif of punctuating the architectural framework with nude figures. Annibale's male nudes are the heirs to Michelangelo's '*ignudi*' (see Plate 17) and have an equally important part to play. Their idealized forms and healthy rose-coloured flesh are contrasted with the off-white of the simulated sculptural herms. Both provide a second framework, in addition to the architecture, around the central scene.

Unknown artist of the French School, sixteenth century
33 Gabrielle d'Estrées and the Duchesse de Villars
Panel, 37¾ × 49¼ in. About 1596. Paris, Louvre.

One of the results of the introduction of Italian Mannerism into France by way of the School of Fontainebleau (see Plate 29), was the development by François Clouet and a number of anonymous followers of a slightly quirky series of portraits. The sitters, who are often favourites of the Court, are shown nude behind a parapet, a device for portraiture which originated in Italy with Leonardo. They are sometimes disguised optimistically as Diana, goddess of chastity, or Venus, goddess of love. The approach is exquisitely sensual in a refined linear manner and the precise gestures belong to the complex symbolism of eroticism. The two women are painted smoothly like dolls at a puppet-show, with their elegant *coiffures* maintained intact. The treatment of the nude is at once obvious, if slightly naughty, but also obscure; a refined and courtly hedonism, which is the basis of much Mannerist art.

Caravaggio (1573–1610)
34 Amore Vincitore (Cupid Triumphant)
Canvas, 60⅝ × 39⅜ in. About 1598–9. Berlin, Staatliches Museum.

This nude image is powerful and direct, even embarrassingly so. It was painted at the beginning of Caravaggio's career, when he was experimenting with subjects from what has been described as the 'flash underworld'. The nudity is insistent; the still-life of the musical instruments and armour is painted in precise detail, and the smooth high finish adds to the disconcerting effect of love cheekily triumphant over knowledge, art and war. Caravaggio seems to have preferred painting directly from life (no drawings by him are known), and his models are neither aesthetically nor morally improved. Yet, though his art has been thought revolutionary, his later expressive development using dramatic lighting and carefully posed religious groups shows that he realized that style (or 'what was in his imagination') was as important as the knowledge of what he could see; an attitude close to that of his academic contemporary, Annibale Carracci (see Plate 32).

Sir Peter Paul Rubens (1577–1640)
35 'The Pelt Skin'
Panel, 69 × 32⅝ in. About 1638. Vienna, Kunsthistorisches Museum.

Rubens has endowed this personal image of his second wife, Hélène Fourment, whom he had married in 1630, with so much appeal by exquisitely contrasting the texture of the fur with the lovingly painted flesh. In this respect he follows from the Venetians he so admired, but the nude is posed as a Baroque Venus, with less reserve and a greater emotional impact. Her figure is made more ample, the twist and forms of her body accentuated by the cross-over of her arms holding the fur. The picture remained in Rubens's studio until his death when it was given its inimitable title in his will.

Sir Peter Paul Rubens (1577–1640)
36 The Rape of the Daughters of Leucippus
Canvas, 87⅝ × 82½ in. About 1619. Munich, Alte Pinakothek.

Rubens shows the twins, Castor and Pollux, in the act of carrying off the two daughters of Leucippus. Their martial ardour and prowess as horsemen is emphasized by the rearing horses, symbols of passion; but it is in the two nudes that Rubens reveals his full powers. Henry James wrote of Rubens's 'carnal cataracts', but the description hardly looks good here. The nudes are the pivot of the composition, which swirls powerfully within the square format. It is their bodies, through their complementary poses, which actively express the anguish and vigour. Rubens has borrowed Michelangelo's design for *Leda* (Pollux's mother) for the central figure, but has radically transformed it into a complicated Baroque image of weight, breadth and detail. Above all, the remarkable blond and glowing painting of the flesh contrasts with the darker tones of the horses and twins.

Sir Anthony Van Dyck (1599–1641)
37 Cupid and Psyche
Canvas, 78½ × 75½ in. About 1639–40. London, Royal Collection.

This masterpiece was possibly painted for Queen Henrietta Maria's Cabinet at Greenwich. It expresses all that was finest in Van Dyck's style at the end of his career in England. Both Van Dyck and his master, Rubens, were influenced by the paintings of the Venetians, with which the Court of Charles I was richly endowed. But whereas Rubens's interpretations are Baroque statements whose nudes are almost larger than life (see Plate 36), Van Dyck's use of the figure and its landscape setting is more sensitive, smaller in scale, whispering more to private ears than to public places. The poetic mood looks forward to the eighteenth century and the Rococo charms of Watteau and Boucher, even to Gainsborough (see Plate 44). Psyche is discovered by Cupid, elegantly relaxed in the 'dull lethargy' of sleep, after she has opened the box of beauty brought to her from Proserpine at Venus's command.

Rembrandt (1606–69)
38 Bathsheba
Canvas, 55⅞ × 55⅞ in. Signed and dated 1654. Paris, Louvre.

Rembrandt painted only two life-size nudes and Venetian painting, particularly Titian, has influenced the sensuousness of his approach in both. In *Bathsheba*, the actual poses of the two figures are borrowed from an engraving of an Antique relief. The model is probably his beloved Hendrickje Stoffels. His borrowings and debts to other artists, however, matter little compared with the profound psychological impact of his nude. He has chosen the moment, unusual for the subject, when Bathsheba has received David's letter and has to decide between her husband, Uriah, and David's importunities. Rembrandt's insight, his painterly technique and the glowing corporeality transcend the weight of the body and the realistic details. The result is a masterpiece: 'The naked body permeated with thought,' as it was described by Kenneth Clark.

Diego Velázquez (1599–1660)
39 The Toilet of Venus ('The Rokeby Venus')
Canvas, 48¼ × 69¾ in. About 1649–51. London, National Gallery.

Velázquez is known to have painted a number of nudes, but this is the only surviving example. It was probably painted during his second visit to Italy, as he has taken a rare but elegant back view of the nude based on the famous reclining Hermaphrodite then in Rome. The sculpture leans similarly on the right arm. Velázquez, however, has turned Venus's head towards the mirror held by Cupid. It is a symbol of vanity, but also reveals an interest in images within images, which looks forward to Manet. The fluid technique, brilliant light effects, and the realism of the rich crimson drapery, which so beautifully follows the curve of the body, also look forward to the nineteenth century, when it was much admired as a precursor of Impressionism.

François Boucher (1703–70)

40 Mlle Louise O'Murphy

Canvas, $23\frac{1}{4} \times 28\frac{3}{4}$ in. Signed and dated 1752. Munich, Alte Pinakothek.

This is one of Boucher's most famous paintings. The model was almost certainly the young Louise O'Murphy (1737–1814) of Irish extraction, who afterwards became for a short time mistress of Louis XV. She is cast not as Venus on her couch but rather as a modern nymph, sprawled sensually in the studio, amidst a confusion of draperies, hangings, strewn flowers and incense. She is the perfect embodiment of a type of fresh beauty for which Boucher became famous, with her small body and youthful expression, all dimples and softness. Her erotic appeal is instantly recognizable and later in the century such seductive nudes for private cabinets were considered somewhat reprehensible. But the painting can be seen as a straightforward though sensuous development of the example of Watteau and, ultimately, of the Venetians.

Giovanni Battista Tiepolo (1696–1770)

41 Danaë

Canvas, $16\frac{1}{4} \times 20\frac{7}{8}$ in. About 1736. Stockholm, University Museum.

This small and languorous example of Venetian eighteenth-century painting was brought to Stockholm by the Swedish minister in Venice. Tiepolo was admired in Stockholm, Milan, Würzburg and Madrid, as well as in Venice. Even Boucher owned some of his drawings, though Tiepolo's brilliant and courtly art is very different from the earthly delights of the French Rococo. His debt to the late nudes of Titian, in the slow turn of Danaë's body, and his love of Veronese's decorative architectural detail are very apparent. The foreground motif of the surprised dog who barks at Jupiter's eagle is also reminiscent of Veronese's art. Tiepolo's figures and setting look back to the Venetian sixteenth century and are more heroic, more neutrally pagan than the intimacies of the French court.

Antoine Watteau (1684–1721)

42 A Lady at her Toilet

Canvas, $18\frac{1}{4} \times 15\frac{1}{4}$ in. About 1718–20. London, Wallace Collection.

Some of Watteau's beautiful paintings of the nude are not allegories but intimate studies from the life intended for private enjoyment. Here he gives little hint of the Grand Manner, even though the pose of the model reflects that of a classical crouching Venus, while the debt to the Venetians, whom he so much admired, is only partly apparent in the richness of colour and handling and the attendant maid. These nudes are seen direct with little comment and only Rembrandt, perhaps, in the previous century or Degas in the next, painted or drew such engaging realistic studies. Nevertheless, Watteau's paintings of the model half-dressed, or preparing her *toilette*, are consciously made attractive and are the forerunners of the later eighteenth-century keyhole views by Boucher and Fragonard, who, however, were rather more arch. It was not until Manet's *Olympia* (Plate 62) that the nude and her attendant could again be seen so objectively, yet so attractively.

François Boucher (1703–70)

43 Venus and Mars Surprised by Vulcan

Canvas, $65\frac{1}{2} \times 33\frac{3}{4}$ in. 1754. London, Wallace Collection.

This painting, one of four decorative allegories, was once thought to have been painted expressly for a boudoir of Madame de Pompadour, the mistress of Louis XV and Boucher's great patron. Though this now appears unlikely, it is very much to her taste, a taste which Boucher exploited so richly and with an inventive and amused tolerance. The motif of the reclining Venus, caught *flagrante delicto* by Vulcan, allowed the artist to give his delightful allegory a sense of instant drama, echoed by the startled dove and fluttering draperies supported by worried cupids. It is a confident and colourful example of the Rococo style.

Thomas Gainsborough (1727–88)

44 Diana and Actaeon

Canvas, 61×73 in. About 1787–8. London, Royal Collection.

Although Gainsborough is best known for his ravishing portraits, he did, at the end of his life, paint a number of what were called 'fancy pictures' of a romantic nature, including two paintings of nudes: *Musidora Bathing* (Tate Gallery) and this late unfinished masterpiece. Unlike his other 'fancy' pieces, which often have a personal view of the rustic world, *Diana and Actaeon* is an attempt at the Grand Manner, of which Reynolds thought him incapable. But

Gainsborough's fresh and non-academic sketch bears closest comparison with the mood and painting of Fragonard, Watteau, the Venetians and, above all, Van Dyck, whom he particularly admired (see Plate 37). His poetical creation glows with an ethereal vision in which the nudes are part of the landscape, painted with that flickering touch where oil is indistinguishable from watercolour or pastel, and which, as Reynolds so fairly observed, 'by a kind of magick, at a certain distance assumes form . . .'.

Jean Honoré Fragonard (1732–1806)

45 The Bathers

Canvas, $25\frac{1}{4} \times 31\frac{1}{4}$ in. About 1765–70. Paris, Louvre.

It is too easy to discuss Fragonard in the wake of Boucher, his master, as a vulgar purveyor of confectionary, a decorator to the fashionable world around Madame Du Barry. His portraits, landscapes and 'fancy pictures' were the equal of any of his contemporaries. *The Bathers*, painted at the height of his fashionable success, at first seems merely a more extravagant version of Boucher's dreams, but, like Gainsborough in England (see Plate 44), Fragonard is able to create a lyrical transformation by an overall vivacity of handling which unites the nudes with the landscape. The subject of bathers by the bank of an imaginary stream is often an excuse for the nude, but for 'these exquisite dreams', as the Goncourt brothers declared, 'Fragonard's imagination rose to miraculous visions, to heights of ravishment and burning sweetness, to a kind of ecstasy.'

Jacques-Louis David (1748–1825)

46 Death of Barra

Canvas, $46\frac{1}{2} \times 61$ in. 1794. Avignon, Musée Calvet.

David, in his fervour for the French Revolution, has here commemorated the death of the thirteen-year-old Joseph Barra in the pose of the martyred St Cecilia. According to Robespierre, Barra had been killed by Royalist troops for refusing to cry 'Vive Le Roi'. David, with his heroic Neo-Classical ideals, has painted him in the nude, clutching the tricolour to his bosom. But, as with most revolutions, the heroes are not quite what they seem. Robespierre's speech was apparently a fabrication and Barra was really killed by brigands. Furthermore, the painting is unfinished and David may have intended to paint Barra in his uniform. Nevertheless, the picture remains, with the best history pictures whose facts are suspect, as a stirring image. It reminds us that a Neo-Classical nude could have romantic sentimental overtones and could be painted in an indulgent loose technique.

William Etty (1787–1849)

47 Hero and Leander

Canvas, $30\frac{1}{2} \times 37\frac{1}{4}$ in. 1829. R. W. T. Britten Collection (on loan to York Art Gallery).

It was not easy for an English history painter to make a living from subject pictures. Etty's pictures were always nude figure compositions. He often drew and painted at the Academy's life class, incurring the amusement of his fellow professionals and students. Early in his career *The Times* warned him, perhaps unfairly, of the possibility of impropriety: 'Naked figures, when painted with the purity of Raphael, may be endured: but nakedness without purity is offensive and indecent, and in Mr. Etty's canvas is mere dirty flesh.' The present picture was exhibited at the Royal Academy in 1829 with its full title: 'Hero, having thrown herself from the Tower at the sight of Leander drowned, dies on his body.' It is boldly composed and has that lusciousness which Etty enjoyed and Delacroix admired. It comes quite near, but not near enough, to the Romantic paintings of Géricault, and it has an earnestness of purpose which is sometimes embarrassing.

Eugène Delacroix (1798–1863)

48 Odalisque

Canvas, $14\frac{7}{8} \times 18\frac{1}{4}$ in. Signed, about 1825–9. Cambridge, Fitzwilliam Museum.

Delacroix is rightly considered a giant of the French Romantic movement. His nude figures play heroic and emotional roles in his great history pieces. He drew on Rubens, Michelangelo, the Venetians and stirring events in such pictures as the *Death of Sardanapalus* (Plate 55) or *Liberty Guiding the People* (1830), where the expressiveness of his figures and broken colour look forward to the end of the nineteenth century. The present picture deserves to be better known and, with its oriental trappings of hookah and richly decorated scabbard, is an example of a number of exotic eastern subjects which he and others painted in the mid 1820s. Ingres, too,

his great rival, had painted similar nude figures (see Plate 51). Delacroix's work differs, however, in the sprawling *contrapposto* of the figure and the dramatic light and shade, painted with many changes of mind. Above all, it is loosely painted with thin glowing glazes, very like the watercolour technique he so much admired in the work of his English friend, Bonington. Only the body is painted more thickly and passionately.

Pierre Paul Prud'hon (1758–1823)
49 (*top*) Study for 'La Source'

Black and white chalk on blue-grey paper, $21\frac{3}{16} \times 15\frac{5}{16}$ in. About 1801. Williamstown, Massachusetts, Sterling and Francine Clark Art Institute.

Prud'hon's drawings of the nude are among the most ravishing creations of the end of the eighteenth century. They can hardly be described as Neo-Classical because of their sensuousness and personal involvement. The lavish use of black chalk with white heightening on blue paper is typical, and they are usually of single figures, often the same model, in this case Marguerite. Nevertheless, the origin of the present drawing seems to have been an official commission for a proposed monumental column with figures symbolizing the rivers Rhine, Po, Nile and Danube at its foot. The official nature of the commission probably accounts for the statuesque quality of the figure, drawn from life, and its detailed finish. It reminds us, however, that Neo-Classicism and Romanticism should not be rigidly separated.

Jean Auguste Dominique Ingres (1780–1867)
49 (*bottom*) Study for 'Andromeda'

Monochrome oil sketch, $17\frac{3}{4} \times 14\frac{1}{2}$ in. About 1819. Cambridge, Massachusetts, Fogg Art Museum (Bequest of Grenville L. Winthrop).

This ravishing monochrome sketch has been identified as a preliminary study for *Roger and Angelica* (1819, Louvre). Other sketches, however, show that Ingres first conceived his subject as 'Perseus freeing Andromeda' and Andromeda is shown with her head bowed as in the present study. Only in the development of the composition did he adopt the well-known pose with the figure's hands across her body and her head thrown violently back. This sketch, perhaps because it has a reduced emotional content, can be considered more successful. Painted from the life, it has a very delicate internal modelling, a careful concentration on the curve of the hip and outline of the body: 'The essential is the contour, it is the modelling of the figures,' as he himself said.

Francisco Goya (1746–1828)
50 'The Naked Maja'

Canvas, $38\frac{1}{4} \times 74\frac{1}{4}$ in. About 1800–5. Madrid, Prado.

'The Naked Maja', together with its famous companion, 'The Clothed Maja', was probably commissioned by Emanuel Godoy, the Chief Minister at the Court of Charles IV of Spain. He also owned Velàzquez's 'Rokeby Venus' (Plate 39), which obviously had an influence on Goya. Contrary to romantic legend the sitter was not the Duchess of Alba, and the term *maja* refers to the Spanish costume in the clothed version which was worn by certain artisans. Goya never again painted such fresh and life-enhancing images with no hint of his later gloomy preoccupation with war and man's inhumanity. The nude '*Maja*' combines elements of the Rococo in the attractiveness of the subject and the painterly rendering of the pillows and couch, and it looks forward to Manet's *Olympia* (Plate 62) in its frankness and realism. In 1815 Goya was asked by the Inquisition to account for these 'two obscene paintings'. Unfortunately, his answers are not known, but the two pictures, luckily, still survive in Madrid.

Jean Auguste Dominique Ingres (1780–1867)
51 'La Grande Odalisque'

Canvas, $24\frac{3}{8} \times 35\frac{3}{4}$ in. Signed and dated 1814. Paris, Louvre.

This nude was commissioned by Queen Caroline Murat of Naples in 1813 and was painted in Rome but never delivered. She is an oriental Venus in classical reclining pose, with Gothic proportions created by a Neo-Classicist of academic rigour. A critic complained that she had 'three vertebrae too many', but this only becomes obvious when her languorous pose is analysed. She reclines on her left hip, but has her back and buttocks turned towards the spectator; an immensely long arm frames the smooth curves of her impossibly long back. The rich oriental trappings of silks, jewellery, pipe and whisk complement the impeccable skin and provide a romantic setting which was taken up by Ingres's rival, Delacroix (see Plate 55). The expressive points,

however, come where one line touches the edge of another form, as is particularly obvious in his preliminary drawings. 'He follows the slightest undulation of the lines with the ardour of a lover,' Baudelaire remarked.

Giovanni Battista Tiepolo (1696–1770)
52 (*top*) Time and Truth

Pen, brown ink, brown wash and black chalk, $10 \times 8\frac{11}{16}$ in. 1740–58. New York, Metropolitan Museum of Art (Rogers Fund).

Tiepolo drew constantly throughout his career. Towards the end he gathered together his vast output and arranged them into various groups of allegorical figures, 'fantasies', caricatures and so on. Their purpose was twofold: first, to provide a repertoire for his assistants to help in large-scale decorative work, second, and equally important for an eighteenth-century artist, to demonstrate his virtuosity by variations on a given theme. There are other versions of *Time and Truth*, but this, in particular, is outstanding for its sunny acceptance of a make-believe world where beautiful figures, casually yet dramatically foreshortened, rest idly on the clouds. Tiepolo's skill in suggesting the play of bright sunlight on the nude figures should not be underestimated.

Antoine Watteau (1684–1721)
52 (*bottom*) Male Nude, Study for Jupiter

Red, black and white chalk, $9\frac{5}{8} \times 11\frac{5}{8}$ in. About 1712–16. Paris, Louvre, Cabinet des Dessins.

Though Watteau's drawings and paintings of the female model have an immediate appeal (see Plate 42), his few drawings of the male model are remarkably vivid and powerful. This drawing is a study from the model, with the head made more satyr-like, for his painting of *Jupiter and Antiope* now in the Louvre. The subject and the sketchy treatment of the painting and drawing are Venetian in origin—Watteau was at this time making copies from Venetian drawings—but there is a reminiscence too, in the attenuated forms, of Van Dyck, a Flemish predecessor whom he also admired. Watteau's own, however, are the sharp accents of red and black around the arm and torso, the free use of chalk and the sensitive details, such as the hands. The drawing fully reveals that 'subtlety, grace, lightness, correctness, facility and expression', which his friend Gersaint praised.

François Boucher (1703–70)
53 Female Nude

Red chalk, 19×16 in. 1730–40. London, Thos. Agnew and Sons Ltd.

Although Boucher was later to boast to Sir Joshua Reynolds that he had long given up drawing from models, this beautiful example reveals that he did, in fact, draw from life. The elements of the Rococo style are here, in the graceful pose and delicate proportions of the model, but it appears to be an independent study, full of close observation, not connected with any painted composition (see Plate 40). The sensitive handling and feeling for the soft fall of light on the figure derive from Watteau and, ultimately, from his sources, Van Dyck and the Venetians, rather than from the rigorous intellectual draughtsmanship of the Academy.

Jean Auguste Dominique Ingres (1780–1867)
54 The Turkish Bath

Canvas, diameter $42\frac{1}{2}$ in. Signed and dated 1863. Paris, Louvre.

This 'erotic daydream of an octogenarian', as it has been described by a modern critic, comes as a climax to Ingres's lifetime worship of the female body. It was begun as a square in about 1859, but was apparently returned by Princess Clotilde, who was shocked by so many nudes. Ingres then modified various figures and turned it into its present circular format. The subject of the harem or bathing place is itself a reworking of earlier motifs (see Plates 6 *bottom* and 21) and recurs in a number of nineteenth-century works by other, mainly academic, artists. The careful construction and overlaid bodies mark *The Turkish Bath* as a triumph of academicism, but an academicism imbued with a passionate feeling for the nude.

Eugène Delacroix (1798–1863)
55 The Death of Sardanapalus

Canvas, $155\frac{1}{2} \times 194$ in. 1827. Paris, Louvre.

The subject is partly taken from Byron's poem, *Sardanapalus*: the King of Nineveh, his palace besieged by rebels has ordered the

destruction of his entire household, favourite horses, treasure and concubines. Delacroix has much embroidered Byron's text to produce a controversial Romantic masterpiece. The vehemence and drama that Delacroix admired in Rubens is carried through in a riot of bodies and colour, 'like an assembly where everyone speaks at the same time,' as he put it when describing Rubens. His interest in reflected colours, partly spurred on by the sight of Constable's work, is manifest in his painting of the nudes and the changes of colour in their skin. He also shows how, unlike his contemporary Ingres who had difficulty with large-scale figure composition, he was able to control such a swirling composition with so many figures.

Jean Auguste Dominique Ingres (1780–1867)
56 Two Nudes: Studies for 'The Golden Age'

Pencil, $16\frac{3}{8} \times 12\frac{7}{16}$ in. About 1843–8. Cambridge, Massachusetts, Fogg Art Museum. (Bequest of Grenville L. Winthrop).

Ingres was commissioned in 1837 to paint a large fresco representing 'The Golden Age' for the Duc de Luynes for his Château de Dampierre. It was begun in 1843 but remained unfinished in 1850. A matching fresco, 'The Iron Age', was never begun. Thus what should have been the culmination of Ingres's academic theories, the creation of enormous allegorical compositions, came to nothing, whereas the large-scale murals in the Paris church of St Sulpice by his rival, Delacroix, were to influence a whole new generation of painters. All that survives is the wreck of the fresco, a small replica in oil of 1862, and a number of studies such as this. It is drawn in Ingres's highly refined manner, paying great attention to external lines and individual details and yet remaining somewhat awkward. The rhythm of the figures is an attempt to work anew the classical theme of the three Graces.

Julius Schnorr von Carolsfeld (1794–1872)
57 Nude Youth with a Shawm

Pen and black ink, $17\frac{1}{4} \times 11\frac{7}{16}$ in. 1822. Hamburg, Kunsthalle.

In 1818 Schnorr joined the group of young German painters in Rome called the Nazarenes. Their aims, rather like those of the later Pre-Raphaelites in England, were prompted by a mixture of intense Catholicism and a desire to return to a simple, spiritual conception of art in which fresco painting was important. The hard outline and precise drawing of this study, reminiscent of Dürer and German Renaissance prints, were also typical of the young Germans' approach. There are, however, still overtones of the academic Neo-Classical style, even though the group deliberately chose young amateur models, 'unspoilt by the routine of sitting'. This model has been identified as a young Italian called Carluccio and the sitting was in a café where they met on 19 January 1822.

Henri Gervex (1852–1929)
58 Rolla

Canvas, $68\frac{3}{4} \times 86\frac{1}{2}$ in. 1878. Bordeaux, Musée des Beaux-Arts.

Gervex became as notorious as Manet (see Plate 67) when his *Rolla* was turned down for the *Salon* of 1878 on the grounds of its impropriety. But whereas Manet had single-handed fought for modernism and a revolutionary technique, Gervex took a form of Impressionism at second-hand to illustrate Alfred de Musset's poem about the most notorious rake in Paris, Jacques Rolla, and his night with Marion. But rejection of this picture hardly affected Gervex's subsequent success as an academic artist. He has only taken from Impressionism what he needs: the fall of light into the interior, the still-life of the petticoat and bed-clothes and the hazy distance through the window. The subject remains an anecdotal, academic exercise, with Rolla's melancholy gaze falling on the prettified and consciously-posed nude, Marion, so that the teasing moral tale becomes as important as the accidental visual effects.

Sir Lawrence Alma-Tadema (1836–1912)
59 The Tepidarium

Panel, $9\frac{1}{2} \times 13$ in. 1881. Port Sunlight, Lady Lever Art Gallery.

Alma-Tadema's reconstructions of everyday scenes from Roman life were put together with painstaking attention to detail and were an instant success at the Royal Academy when he settled in England in 1869. Nudes were acceptable to the fashionable public, providing they were either goddesses or from exotic parts. What people failed to detect, and what has become more obvious today, is how near the paintings are to the borders of prurience, or even unconscious humour; the models are so clearly Victorian girls, painted realistically and anecdotally, with the studio paraphernalia from St John's Wood. Like Rubens (see Plate 35), but more meretriciously, Alma-Tadema has appreciated the sensuous qualities of fur, feathers

and flesh; and like Ingres (see Plate 54), but less fervently, he has realized the erotic possibilities of the Roman bath.

William Blake (1757–1827)
60 Glad Day

Engraving, $10\frac{3}{4} \times 7\frac{1}{8}$ in. 1780. Washington, National Gallery of Art (Rosenwald Collection).

In this quite early engraving Blake shows his ability to transform other artists' designs into an extraordinary vision, with what his biographer, Gilchrist, called 'the peculiar Blake quality and intensity about it.' His artistic training was mainly as an engraver and there are few drawings from the life known by him, but he was able to make use of prints from all sources. Not only has he used the well-known one by Scamozzi, from the treatise on architecture, illustrating the proportions of the human figure (see Leonardo, Plate 14), but he has also taken the pose of a Roman bronze, published in a volume of antiquities from Herculaneum between 1752–92. Although gaining his knowledge of figures at second-hand, he has created a radiant personification of Morning, 'exultingly bringing joy and solace to this lower world' (Gilchrist).

Henry Fuseli, R.A. (1741–1825)
61 Siegfried Having Slain Fafner the Snake

Pencil, pen and grey wash, $13\frac{3}{4} \times 9\frac{3}{8}$ in. 1806. Auckland, City Art Gallery.

The subject is taken from the *Nibelungenlied*, and shows Siegfried, the hero, bathing in the blood of the dead snake Fafner. Fuseli's dramatic designs ranged over the whole history of epic myths and his sources, like other early Romantics, were as far ranging as his equally eclectic mannered style. His drawing was particularly influenced by Michelangelo, Rubens and late sixteenth-century Mannerists. His nudes are often violent, occasionally even pornographic, and he became obsessed, as in this example, with elaborate and artificial hair styles. The anatomy is distorted for dramatic effect and though the pen work is somewhat coarse, the debt to the Mannerists is clear. The result is a disturbing image of the nude, which is part of the development of a Romantic figure style, very close to Blake (see Plate 60).

Edouard Manet (1832–83)
62 Olympia

Canvas, 51×75 in. Signed and dated 1863. Paris, Louvre.

For an artist of such traditional sympathies, the shock which greeted the exhibition of *Olympia* at the Salon of 1865 was particularly hurtful. She was thought indecent, because of the directness of her gaze and her insistent nudity, and she was described as a 'female gorilla', because she was so obviously a contemporary model, attended by a Negress with a bouquet and a black cat hardly visible in the shadows at the foot of the bed, instead of being disguised as a Roman or oriental nymph. Yet, as was also seen at the time, she bears an obvious debt to all the reclining nudes that had gone before: to Boucher and the Rococo (see Plate 40), and obviously to Titian's *Venus of Urbino* (Plate 13). She is also Ingres's *Grande Odalisque* (Plate 51) turned more frankly to the spectator and painted with great freedom in a high key to emphasize the dark areas. The result is a striking and beautiful image of modernity, which made Manet the unwilling leader of a younger revolutionary group of artists.

Paul Gauguin (1848–1903)
63 'Nevermore'

Canvas, $23\frac{3}{4} \times 45\frac{5}{8}$ in. Signed and dated 1897. London, Courtauld Institute Galleries.

Gauguin explained that he wanted to suggest a barbaric splendour by a simple nude but one whose imagination was at work with the fear of evil spirits. The title refers not so much to Edgar Allan Poe's raven, as to the bird of death, always on the watch. His attempt to suggest states of mind through his nude could be compared with Rembrandt's *Bathsheba* (Plate 38), but he was also impressed by the formal tradition of the reclining nude, particularly Manet's *Olympia* (Plate 62), which he much admired. Gauguin's attraction to the primitive world of Tahiti, his simplification of form and his rich display of unnatural glowing colours led directly to the art of the twentieth century, for example, Matisse (see Plate 91) and the German Expressionists (see Plate 79).

Ernst Ludwig Kirchner (1880–1938)

64 (*top*) Reclining Nude (Isabella)

Charcoal, $35\frac{3}{8} \times 27\frac{1}{8}$ in. 1906. Kassel, Staatliche Kunstsammlungen.

Kirchner had just finished his studies as an architectural student in Dresden when he made this drawing. He was sharing a studio with Erich Heckel and, with Emil Nolde and Max Pechstein, he produced a programme for a modern German style which would go back to primitive roots and be called the *Brücke* (see note to Plate 79). Their first exhibition was in the autumn of 1906. The drawings and woodcuts which Kirchner produced are consciously large in scale, severely black and white, vigorous and crude in execution; his lack of formal training was no inhibition.

Thomas Eakins (1844–1916)

64 (*bottom*) Seated Masked Woman

Charcoal, 24×18 in. 1866. Philadelphia Museum of Art (Gift of Mrs Thomas Eakins and Miss Mary A. Williams).

This early study, by the American artist Thomas Eakins, was drawn the year he left for Europe to study under Gérôme in Paris. It is at once direct and, because of its frankness, not immediately attractive. The model is naked, as Rembrandt's drawings were naked (see Plate 27 *top*), but without the latter's greater vision. Eakins remained concerned throughout his career with direct and realistic observation, dissecting corpses, painting pictures of operating theatres and enthusiastically helping Eadweard Muybridge with his photographic experiments in the 1880s. This rough sketch, with stark accents of light and dark, contains the seeds of his later tonal realism, when his paintings were as sharp and clear as the photographs he took. The surrealist effect of the mask on the model is probably due to the prudery of the Pennsylvania Academy of the Fine Arts, rather than to a search for dramatic effect.

Edgar Degas (1834–1917)

65 After the Bath

Charcoal, $15\frac{3}{4} \times 21\frac{1}{4}$ in. About 1900. Stuttgart, Staatsgalerie.

Degas was the most traditional of the Impressionists and the one who relied most on drawing. He never ceased to admire Ingres, whom the others despised. Towards the end of his career, his style and type of drawing changed through the influence of Impressionism, and of photography. His nudes were seen casually, in action, not idealized, their garter marks observed with relish (see Rembrandt, Plate 27 *top*). Standing or crouching, drying themselves, with or without surrounding space, they are drawn quickly, almost without style, and yet they are instantly recognizable as his own. They were an important influence on a new generation of painters, such as Sickert and Bonnard (see Plate 84).

Paul Cézanne (1839–1906)

66 The Bathers

Canvas, 82×99 in. 1898–1905. Philadelphia Museum of Art.

At the end of his life Cézanne laboured over the greatest of his series of *Bathers* in a studio specially built for him. It is no exaggeration to see this painting as the culmination of 500 years of figure composition, in the same tradition as Michelangelo's Sistine Chapel (see Plate 17) or Titian's series of mythologies (see Plate 28). All idealized the nude, but whereas the others occasionally have a moral content, Cézanne's approach is entirely formal. He attempted to construct something solid out of Impressionism, so that light and the leaves are seen as overlapping planes. The bodies are arranged, like the trees, as a severely organized series of plastic volumes, without edges, and three dimensions become two, with no concession to frivolity. It is a non-linear counterpart to Ingres's *The Turkish Bath* (Plate 54), with the nude becoming subordinate to an abstract ideal.

Edouard Manet (1832–83)

67 Le Déjeuner sur l'Herbe

Canvas, 82×104 in. Signed and dated 1863. Paris, Louvre.

'This revolutionary painter who adored the fashionable world had always dreamed of the success that would one day be his in Paris,' commented Zola. Manet hardly seems to have foreseen the furore which this large and, to him, traditional figure composition aroused when it was rejected at the official *Salon* of 1863 and exhibited at the the *Salon des Refusés*. 'What were those two fashionable men-about-town doing in the countryside with one nude woman and another nearly so?' was the obvious question. Manet hoped that the poetic parallels with Giorgione's *Concert Champêtre* (Plate 20) would be recognized and that the quotation from Marcantonio Raimondi's

engraving after Raphael's *Judgement of Paris* (Plate 7), which was noticed, would win approval. He was, in fact, attempting to create an idyllic modern version of Venetian nude figure compositions, but he scandalized because his figures were too real and his approach too direct for his academic contemporaries.

Aubrey Beardsley (1872–1898)

68 The Mysterious Rose Garden

Pen, brush, indian ink, $8\frac{3}{4} \times 4\frac{3}{4}$ in. 1895. Cambridge, Massachusetts, Fogg Art Museum (Bequest of Grenville L. Winthrop).

Beardsley's designs earned him great notoriety as a member of the decadent set of the 1890s and he did little to change his reputation until he was sacked from *The Yellow Book*. 'If I am not grotesque, I am nothing,' he said. This design is typical of his style as a book illustrator. It appears originally to have been entitled 'The Annunciation', but it was reproduced in Volume IV of *The Yellow Book* in 1895 under this less blasphemous title. Strong contrasts of black and white, elongated figures, carefully balanced against a profusion of linear decoration, remained the keynotes of his style. The subject is deliberately outrageous, with the long-haired angel, holding staff and lantern and whispering, in Arthur Symons's words, 'tidings of more than pleasant sin'. This scene of paradox and the lightweight style can be contrasted with the deeper symbolism of Gustave Moreau (see Plate 75).

Henri Matisse (1869–1954)

69 Artist and Model

Pen and black ink, $24\frac{1}{8} \times 16\frac{1}{16}$ in. Signed and dated 1937. Baltimore Museum of Art (Cone Collection).

During the 1930s Matisse produced a number of drawings in which the full range of his mature style embodies his obsession with the nude. The models are posed decoratively in the studio and the surrounding space imaginatively suggested with a rapid pen. In this example, the artist and the back view of the nude are visible in the mirror behind, so that the whole drawing is covered by the flowing line with the space flattened and tilted towards the spectator. Even with such a seemingly casual sketch, the essentials of the contour of the human figure are beautifully expressed. It should be compared with Picasso's nearly contemporary drawing *Le Repos du Sculpteur* (Plate 73 *top*).

Pierre-Auguste Renoir (1841–1919)

70 The Bathers

Canvas, $45\frac{1}{4} \times 67$ in. 1884–7. Philadelphia Museum of Art.

Renoir is justifiably renowned as a painter of nudes which, at the beginning of his career, glowed with an iridescence of impressionist colour, all 'amiable, joyous and lovely', as he himself described them. Of all the Impressionists, however, with the possible exception of Degas, Renoir never lost a love for the art of the past, particularly for eighteenth-century French art. This large composition was based on an eighteenth-century relief, and its artificial poses and the extreme concentration on the outline of the figures reflect the influence of a visit to Italy and a sight of its frescoes. His colour, too, changed, as he attempted to paint 'fresco in oil', as he put it. The number of preliminary drawings and the remnants of impressionist landscape at the right all speak of the labour which this ambitious composition entailed over a number of years.

Georges Seurat (1859–91)

71 'The Models' (small version)

Canvas, $15\frac{1}{2} \times 19\frac{1}{4}$ in. 1888. Previously in the collection of Henry P. McIlhenny, Philadelphia.

This small version of the large finished picture is painted at the height of Seurat's Divisionist style. Light is broken up into its respective primary colours and everything is painted in a series of small dots which describe the local colour and reflections. Seurat deliberately contrasts the red parasol with the green stockings. By this rationalized advance on Impressionism, he has created a static, carefully organized, figure composition. The models posed in the corner of his studio are outlined severely and seen from back, front and side view. Their nudity is further contrasted with the outdoor scene and clothed figures in his painting, *Sunday on the Isle of the Grande Jatte* (1884–6), on the side wall. Roger Fry wrote, 'one cannot move a button or a ribbon without disaster to this amazingly complete and closely knit system.'

Henri Matisse (1869–1954)

72 Seated Nude Clasping Knee

Reed pen, black ink, $11\frac{5}{8} \times 9\frac{1}{4}$ in. Signed and dated 1909. Chicago, Art Institute (Gift of Mrs Emily Crane Chadbourne).

Early in 1909, the Russian patron, Sergei Shchukin, commissioned two large decorative paintings representing Music and Dance (now in Leningrad), in which Matisse could develop his new theories of *Fauvism* on a grand scale. He worked on these during the summer of 1909 at Cavalière and his studio at Issy-les-Moulineaux. This drawing is connected but not identical with the figures in the finished pictures and is dated August 1909. As in the paintings, the style is simplified and Matisse reveals his absolute mastery of a fluid line drawn with the thick reed pen. He was to become a superb draughtsman of the nude, but in 1909 his style is rougher and more calligraphic than in his later works. Yet his control of the tense forms and bulk of the figure is easy and sure. The sensitive line could be compared with the cruder technique of Kirchner (See Plate 64 *top*).

Pablo Picasso (1881–1973)

73 (*top*) Le Repos du Sculpteur

Etching, $7\frac{3}{4} \times 8\frac{3}{4}$ in. Signed and dated 1933. Private Collection.

Picasso's work in the 1930s came closer to his own personal preoccupations and torments than in any other decade. During a period of intense activity in his newly acquired Château de Boisgeloup he produced paintings, sculpture and a number of book illustrations, including nearly one hundred etchings of the 'Vollard Suite'. This one illustrates the sculptor's studio. The relationship between the sculptor and model is here expressed with the same sensitive line that he had used in 1918 (see Plate 76 *top*), but this work is obsessed with his own condition. The middle-aged artist is Picasso; the languid model is his new mistress Marie-Thérèse Walter; the sculpture on the stand is one of the heads he had made at Boisgeloup. Further prints from 1934–6 were to disturb this harmonious image.

Henri Matisse (1869–1954)

73 (*bottom*) Reclining Nude with Arms behind her Head

Charcoal, 15×19 in. Signed, 1937. Baltimore Museum of Art (Cone Collection).

Matisse's nude drawings of the 1930s display a number of styles and moods. In contrast to the lively calligraphy of Plate 69, the present example is much bolder and tougher. There is rough internal modelling of the shapes and the decisive contours express simply yet powerfully the underlying forms of the figure: for example, in the curve of the left arm and shoulder. The pose is complicated and tense, conceived almost like an interlocking abstract sculpture. This tendency to abstraction was to culminate in his great designs of cut-out paper of the 1950s.

Edvard Munch (1863–1944)

74 Madonna

Canvas, $35\frac{3}{4} \times 27\frac{3}{4}$ in. Signed, 1894–5. Oslo, National Gallery.

Like the Symbolists (see Plate 75), Munch is concerned more with states of mind than with the visual representation of an object. The subject is a nude, but it is also a symbol of a woman, who is as dangerous to men as the women in Strindberg's plays. The painting is one of a series called *The Frieze of Life*, which presents a morbid and disillusioned view of the world. It is also known in a lithograph of 1895–1902, where the dark symbolic content is made more obvious by the addition of spermatozoa and a foetus. The handling is free with great facility of touch, but it is the haunting image of a sensual nude Madonna with long strands of enveloping hair and a blood red halo which remains in our minds. She is the ecstatic equivalent of Salome or Swinburne's Dolores: 'O daughter of Death and Priapus, Our Lady of Pain.'

Gustave Moreau (1826–98)

75 'L'Apparition'

Canvas, $21\frac{1}{4} \times 17\frac{1}{2}$ in. Signed, about 1876–86. Cambridge, Massachusetts, Fogg Art Museum (Bequest of Grenville L. Winthrop).

For the Symbolist writers and artists of the late nineteenth century, the story of Salome and St John the Baptist held endless fascination. Salome became, in J. K. Huysmans's words, 'the symbolic deity of indestructible lust . . . the accursed Beauty exalted above all other beauties.' Gustave Moreau, the 'seer' of the Symbolist painters, painted a number of versions of *Salome dancing before Herod* and

'*L'Apparition*'. In a dream-like setting of exotic architecture appears the vision of the head of St John. The picture firmly sets its face against the realistic tendencies of its time and is full of symbols: Salome holds a lotus flower, a black panther crouches on a flower-strewn carpet and in the background is the statue of Diana of Ephesus, the goddess of fertility. Salome is shown nude, apart from rich jewel-encrusted vestments, and Moreau achieves a powerfully erotic vision of decadence.

Pablo Picasso (1881–1973)

76 (*top*) The Bathers

Pencil, $9\frac{1}{2} \times 12\frac{1}{4}$ in. Signed and dated 1918. Cambridge, Massachusetts, Fogg Art Museum (Bequest of Meta and Paul J. Sachs).

In the spring of 1917, Picasso visited Rome to design scenery and costumes for the ballet *Parade*. The visit inspired a renewal of his interest in classical forms which had lain dormant since 1905. Its expression in his work varied between the creation of paintings and drawings with heavy sculptural masses, and a series of drawings in a refined linear manner which look back to his previous work of 1905 and, ultimately, to the drawings of Ingres (see Plate 56). The connection with the ballet and visits to the sea coast, in this case Biarritz, brought about a light-hearted series of designs whose grace and purity come close to Matisse's pre-war compositions. This ambitious figure composition, however, owes most to the influence of Ingres's pure line, even to its distortions, and ushers in a figure style which was to be developed during the 1930s.

Henri Matisse (1869–1954)

76 (*bottom*) Study for 'Pink Nude'

Charcoal and stump on paper, $13\frac{1}{4} \times 18\frac{3}{4}$ in. Signed, 1935. Baltimore Museum of Art (Cone Collection).

Matisse's variations on the theme of the nude underwent a number of changes during the 1930s. His art became, for a time, less decorative and his figures, though simplified, sum up all his experience of the reclining nude. One important painting was the *Pink Nude* (Plate 91) in which all Matisse's feeling for the three-dimensionality of the nude figure is distilled into a vibrant two-dimensional design. This is one of the many preliminary studies. The figure reclines in the reverse direction, with the left hip tilted upwards, but the patterned background on which the figure lies is roughly indicated. The rough energy of the drawing looks back to his '*Fauve*' nudes of about 1907.

David Hockney

77 Study of a Nude Youth

Etching, $14\frac{13}{16} \times 8\frac{3}{4}$ in. 1966–7. Cambridge, Fitzwilliam Museum.

Hockney's development has been precocious. He burst upon the art scene, when still a student, with a series of paintings that looked crude and seemed to contain some comment on modern life. His development as a draughtsman and print maker shows that he is a talented member of the 'Pop Art' scene. His figures are drawn with a sensitive line, sometimes caricatured in a crude illustrator's style, like Georg Grosz or Paul Hogarth, and sometimes drawn with a cool detached view of his subject-matter, which often openly concerns homosexual relationships. This is an illustration to a volume of love poems by the Greek poet Cavafy published in 1966–7; the use of the male nude in this context is clear.

Henri de Toulouse-Lautrec (1864–1901)

78 Woman Pulling on her Stockings

Panel, $23\frac{5}{8} \times 17$ in. Signed, 1894. Albi, Musée Toulouse-Lautrec.

Toulouse-Lautrec drew and painted with great facility. We perhaps look in vain for the great figure compositions of his weightier contemporaries, Gauguin (see Plate 63) and Cèzanne (see Plate 66), but his talent was for exploiting the late nineteenth-century practice of casual life drawing, of which Degas was so great an exponent (see Plate 65). He painted and drew scenes of modern life, spontaneously and directly. To this end he haunted cafés, music-halls and brothels. His women are not goddesses and he hated posed models, but the intimate gesture of this girl pulling on her stockings has produced a ravishing unfinished sketch, thinly painted at great speed.

Ernst Ludwig Kirchner (1880–1938)

79 Half-length Nude with a Hat

Canvas, $30 \times 27\frac{5}{8}$ in. Signed, 1911. Cologne, Wallraf-Richartz-Museum.

The German Expressionist painters who called themselves the *Brücke* have often been linked with their French contemporaries, the

Fauves, led by Matisse. Their aims were similarly revolutionary and anti-naturalistic. They painted the human figure with an intentionally crude technique and violent contrasts of colour. This attitude was, of course, influenced by the example of Van Gogh, Gauguin and primitive art. The Germans, however, were slightly later on the scene and were much more emotional than the French. They produced violent images of overt sexuality with no attempt at idealization. In Kirchner's painting the forms are flattened and the figure starkly outlined against the bright blue background. This background contrasts with the pinks of the body and the red patterning of the dress. It is a deliberately aggressive image.

Gerhard Richter (born 1932)

80 Emma, Nude on a Staircase

Canvas, 79 × 51½ in. 1966. Cologne, Wallraf-Richartz-Museum.

The influence of photography on art has taken many forms since its invention. Marcel Duchamp used it in his *Nude Descending a Staircase* (Plate 81). This work by the German artist Richter, like many modern works, is both a comment on that famous picture and a development of his own preoccupation with the unexpected images produced by amateur snapshots. He has painted a number of nudes, some in monochrome ('grey is a colour, too'), which, like his other images, are made deliberately hazy to create the effect of accident. The basic forms of the nude are recognizable, but the background is slightly out of focus. By these means he makes us look again at the nude, reality, and the processes of art, so that there is, as he put it, 'no style, no composition, no judgement;' a cool objectivity akin to Degas (see Plate 85).

Marcel Duchamp (1887–1968)

81 Nude Descending a Staircase, No. 2

Canvas, 58 × 35 in. Signed and dated 1912. Philadelphia Museum of Art (Louise and Walter Arensberg Collection).

There is an earlier version of this well-known painting where the nude and the staircase are much more recognizable, but Duchamp made no further experiments with the human figure which are as indebted to Cubism and photographs of movement as this one. The Cubists had dissolved the static figure into facets of form (see Plate 83), but as Duchamp admitted: 'The fact that I had seen chronophotographs of fencers in action and horses galloping gave me the idea for the *Nude*.' The dotted lines in the centre give an abstract mechanical suggestion of the movement of the torso. Like the Cubists, Duchamp restricted his palette to monochromatic browns and tans.

Pablo Picasso (1881–1973)

82 Life

Canvas, 77⅜ × 50⅞ in. Signed, 1903. Cleveland Museum of Art (Gift of Hanna Fund).

Picasso painted this statuesque and haunting allegory during his 'Blue period' in Barcelona. With its obscure and anguished comments on existence and its overall blue tonality, it is influenced by the art of the Symbolists. Love and youth are perhaps suggested by the two nudes at the left, sorrow by the pictures in the background and maternity and, possibly, maturity by the figure at the right. It looks backward, too, to the art of Van Gogh and Gauguin. But, in its general simplification of all the forms of the figures, particularly the mask-like faces and flattened picture space, it looks forward to Picasso's revolutionary work of 1906–7 and the creation of a genuine twentieth-century style.

Pablo Picasso (1881–1973)

83 Seated Nude

Canvas, 36¼ × 28¾ in. Signed, 1909–10. London, Tate Gallery.

Picasso applied here, in the spring of 1910, the principles of his newly developed analytical Cubist style to the representation of the nude human figure. Braque and Picasso, 'roped together like mountaineers', had evolved a way of creating a new reality by fragmenting the object or figure into a series of small planes, seen from different points of view. The example of Cézanne had led the way (see Plate 66), but Picasso was not so severely tied to the object in front of him: 'I paint objects as I think them, not as I see them,' he said. Though the bust, arms and head are still very recognizable, the facets of the body, particularly the shoulders, are blended into the shapes of the background which has been brought forward. Light is used to emphasize forms and the colour is extremely monochromatic.

Pierre Bonnard (1867–1947)

84 Nude before a Mirror

Canvas, 60⅜ × 41 in. Signed, 1931–3. Venice, Galleria Internazionale d'Arte Moderna.

At the beginning of the 1930s Bonnard produced an impressive series of vertical paintings of nudes which are flooded with radiant light. They perpetuate his earlier *intimiste* subject-matter: a nude at her *toilette*, in front of a mirror, or in the corner of a bedroom. Bonnard exploited the image within an image by the use of mirrors. The realistic painting of the nudes, seemingly casual but in fact very carefully placed, ultimately depends on the example of Degas (see Plate 85). However, by the 1930s, Bonnard had broken into new realms of colour and texture. Particularly notable in the present example is the caressing use of light on the back of the model, his wife.

Edgar Degas (1834–1917)

85 A Woman Having Her Hair Combed

Pastel, 29⅛ × 23⅞ in. About 1885–6. New York, Metropolitan Museum of Art.

Though Degas exhibited with the Impressionists his position was equivocal. He deeply admired Ingres, and his work never lost its respect for academic art and careful drawing. The classic qualities of the present nude, for example, can be seen in its weight and balance. He did, however, adopt a modern attitude to realistic subject-matter. He was also impressed by the artfully casual compositions found in Japanese prints and photographs. His many interiors of women washing show them caught apparently unawares or cut off by the frame. Furthermore he adopted the Impressionists' revolutionary investigation into the colour of light and shadows and he rendered them in vibrant strokes of pastel. 'The nude', he said, 'has always been represented in poses which presuppose an audience, but these women of mine are honest, simple folk, unconcerned by any other interests than those involved in their physical condition. Here is another, who is washing her feet. It is as if you looked through a keyhole.'

Marc Chagall (born 1887)

86 To My Wife

Canvas, 51½ × 76½ in. Signed and dated 1933–44. Paris, Musée d'Art Moderne.

In Chagall's paintings the figures are simplified and the space flattened in the manner of the Cubists, but the overall effect is personal and dreamlike. His style was affected by his Russian and Jewish origins and he painted evocative scenes from his childhood, or, as here, hymns to the person he adored, with images remembered sometimes years later. He worked on this picture for more than ten years, creating a poetic vision of marriage, not unlike the work of the Surrealists of the 1930s. The figures are seen as intently as the spontaneous creations of 'Le Douanier' Rousseau (see Plate 87), but they are much more self-consciously simplified.

Henri Rousseau (1844–1910)

87 Yadwiga's Dream

Canvas, 80¼ × 121½ in. Signed and dated 1910. New York, Museum of Modern Art (Gift of Nelson A. Rockefeller).

Rousseau's simple approach coincided with his contemporaries' interest in primitive art. He was made much of by Picasso, among others, who recognized his strong formal qualities, firm outlining and bold colour. Rousseau's childlike delight in detail enables us to overlook the incongruity of the nude girl, Yadwiga, posed rather awkwardly on a red *salon* couch, placed in the middle of the jungle surrounded by a variety of flora and fauna and attended by a mysterious piper. Yadwiga was a Polish girl whom Rousseau had loved in his youth; so the whole picture is an insistent well-defined image of a dream, both nostalgic and menacing. It is also slightly humorous and in this respect looks forward to the art of the Surrealists (see Plate 92).

Egon Schiele (1890–1918)

88 Recumbent Nude

Pencil and body colour, 12 5/16 × 19⅛ in. 1914. Vienna, Albertina.

During his short career Schiele, under the influence of Klimt, the Symbolists and together with Kokoschka, developed a specifically Austrian type of Expressionism in Vienna. His style is tortuous; the figures are distorted, less for the aesthetic reasons of the French *Fauves* or even the German Expressionists (see Plate 79), than for a

personal exploration of his heated sensibility, which was, perhaps, a symptom of the decadent world in Vienna before the outbreak of the First World War. The eroticism of many of his drawings brought him into trouble with the authorities, but at their finest and calmest, as in this example, his nudes are drawn with a skilful use of a characteristic brittle line and patches of colour.

Fernand Léger (1881–1955)

89 Three Women

Canvas, 72¼ × 99 in. Signed and dated 1921. New York, Museum of Modern Art (Mrs Simon Guggenheim fund).

Léger thought that the new world of the machine was as beautiful as the nude female figure. Following the example of the Cubists (see Plate 83), he developed a style of painting in which he saw everything in terms of the sphere, the cone and the cylinder. Significantly he admired the guns of the First World War for their polished shapes. When he turns to a classic figure composition in a series of paintings produced between 1920–1, of which this is one, his nudes are treated as if they are mechanical objects. Curves are simplified, space is flattened into a geometrical pattern, faces are reduced to circular masks with incised features and there are dazzling areas of primary colour. Only thus was he able to resist the desirability of the female nude, which he thought had resulted in the decadence of Renaissance art, and promote a new Purist Art, closely linked with the developments in modern architecture of Le Corbusier.

Amedeo Modigliani (1884–1920)

90 Nude on a White Cushion

Canvas, 23⅝ × 36¾ in. Signed, 1917. Stuttgart, Staatsgalerie.

In 1917–18, towards the end of his short and dissolute life, Modigliani produced a number of nudes which, apart from his portraits, reveal his finest qualities. The forms are attenuated but voluptuous. They are often cut at the knees and arms, as here, and so suggest fragments of sculpture, lit by an inner warmth. Modigliani draws on the simplifications of primitive art, particularly for the oval mask-like features, which are very like his own versions of primitive sculpture. He is close to the earlier work of Picasso and Matisse with his firm outline and subtly distorted forms. But, like some Italian Mannerists of the sixteenth century, he never lets abstract ideas overcome his tactile sense of female flesh and his feeling for erotic languorous poses.

Henri Matisse (1869–1954)

91 Pink Nude

Canvas, 26 × 36½ in. Signed and dated 1935. Baltimore Museum of Art (Cone Collection).

The process of simplifying colour, line and subject reaches its ultimate degree in the present work and is only a step away from complete abstraction. The nude is painted with a purified outline, the result of many hours of life drawing (see Plate 76 *bottom*), which firmly expresses the essence of the bulk of the reclining figure. It is a modern restatement of the ancient reclining pose which occurs again and again in sculpture and painting. Its gravity is balanced by simple yet ravishing areas of colour: pink against the patterned blue, in turn contrasted with bright red, yellow and green. As Matisse said at the time: 'Pictures which become refinements . . . call for beautiful blues, reds, yellows, matter to stir the sensual depths in men;' an attitude far removed from Léger's stern doctrines (see Plate 89).

Paul Delvaux (born 1897)

92 The Staircase

Canvas, 48 × 60 in. 1946. Ghent, Musée des Beaux-Arts.

The nudes of Delvaux appear, delightfully unsurprised, in a dream-like setting influenced by the Surrealist townscapes of Magritte and De Chirico. The perspective is distorted, the shadows lengthened and the psychological relationships between the meticulously painted figures is not clear. Delvaux was very impressed by visits to Italy before 1940 and, probably because of the cool classical world from which they come, his figures do not have the sexual unease of Balthus (see Plate 93), nor the violence of Bacon (see Plate 96). They are often based on, or made to suggest, classical sculpture against a background of classical architecture.

Balthus (born 1908)

93 Nude with a Cat

Canvas, 25⅝ × 31¾ in. About 1954. Melbourne, National Gallery of Victoria (Felton Bequest).

Balthus, who prefers to be known by his pseudonym, began by painting enigmatic figure compositions influenced by the Surrealists and, in particular, the evocative street scenes of De Chirico. He then moved inside to create a series of obsessional interiors, populated by day-dreaming adolescent girls who fall into unselfconscious provocative poses. *Nude with a Cat* has just such a young girl, who, in a fit of ennui, idly plays with the cat behind her. Her nudity and pose are disturbing, while the mysterious figure at the window, cut off at the right, lets a flood of light into the carefully composed interior. She occurs in other works as the agent of the light, which achieves a symbolic purpose in the direction of its fall on this sprawled 'Lolita'.

Philip Pearlstein (born 1924)

94 Nude on a Hammock

Canvas, 48 × 48 in. 1974. Washington, D.C., Private Collection.

When American art since 1945 seemed to be committed to abstract styles which were either free and violent or cool and 'hard-edged', Pearlstein and others brought the human figure back into painting. Like other modern images, however, Pearlstein's work is as influenced by photographs as by life itself. In this case, he picks on the instant detail, which the camera lens can bring, painted meticulously and on a large scale almost without choice and certainly without idealization. A comparison with Degas's art of the previous century (see Plate 85) shows what little concession Pearlstein makes to 'fine art'. The image is powerful because it is so much in the raw and almost larger than life.

Richard Diebenkorn (born 1922)

95 Seated Nude—Black Background

Canvas, 80 × 50 in. 1961. New York, Marlborough Gallery.

The revolutionary impact of American abstract painting since the war has stemmed from its large scale, brilliant colours and loose painterly manner. Diebenkorn, a Californian artist, began in this way, but he turned to paint a series of nudes and figures in interiors which keep something of this style. The image moves in and out of reality with planes and volumes and colours very much simplified. Occasionally the figure is barely recognizable and the qualities of paint and colour become uppermost. The influence of late Matisse is never very far away.

Francis Bacon

96 Figures in a Landscape

Canvas, 60 × 46½ in. 1956. Birmingham, City Museum and Art Gallery.

It is very rarely that the nude is treated as an instrument of horror. Bacon's *Figures in a Landscape* are less escapees from the 'flash underworld' than inmates of a prison camp of their own devising. Alone of modern British artists who have been influenced by Surrealism Bacon strains his images to screaming pitch. The two male(?) figures against the striped background are probably variants of those photographs from Eadweard Muybridge's *Animal Locomotion*, 1887, or its reduced edition *The Human Figure in Motion* of 1901, on which Bacon has based a number of his figure compositions. Their actions, however, are enigmatic and the paint is deliberately loose and vague, with the landscape given extra prominence.

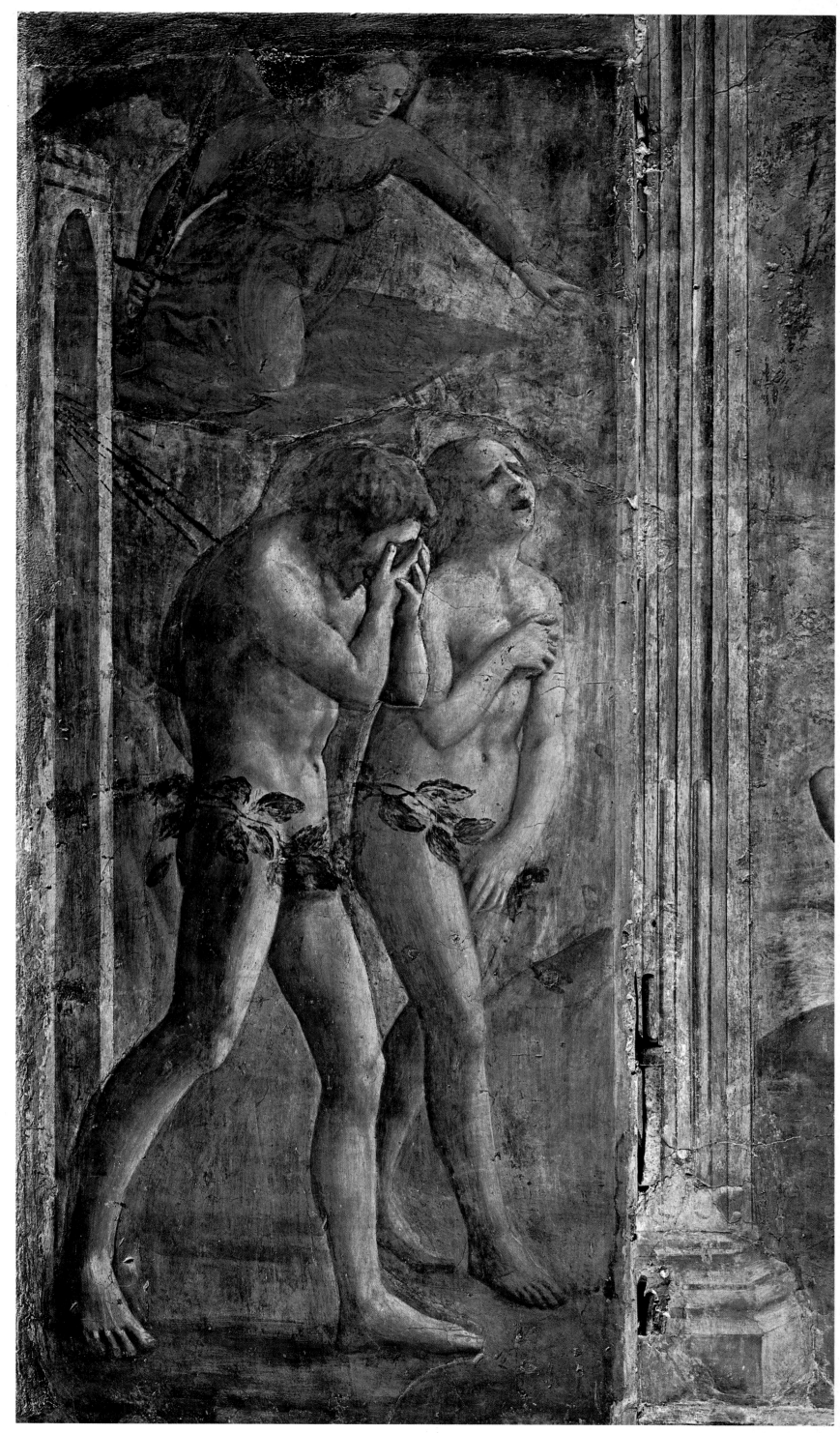

1

2

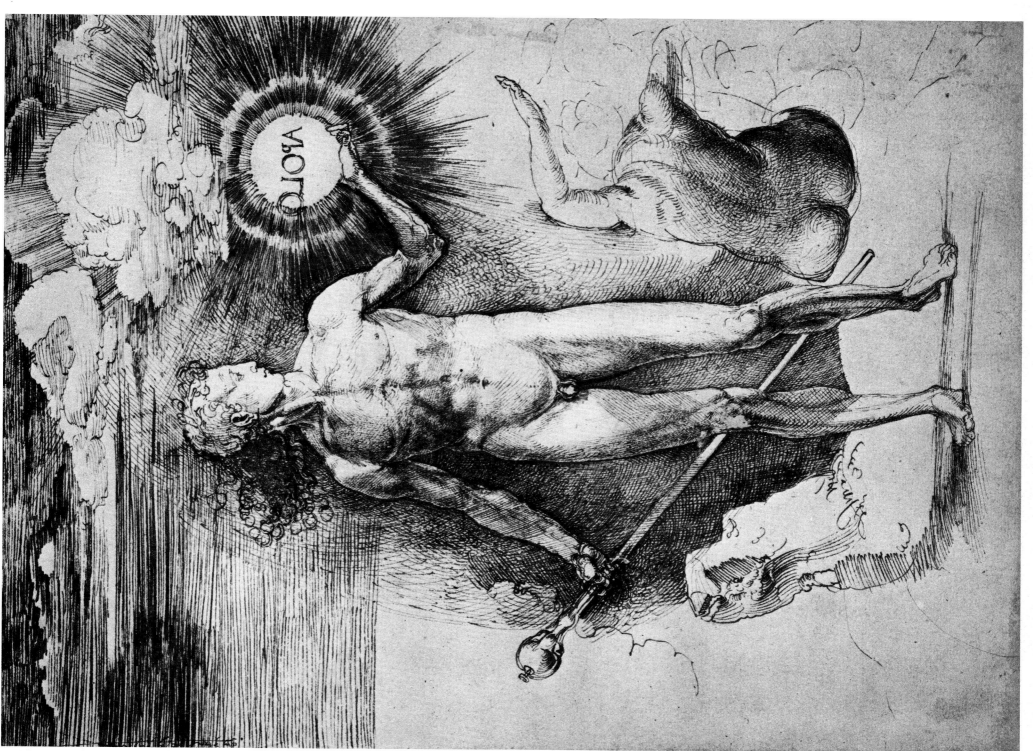

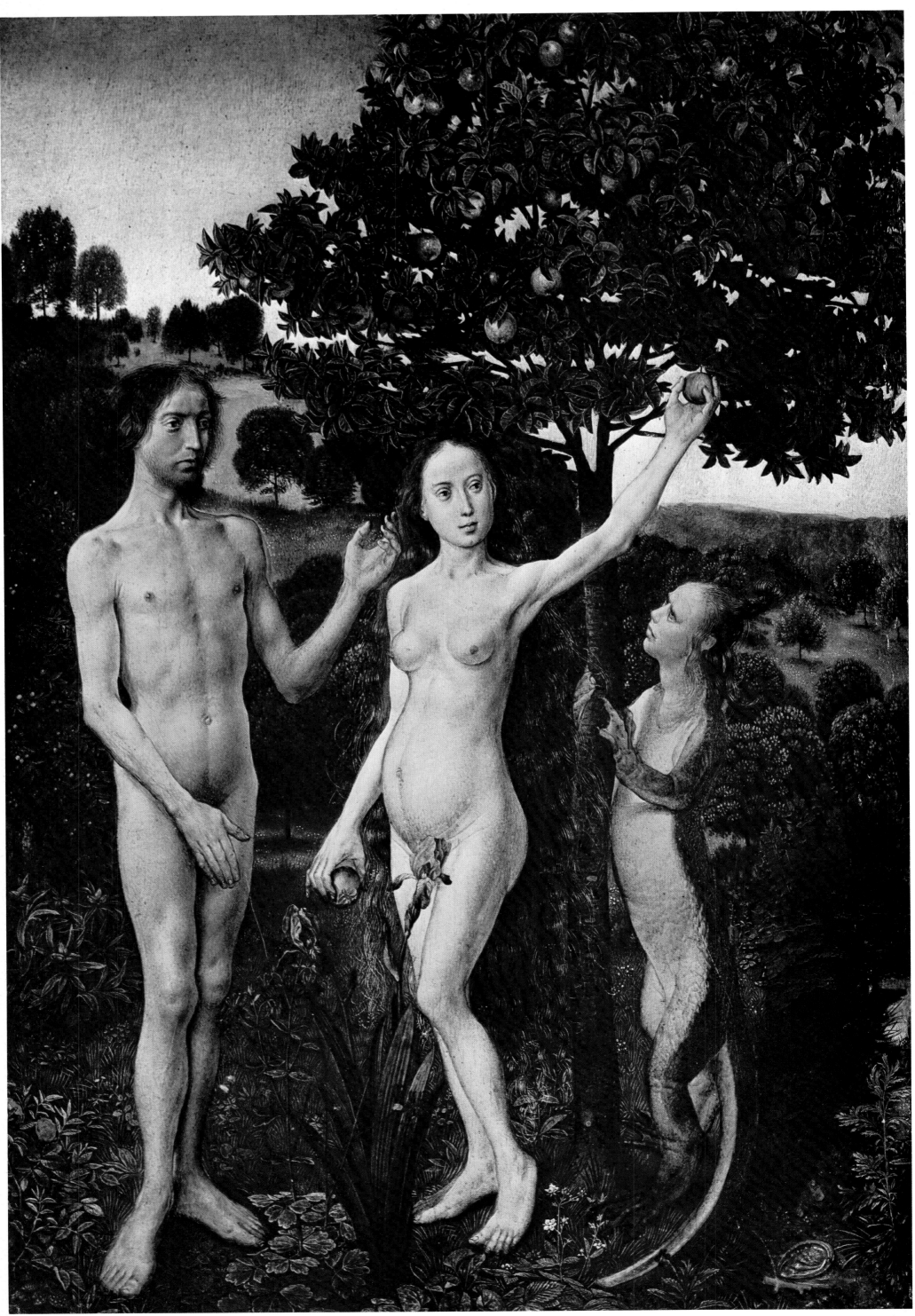

4

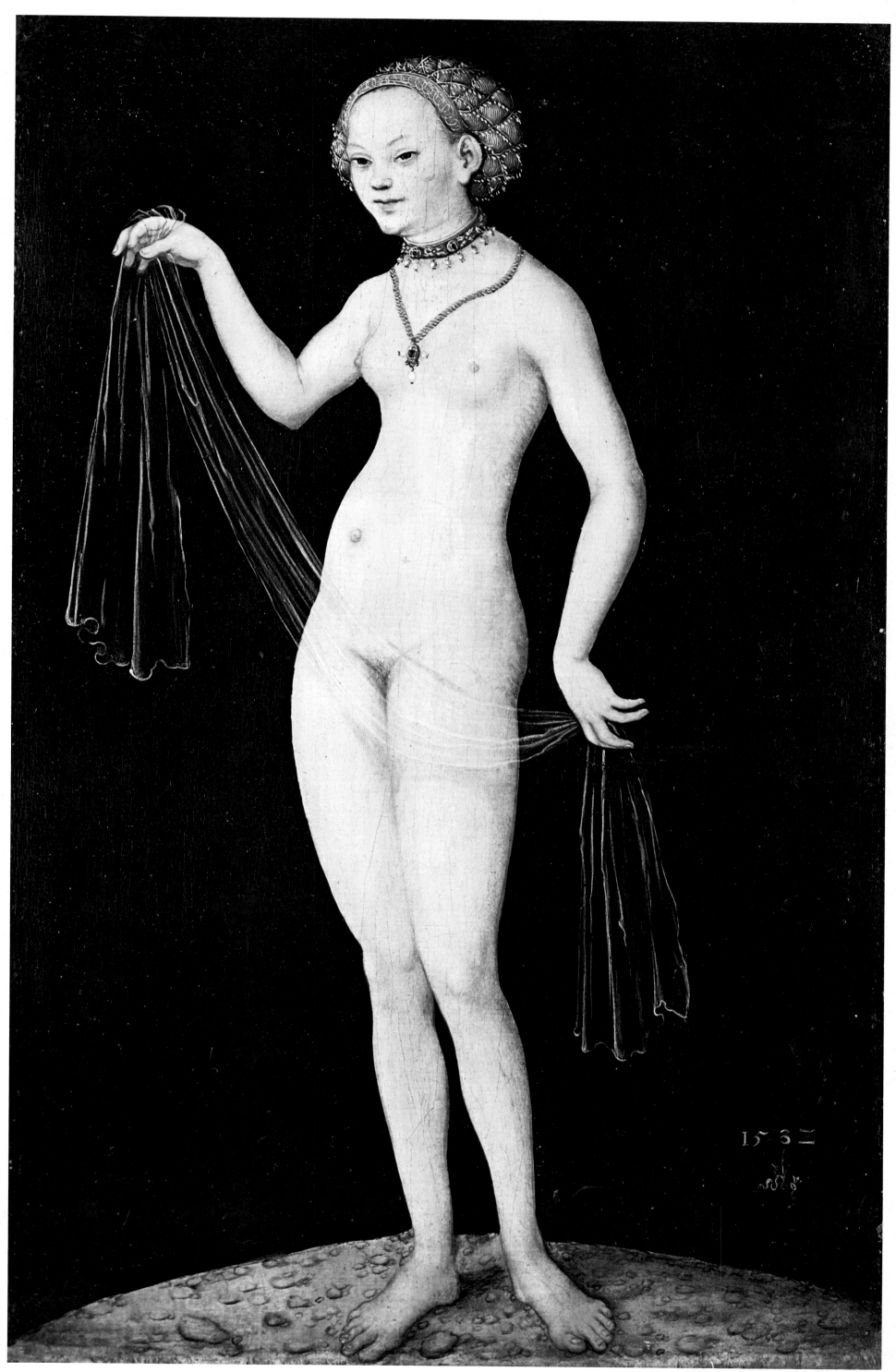

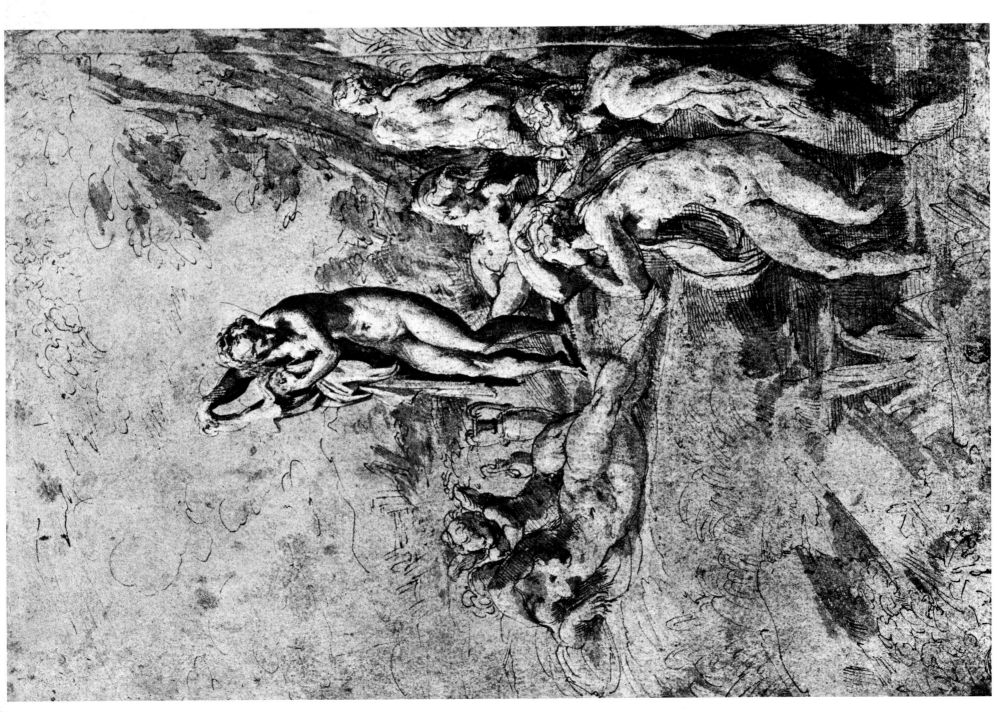

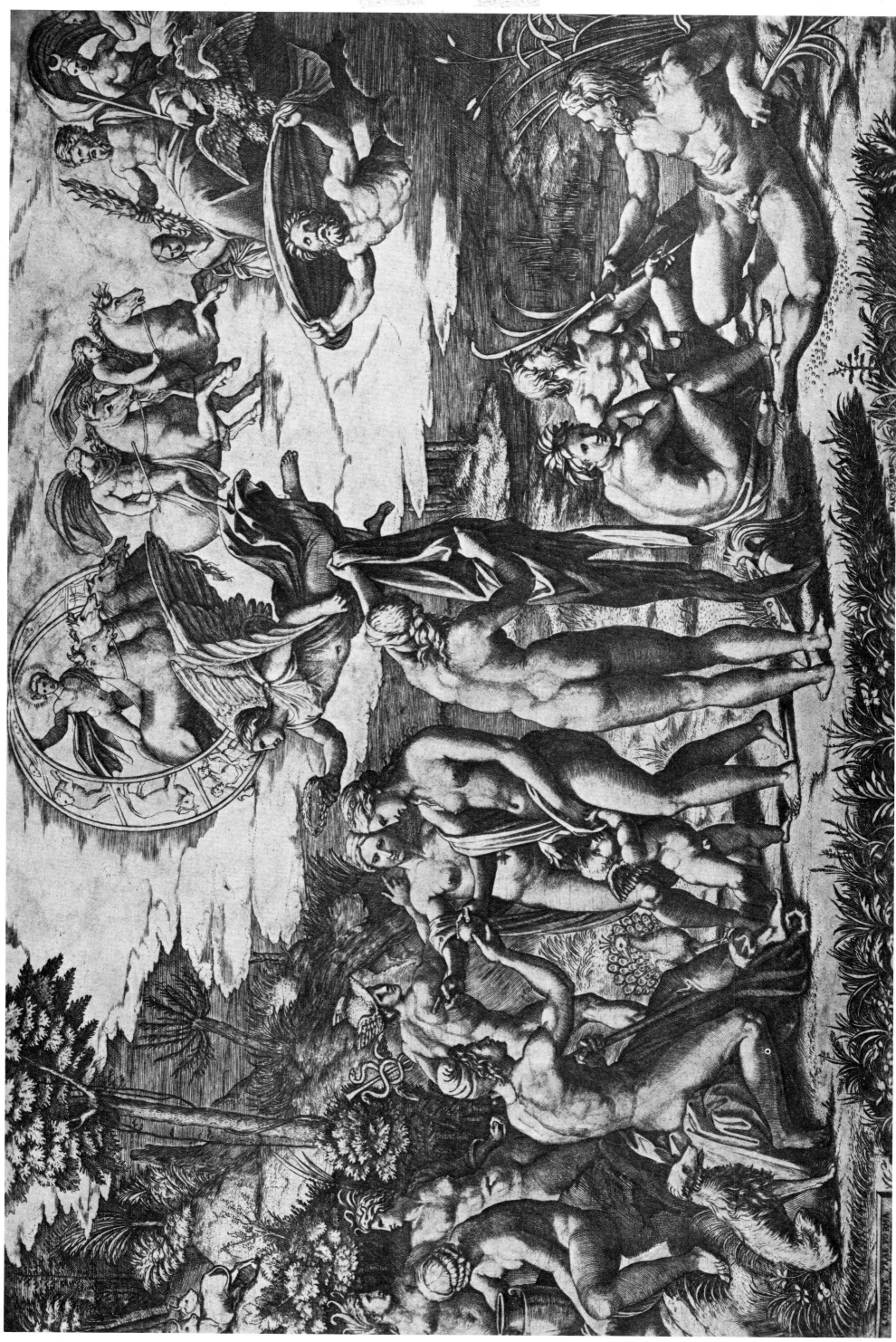

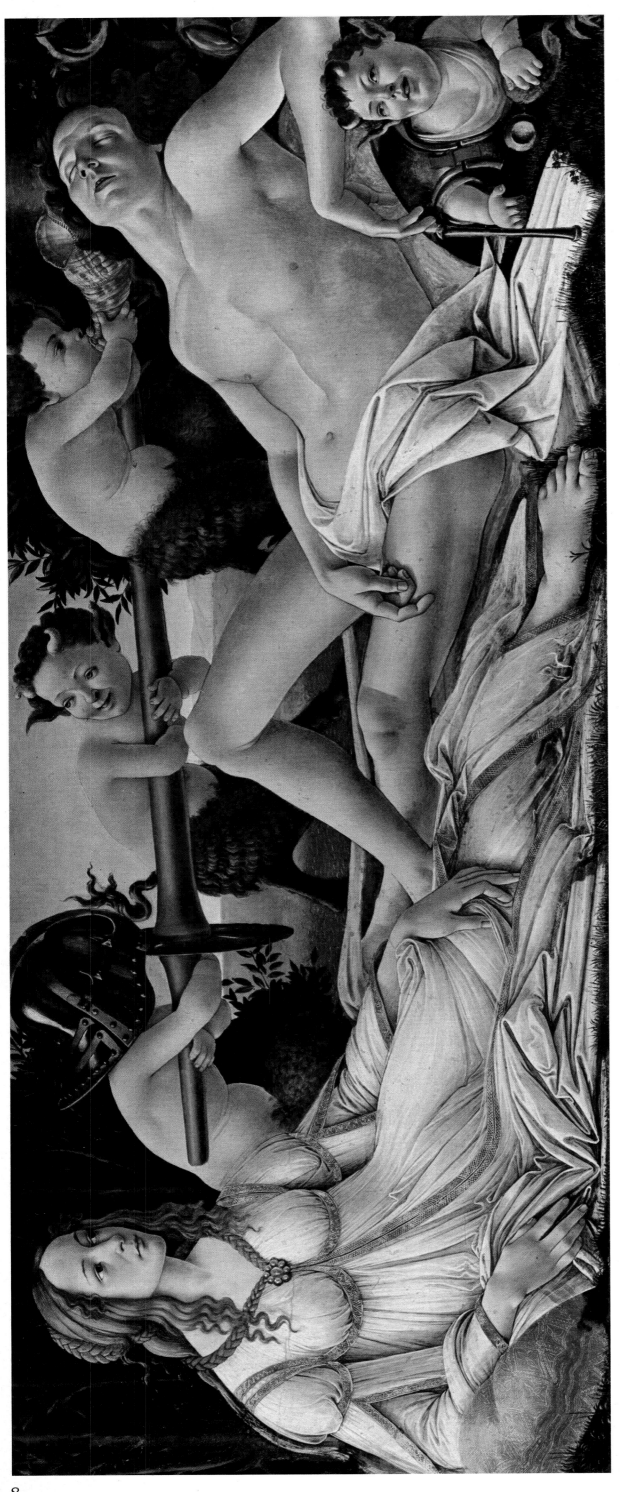

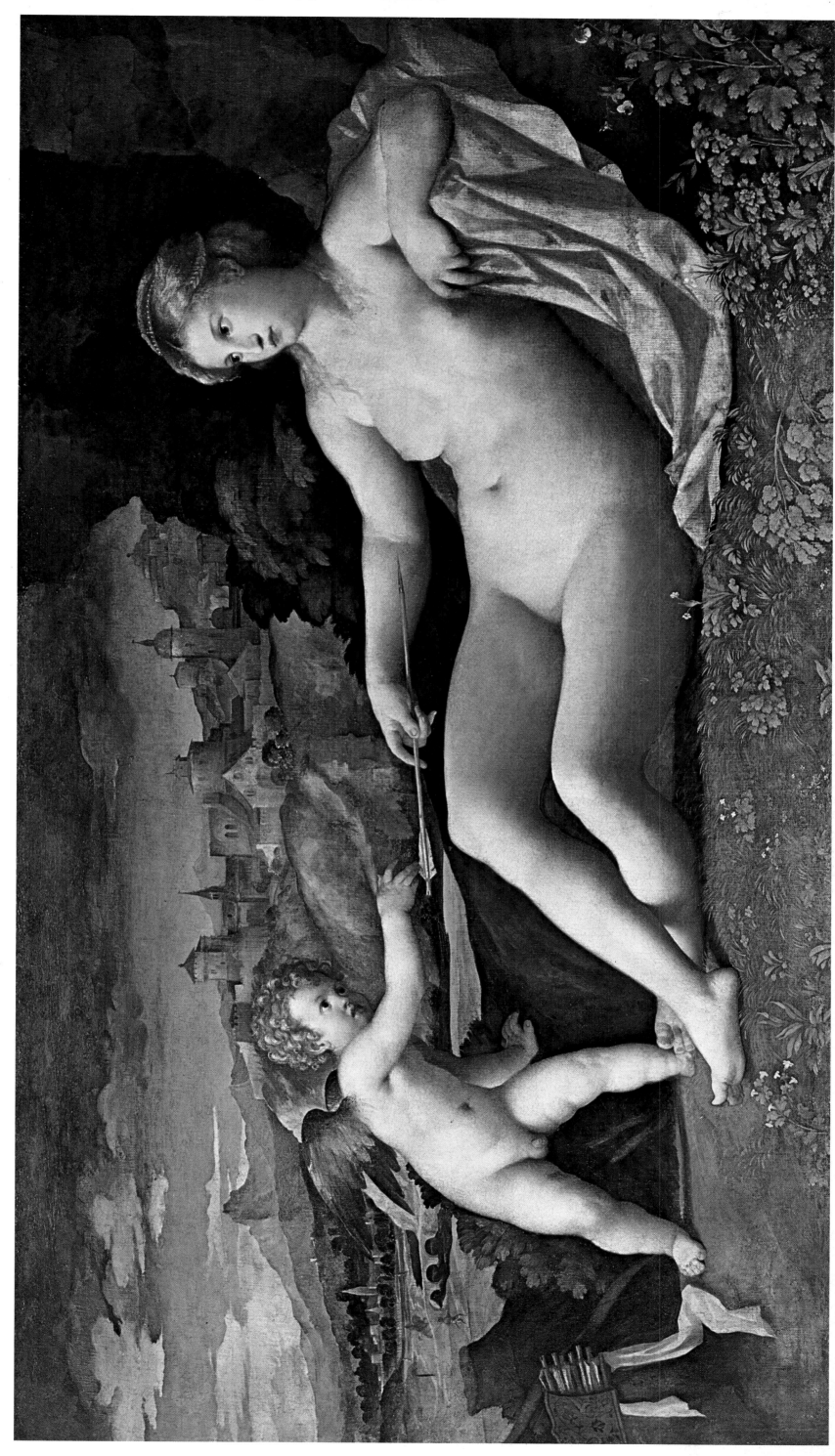

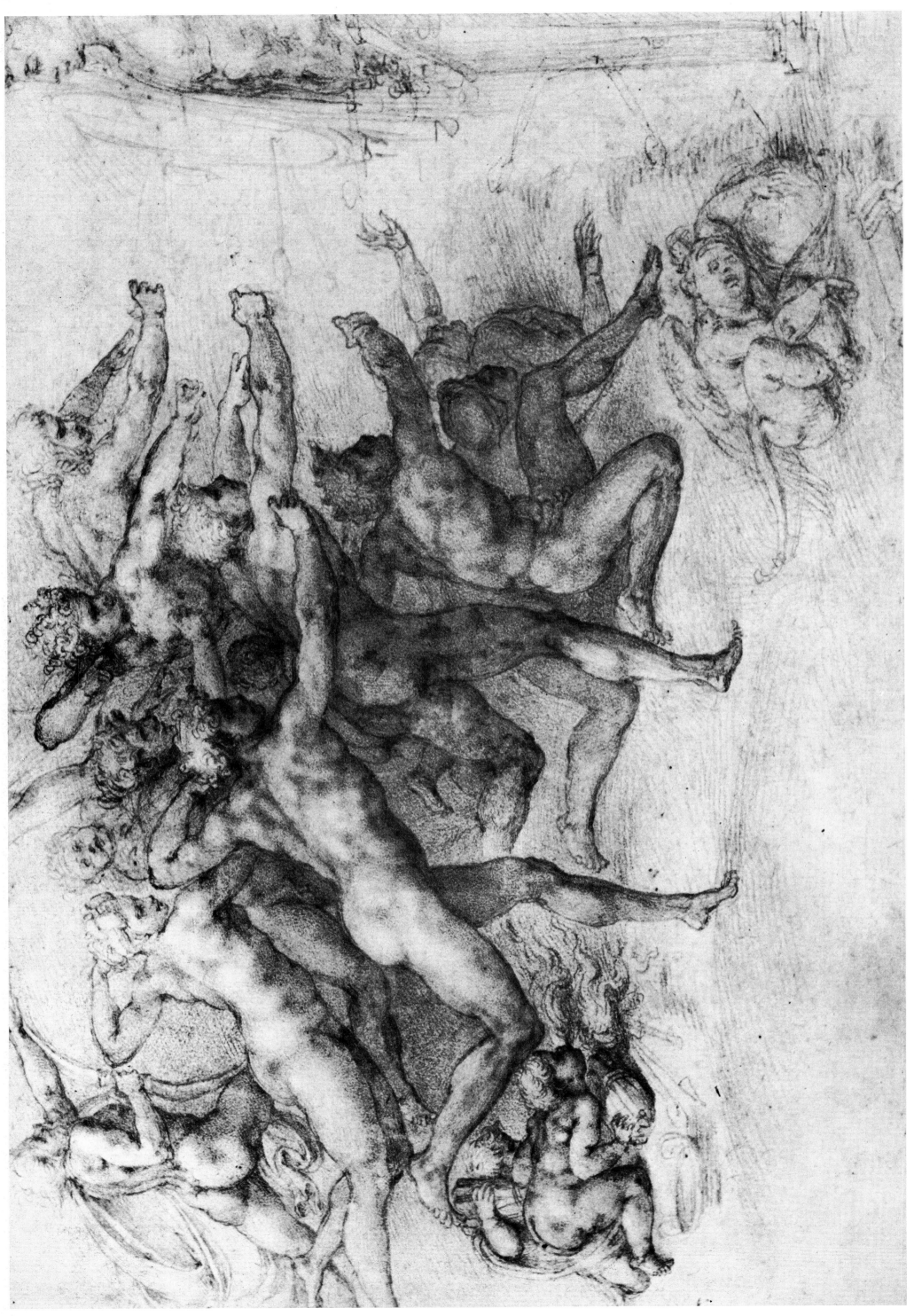

10

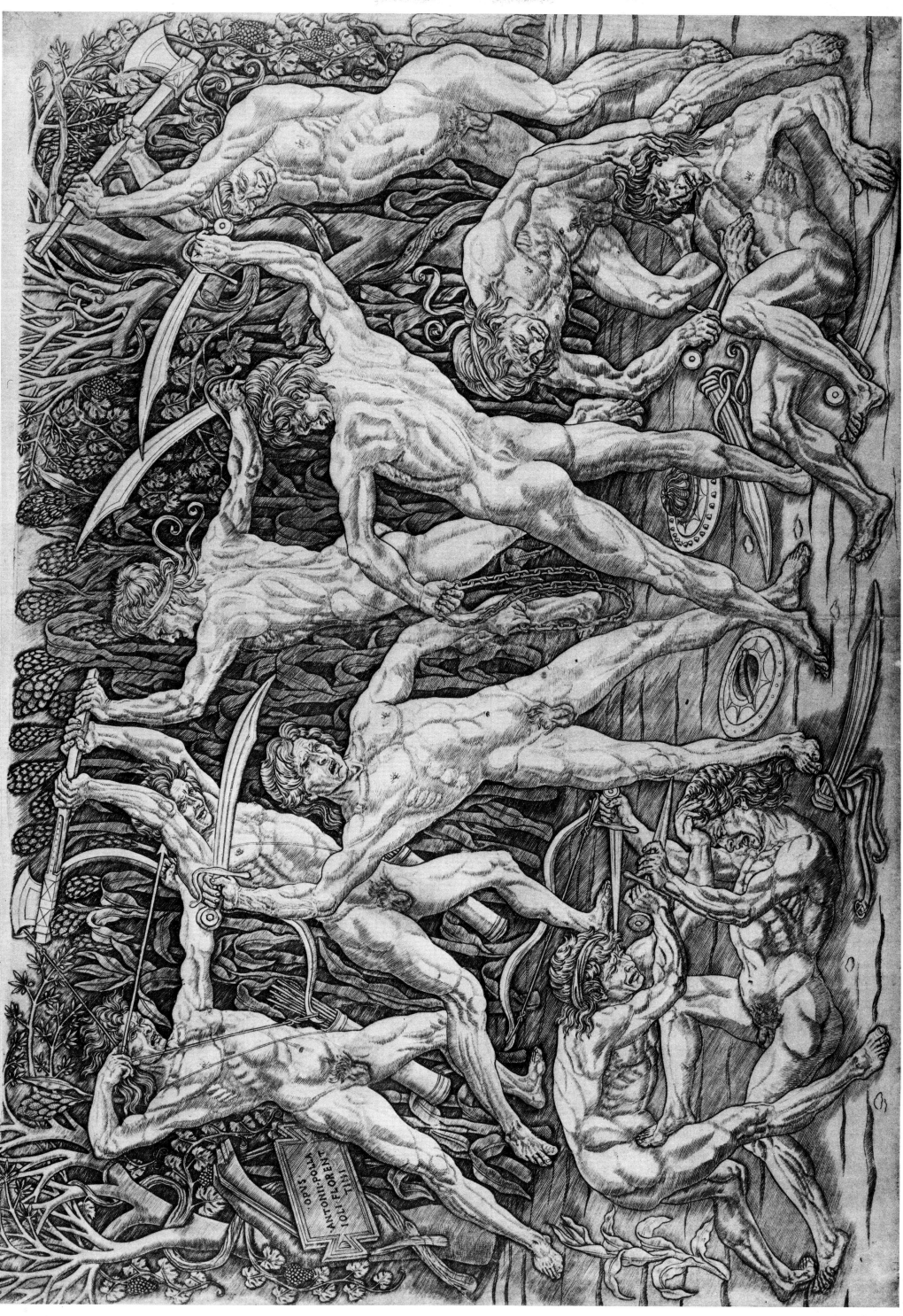

11

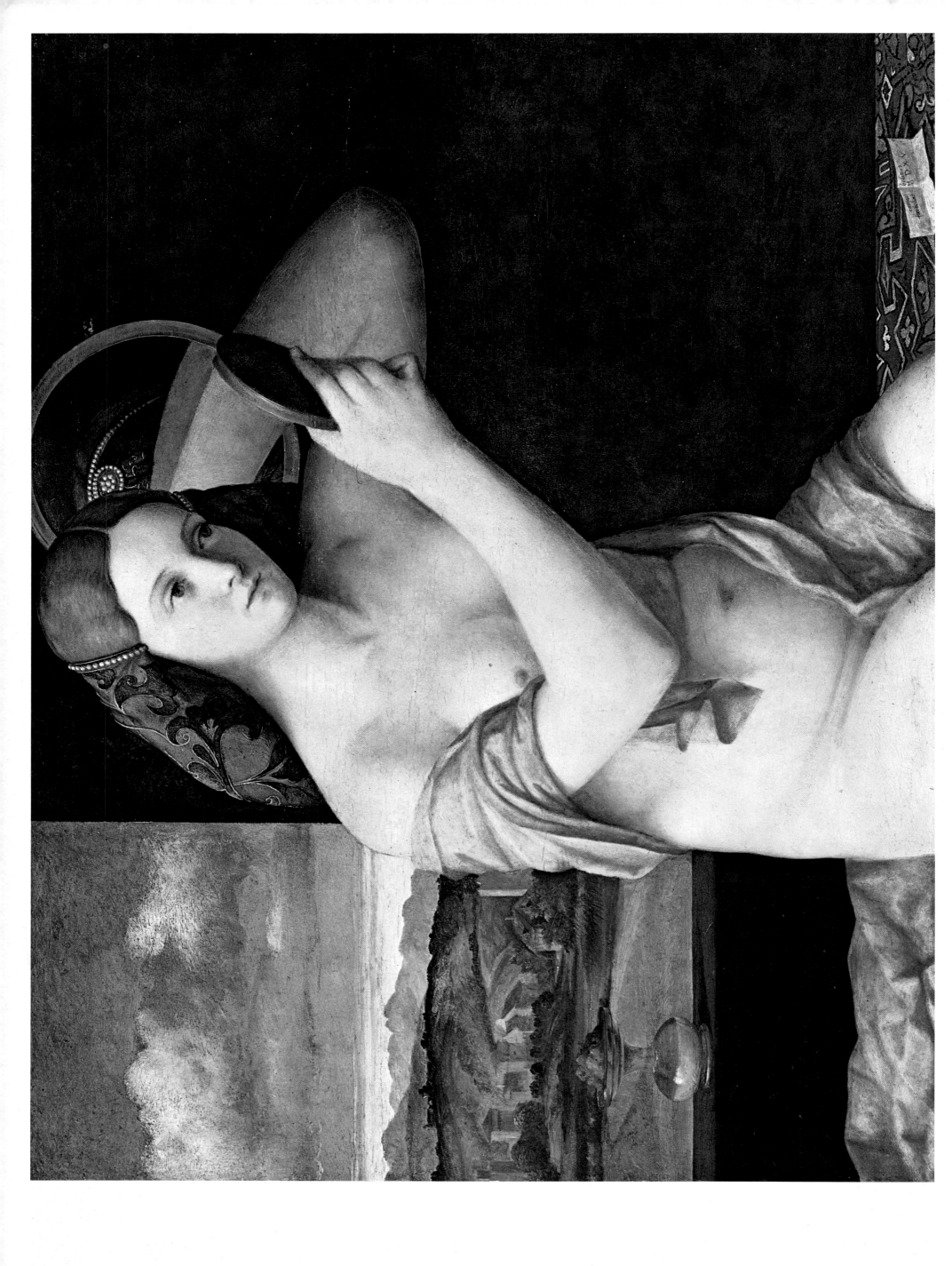

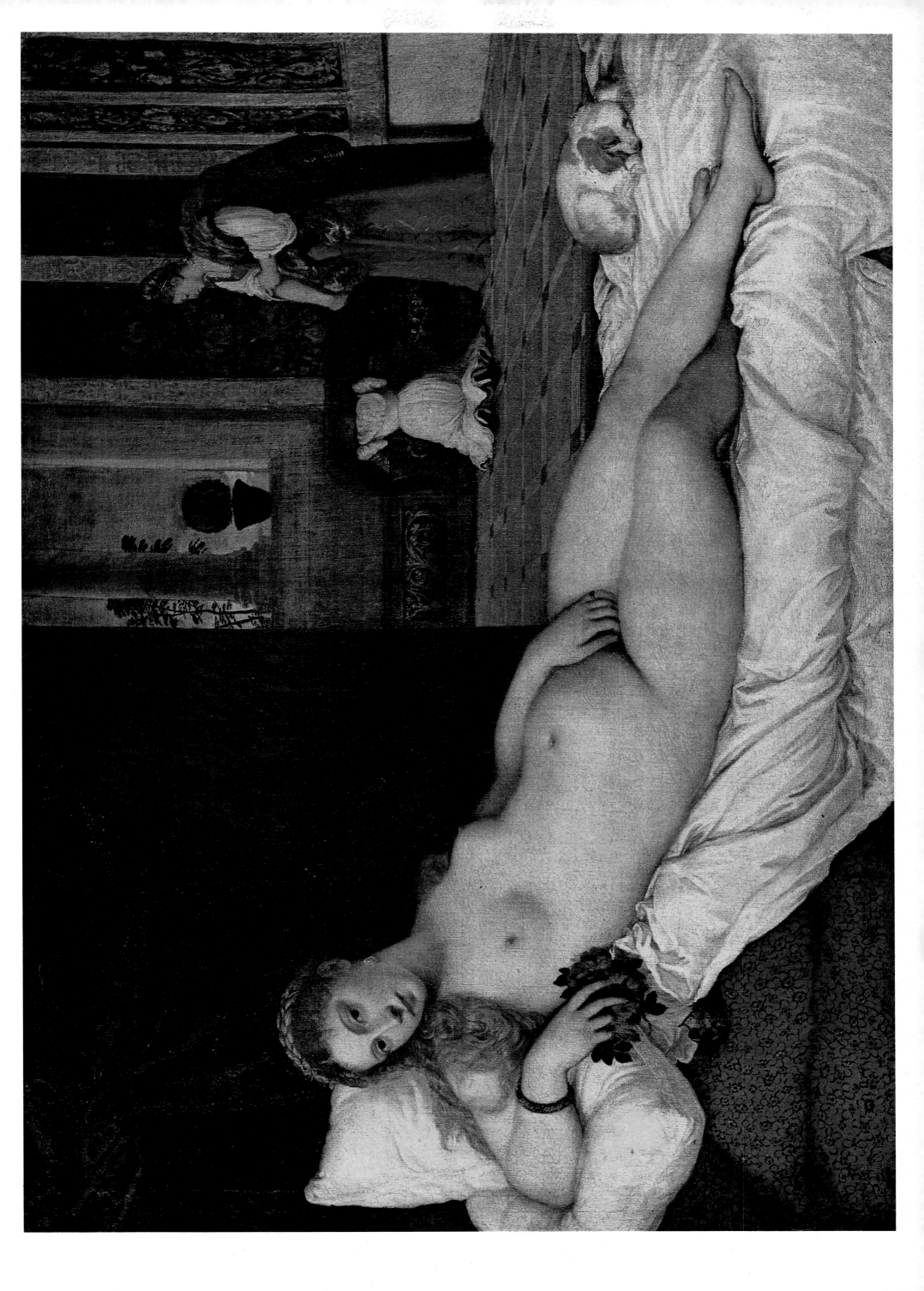

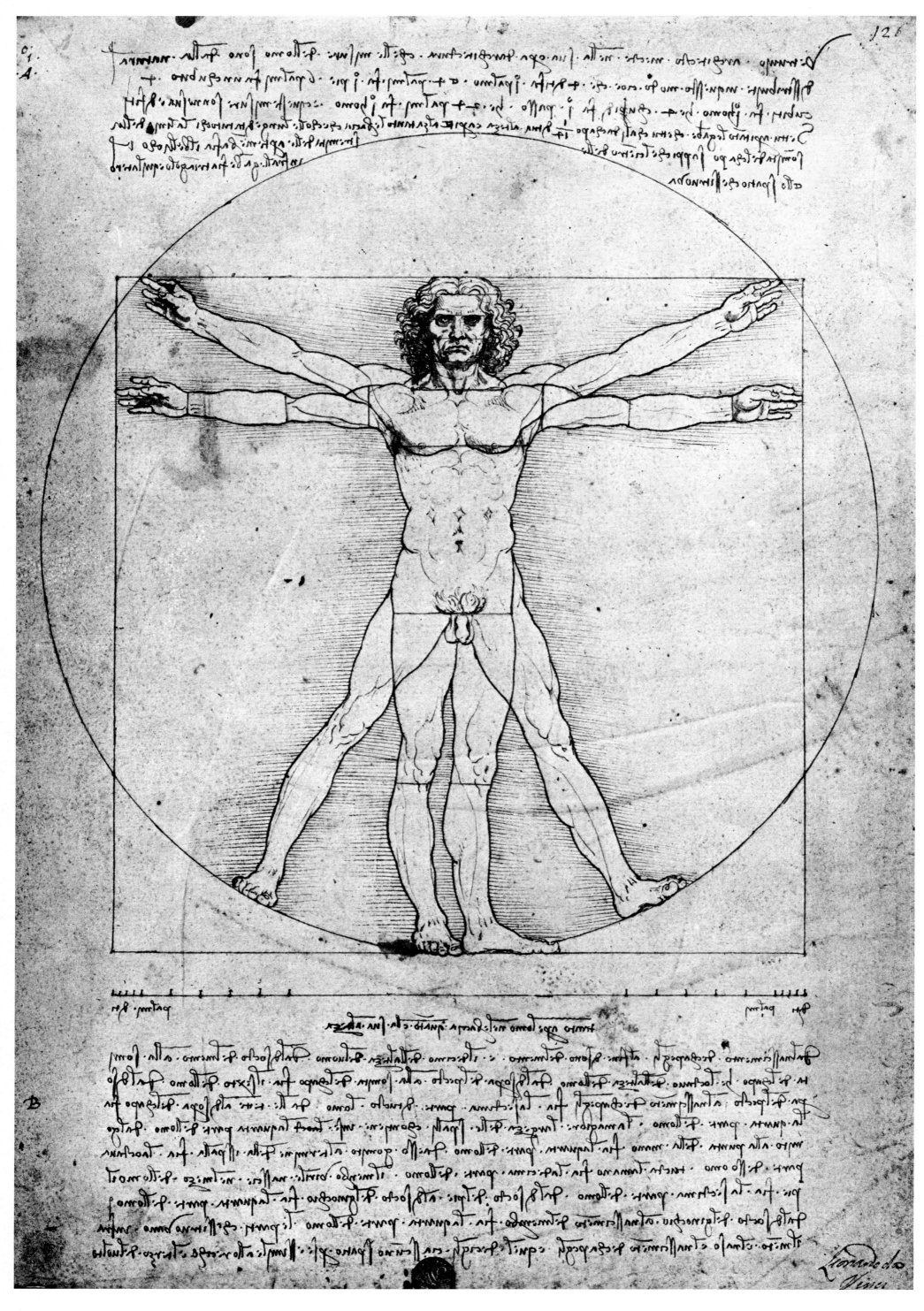

14

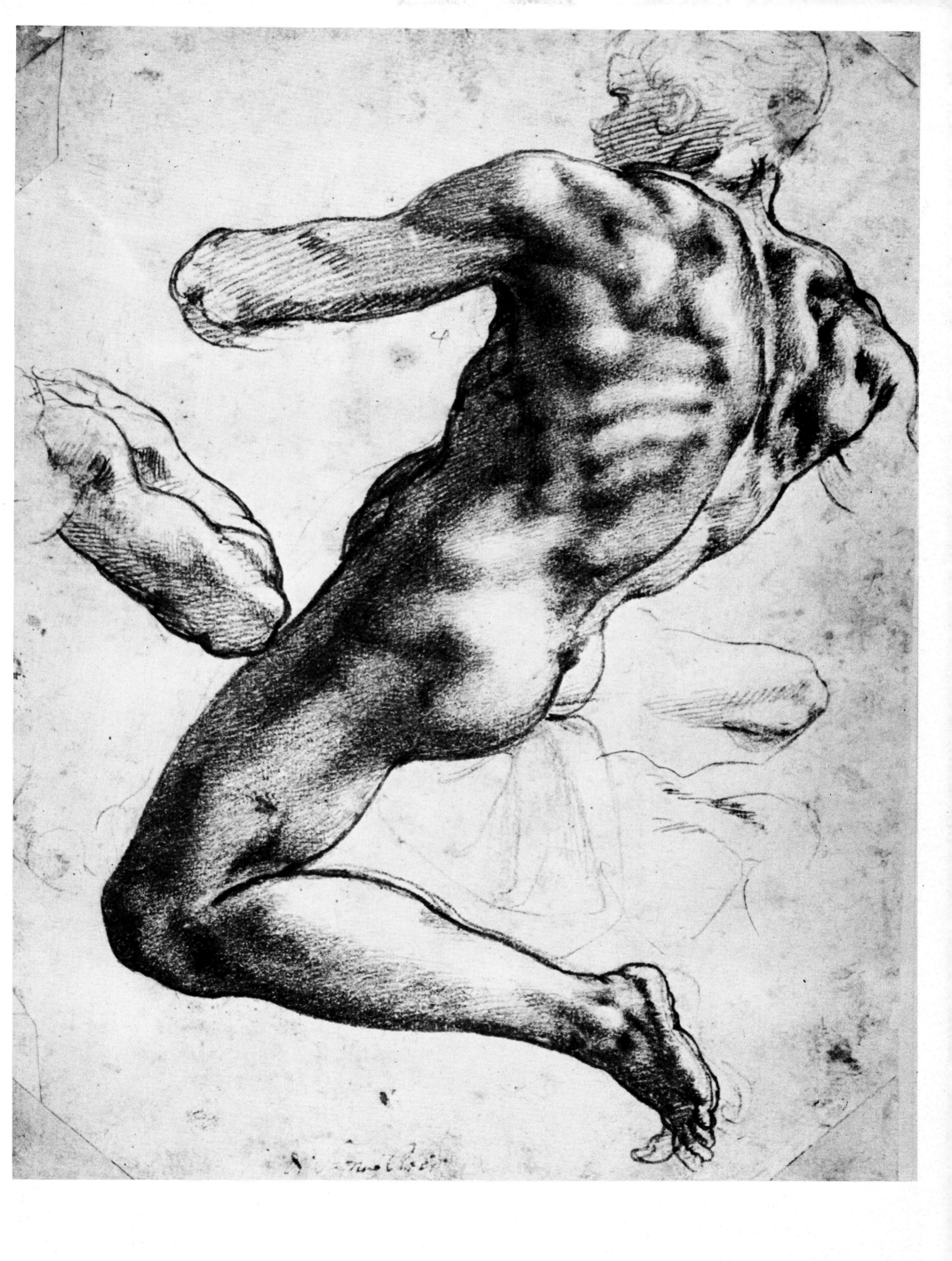

15

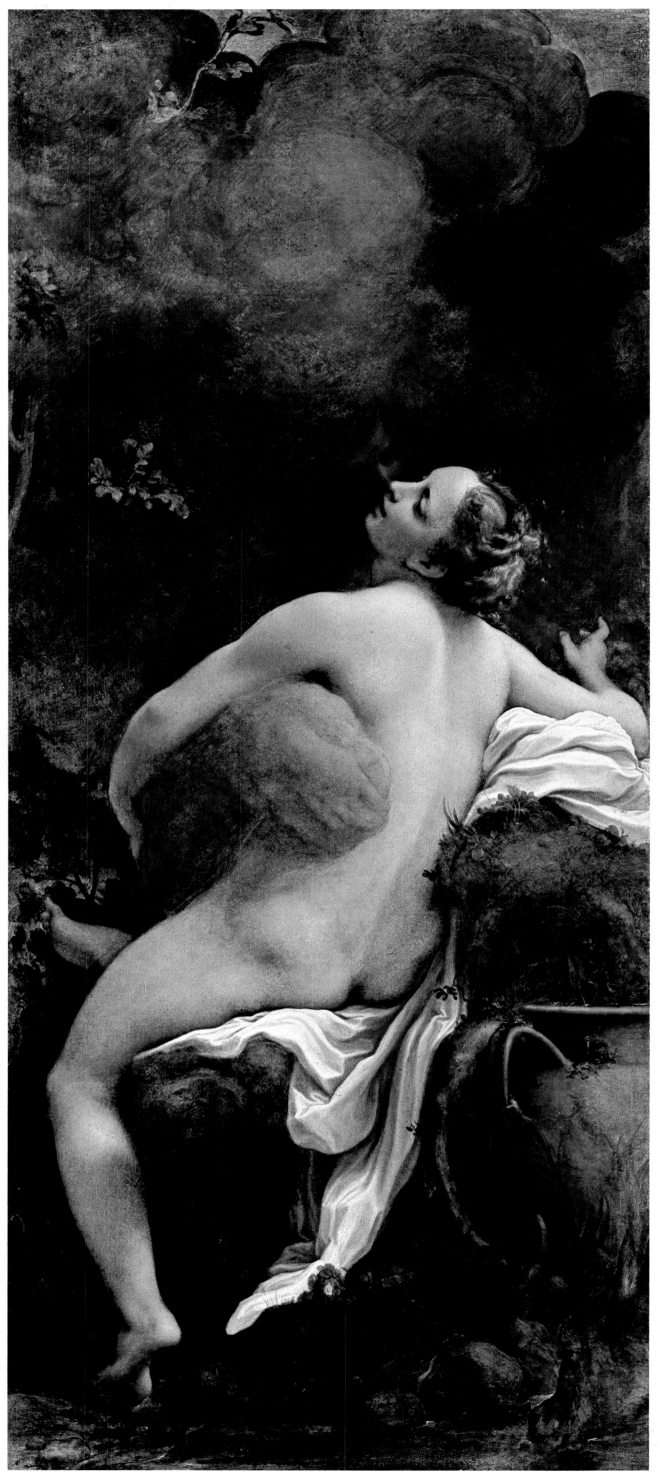

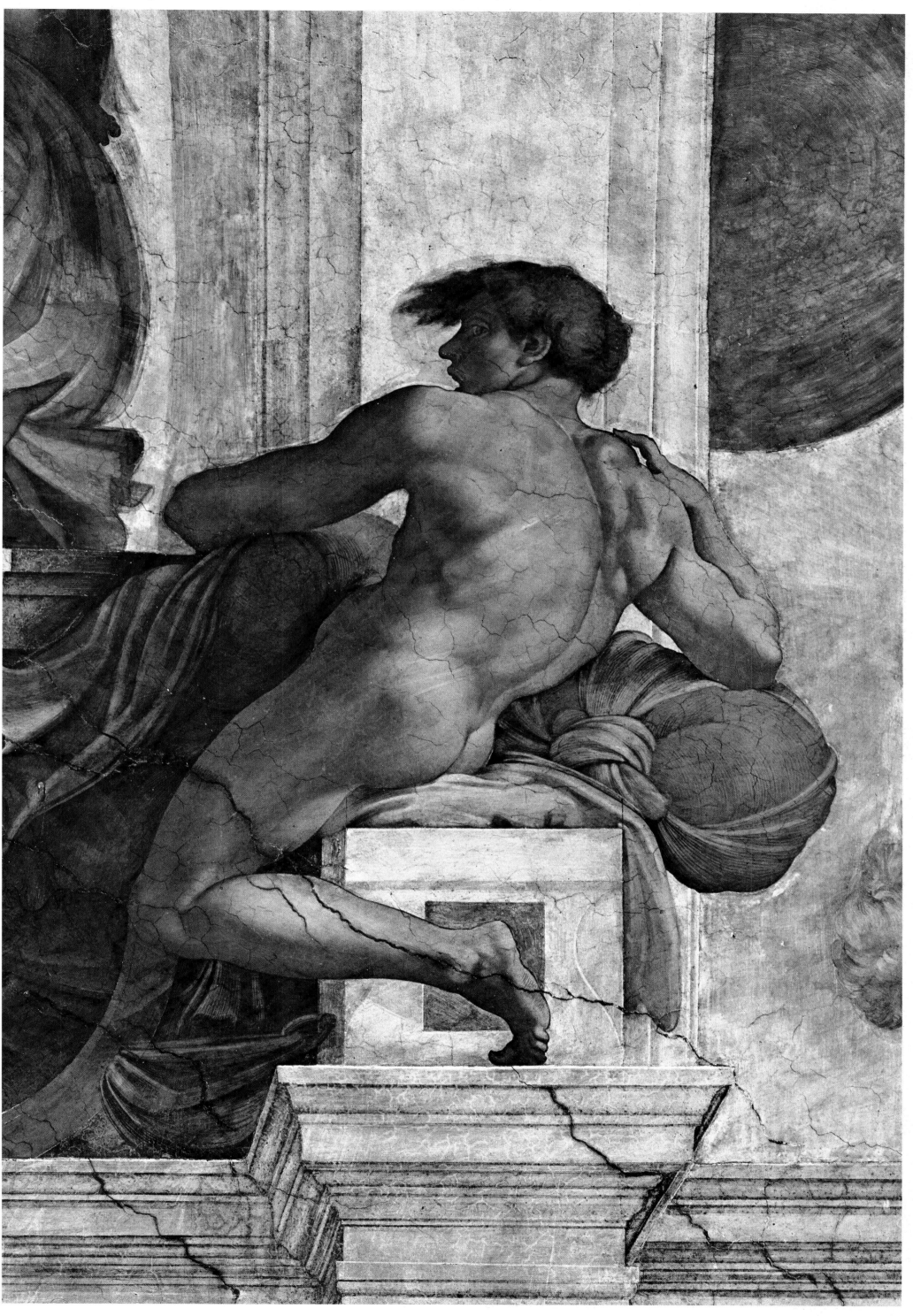

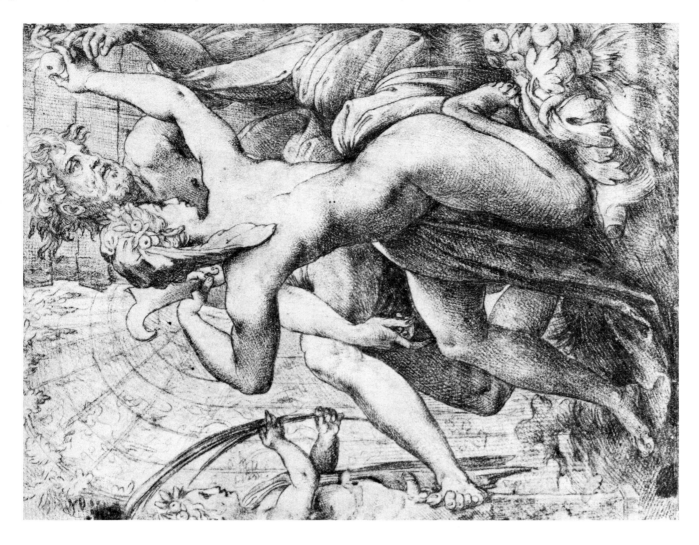

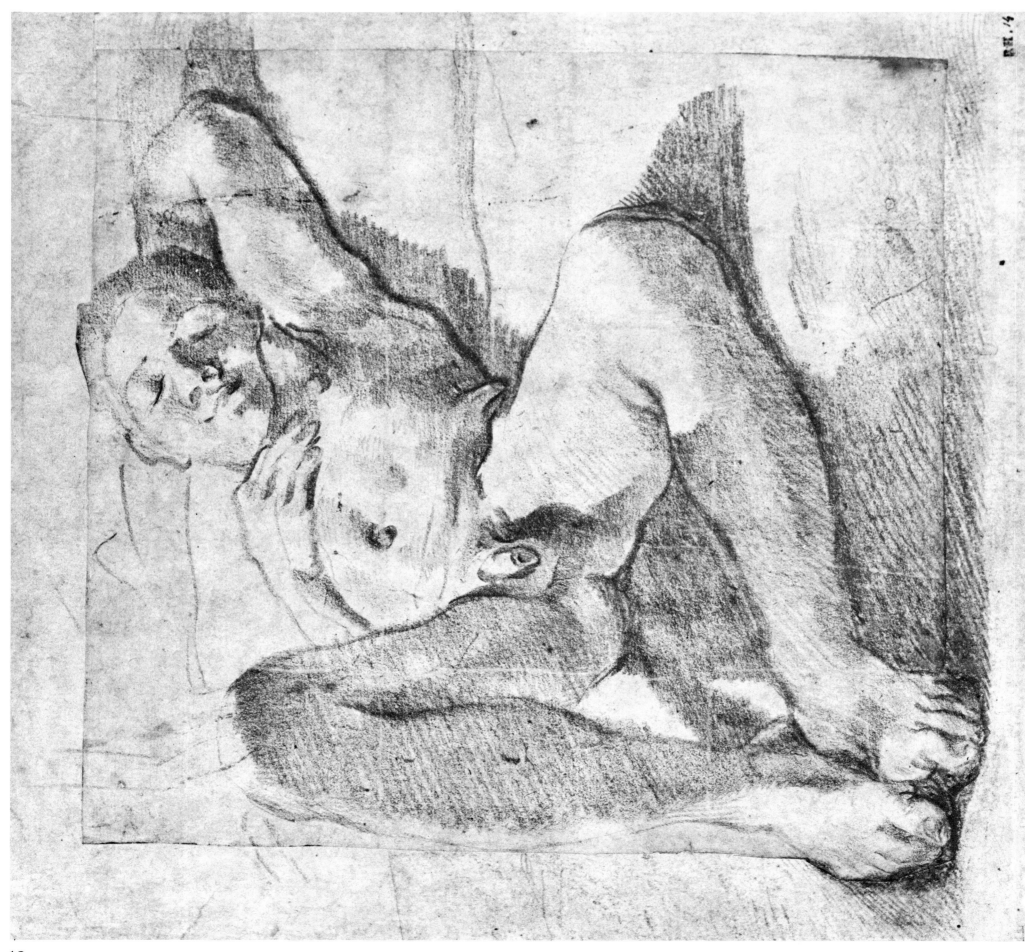

18

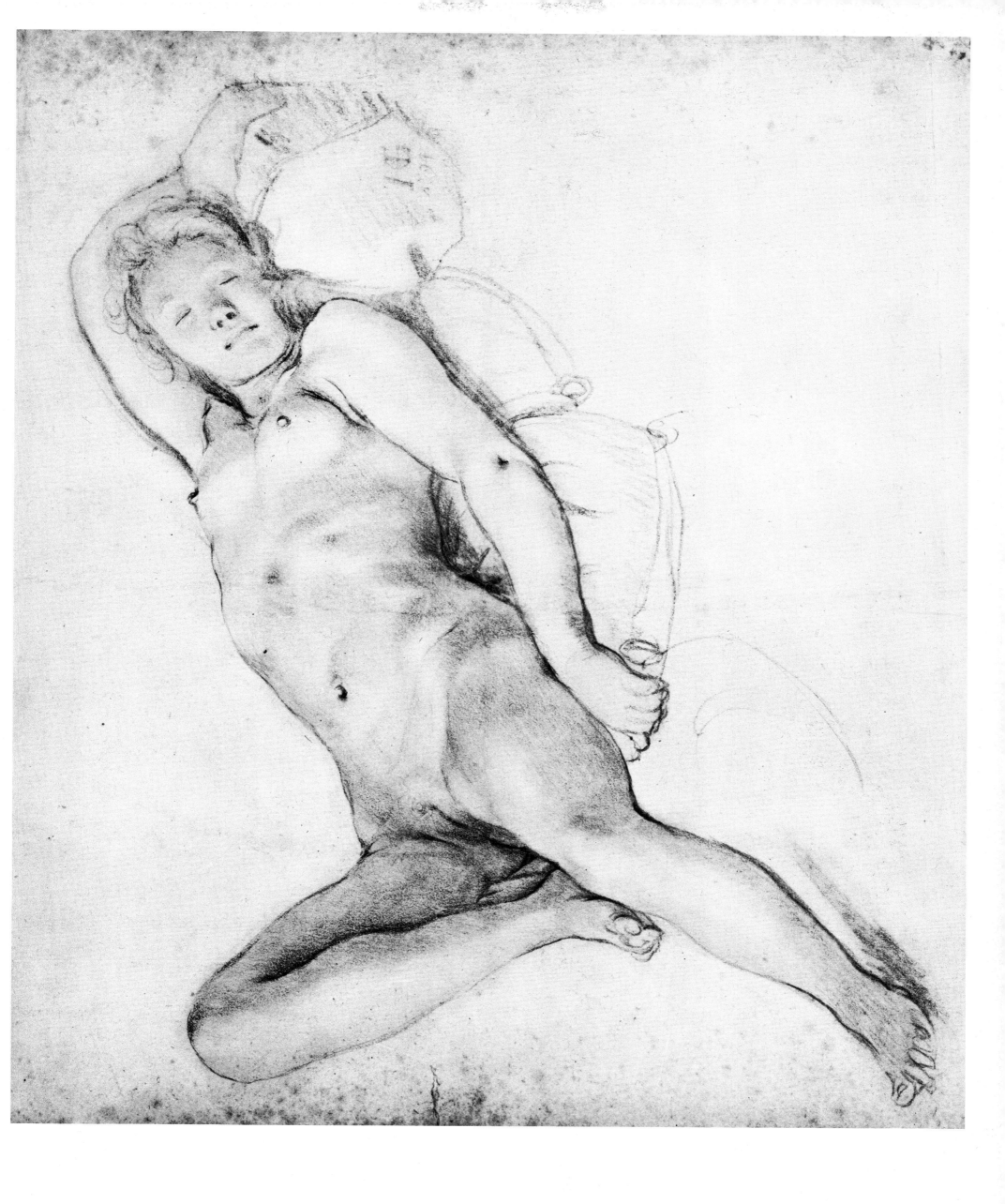

19

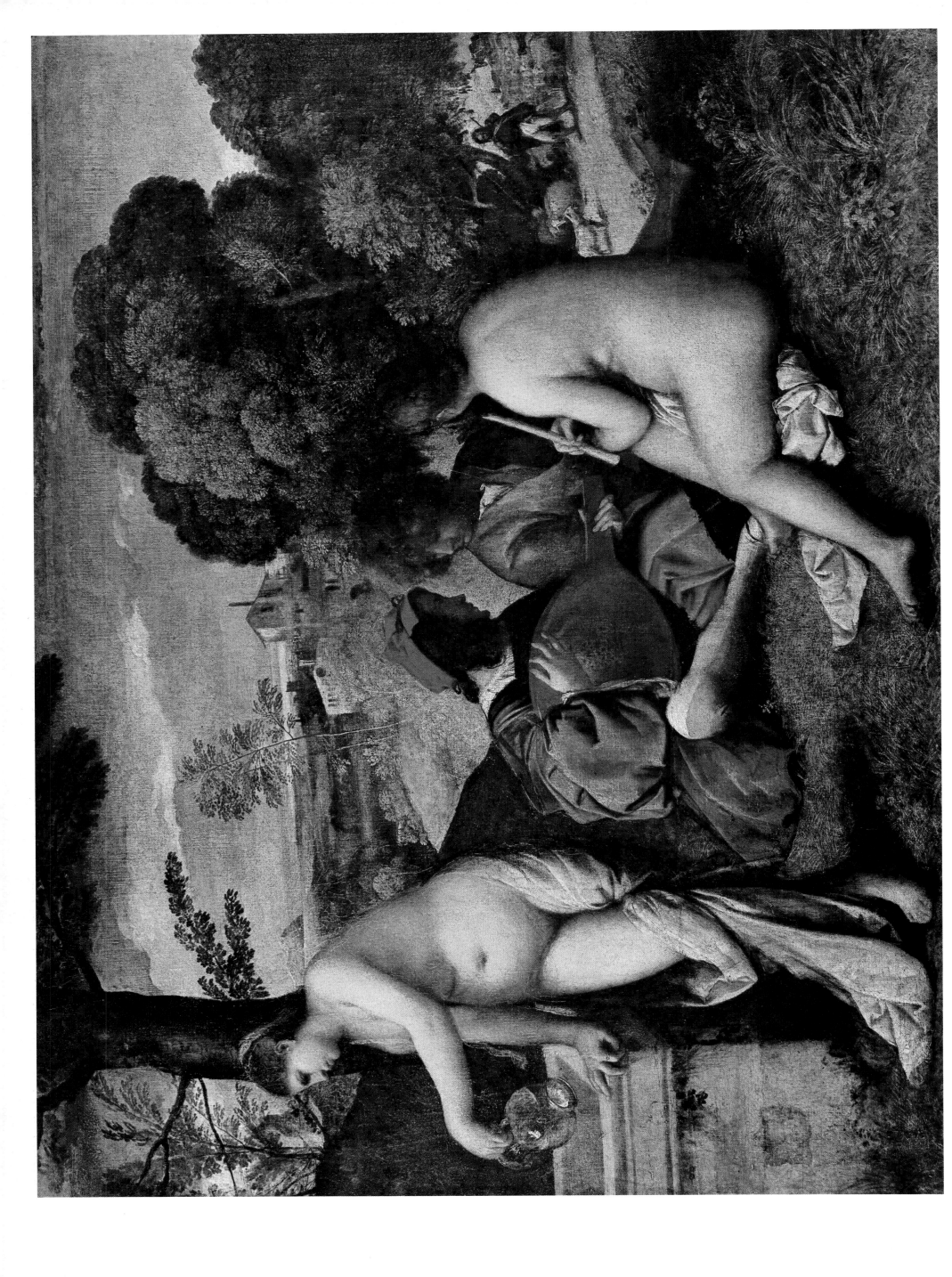

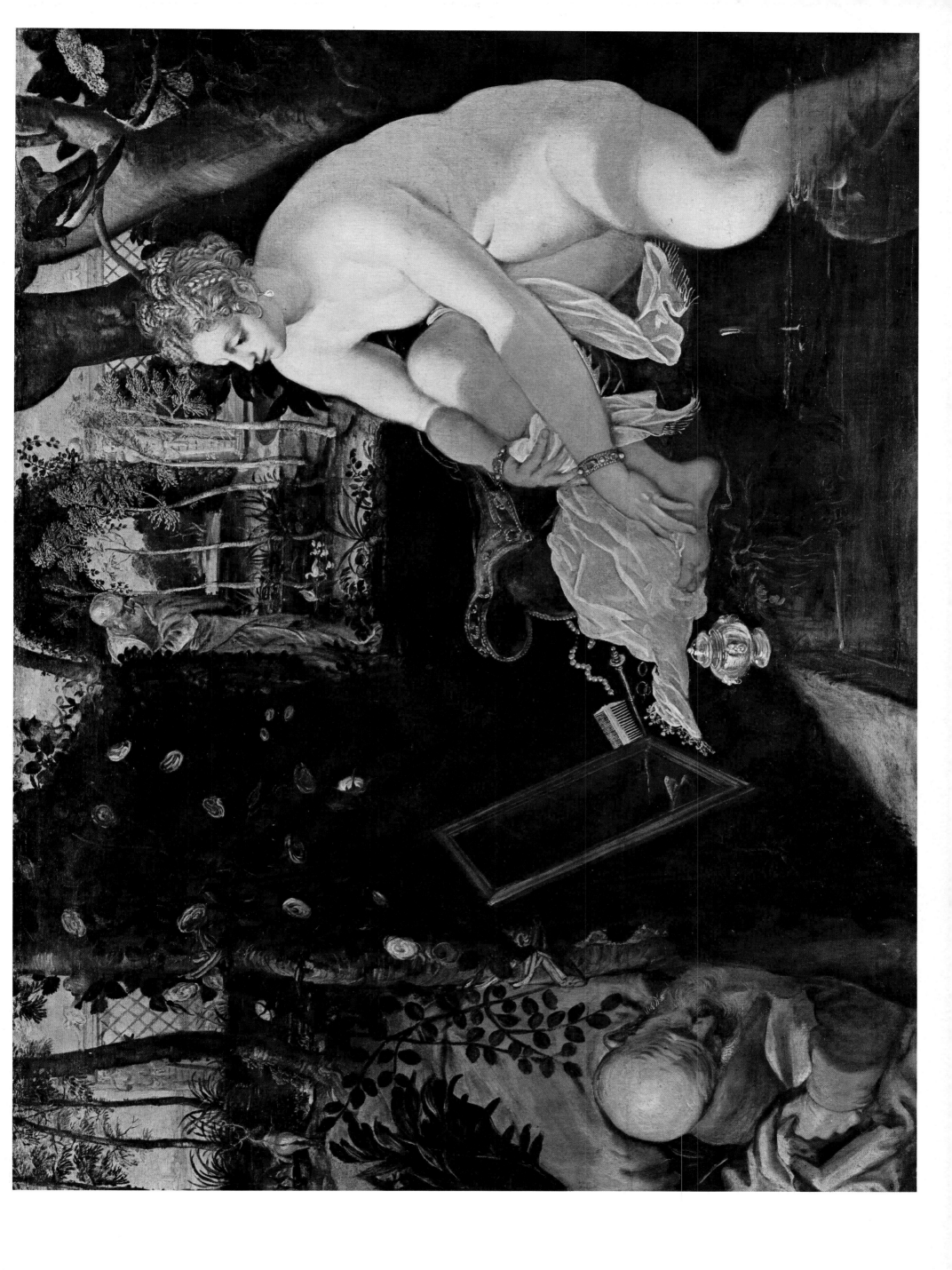

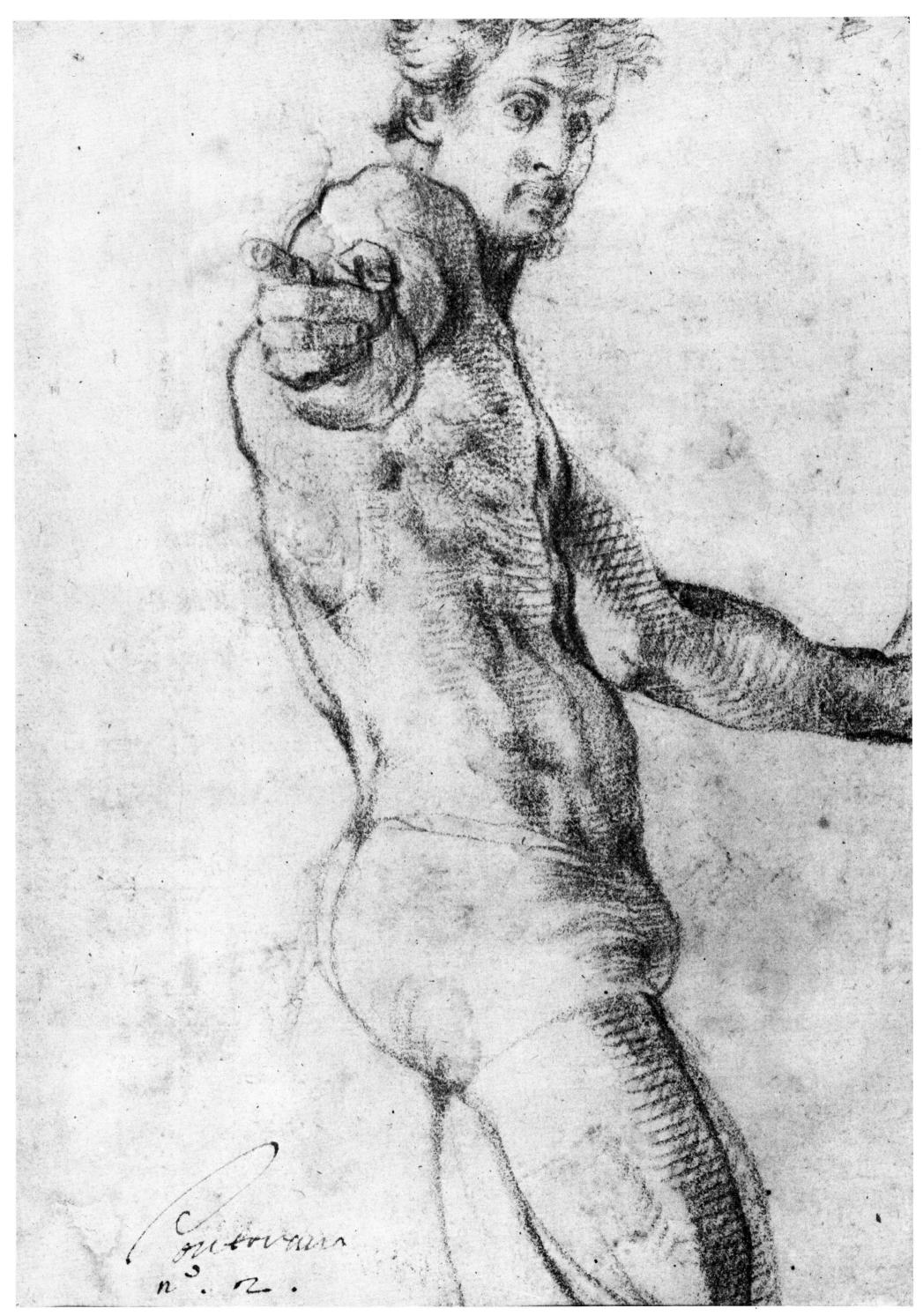

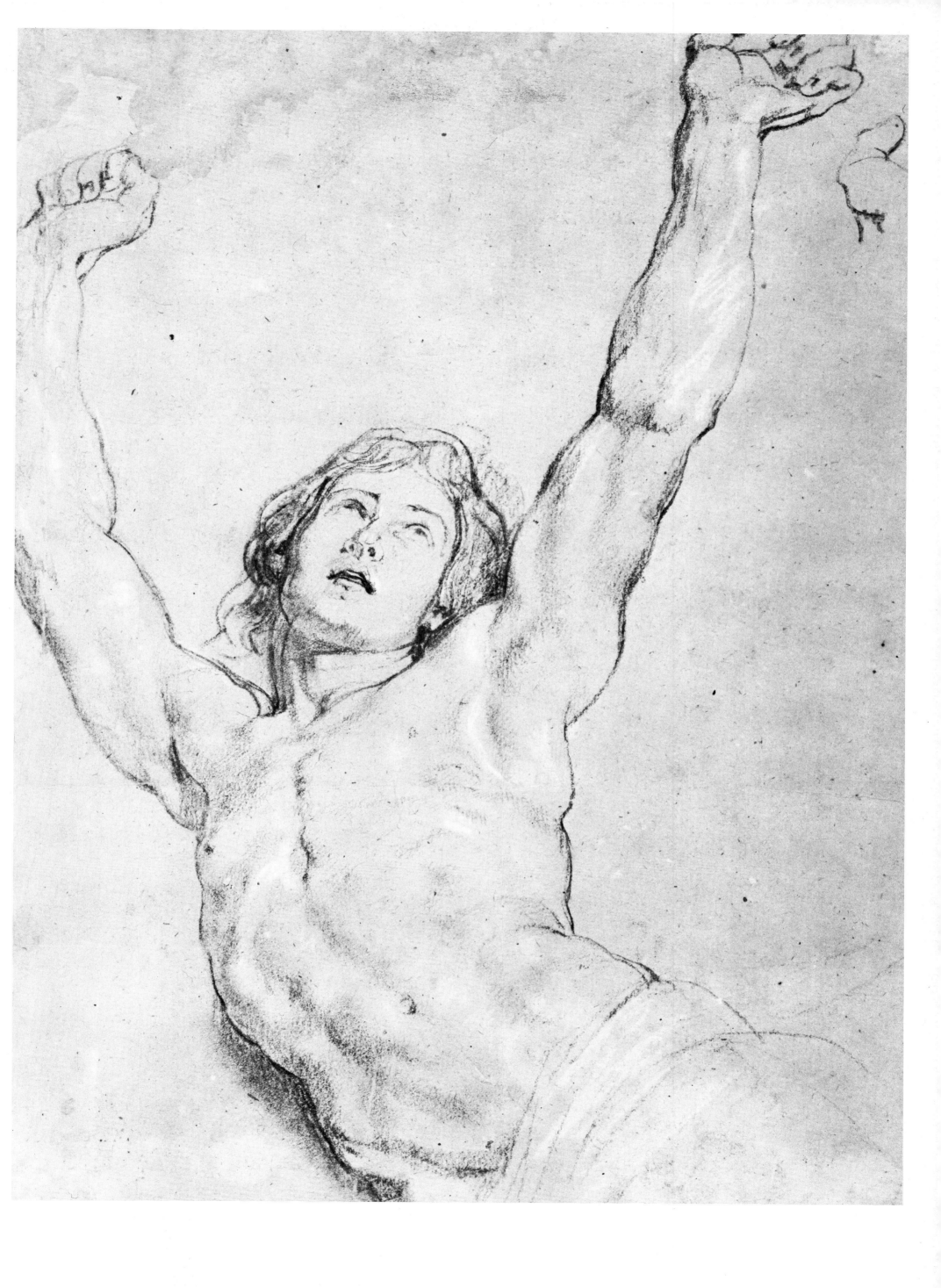

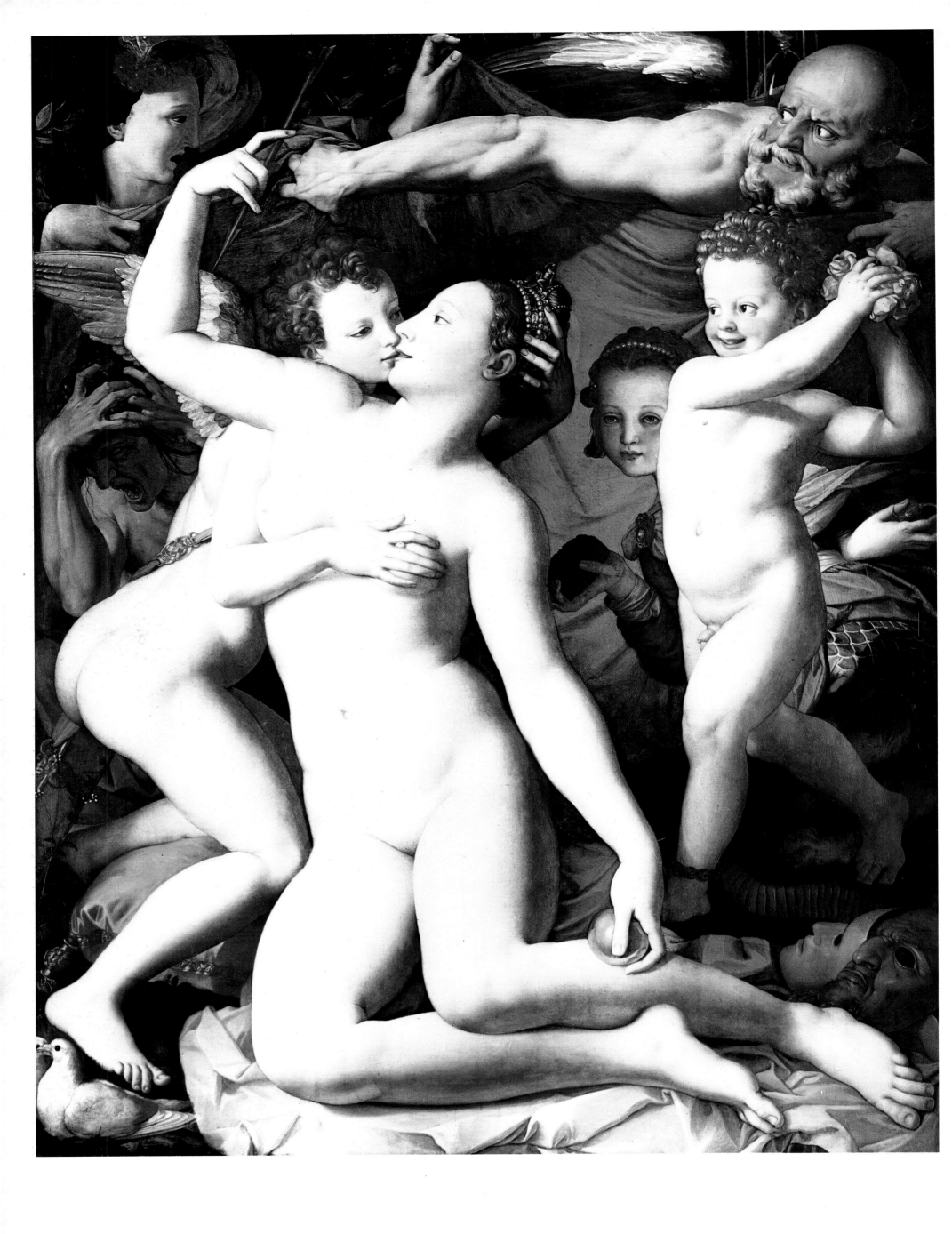

24

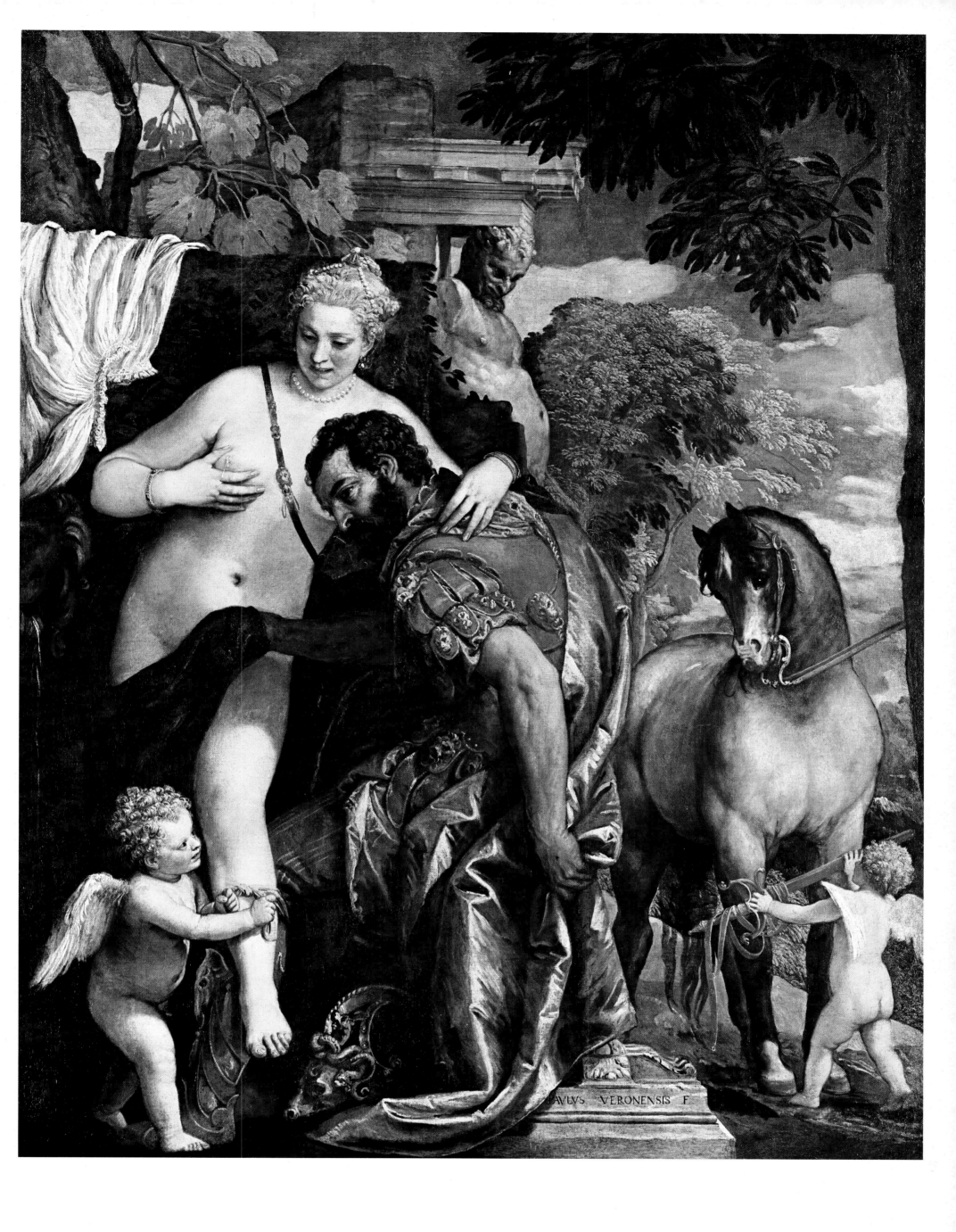

PAVLVS VERONENSIS F

C vm priuilegio Regis.

O Phidias, o Apelles, Quidquamne ornatius vestris temporibus excogitari potuit, ea sculptura, cuius hic picturam cernitis, Quam
Franciscus primus, Francorum Rex potentiss bonarum artium ac litrarum patr, sub Diana, à venatu conquiescentis,
atque vrnam Fontisbellaqua effundentis sittua, Domi suæ inhoatam reliquit ~

Rous. Florin. Inuen ~

26

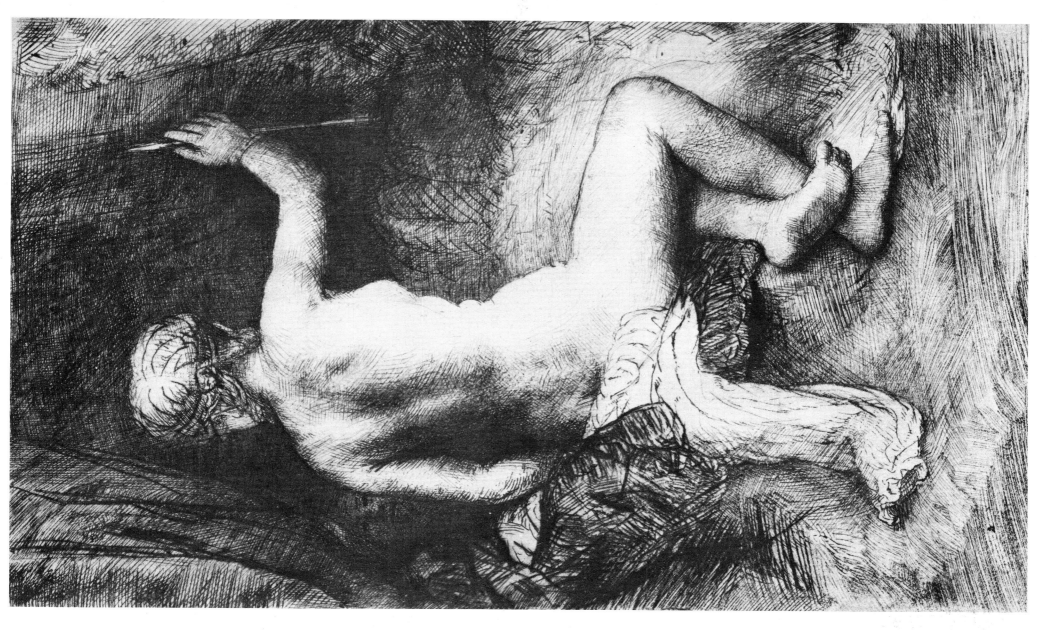

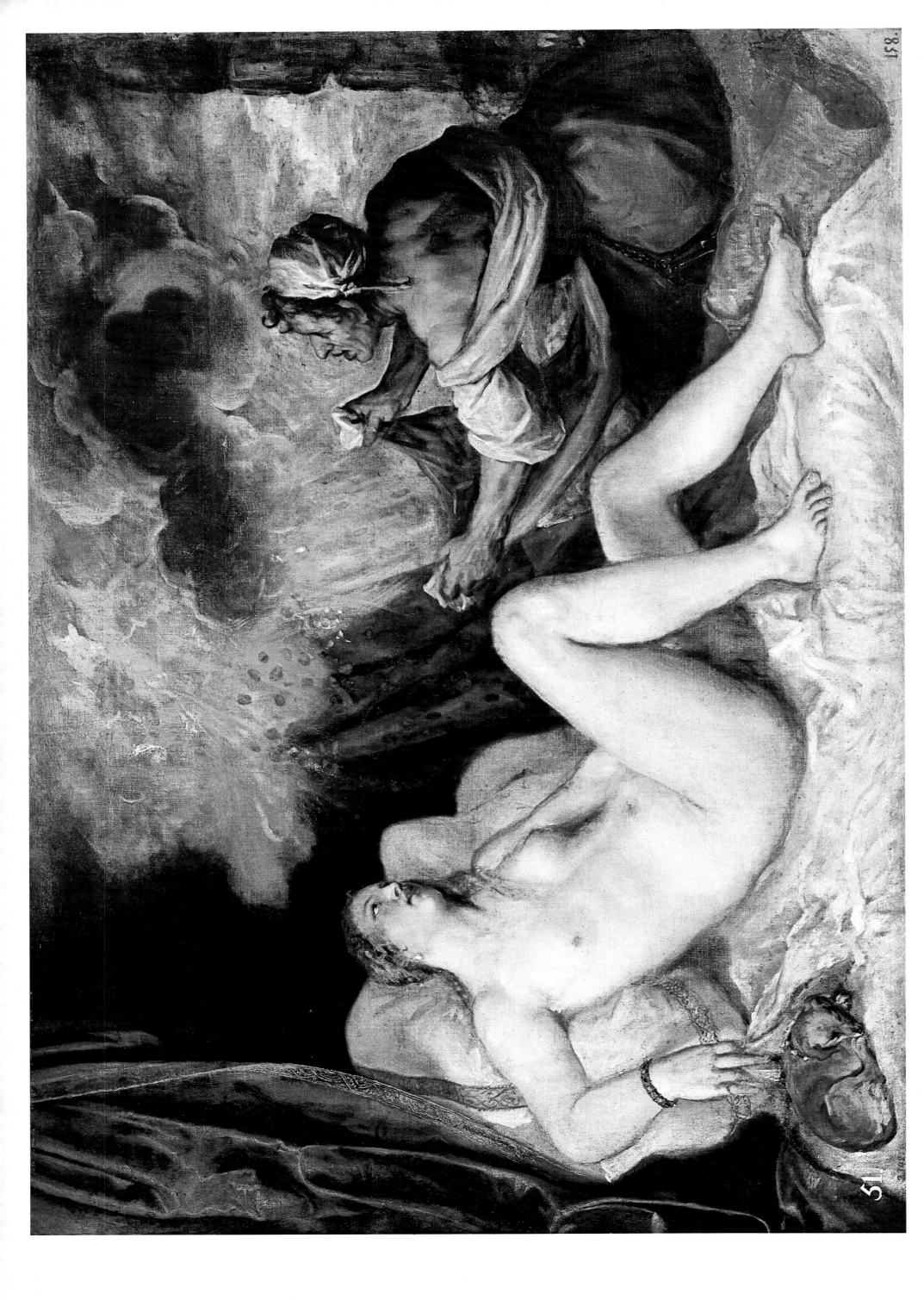

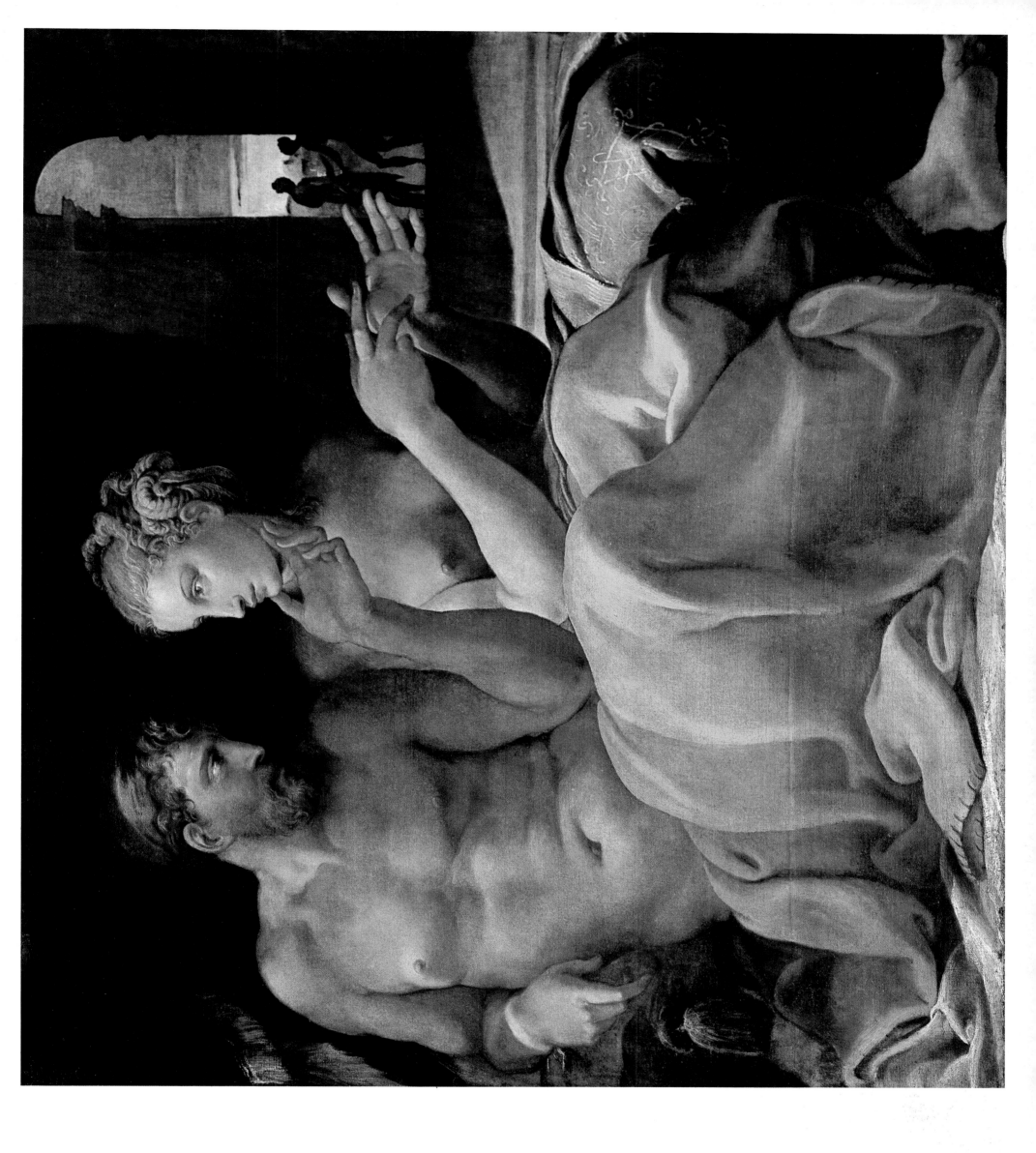

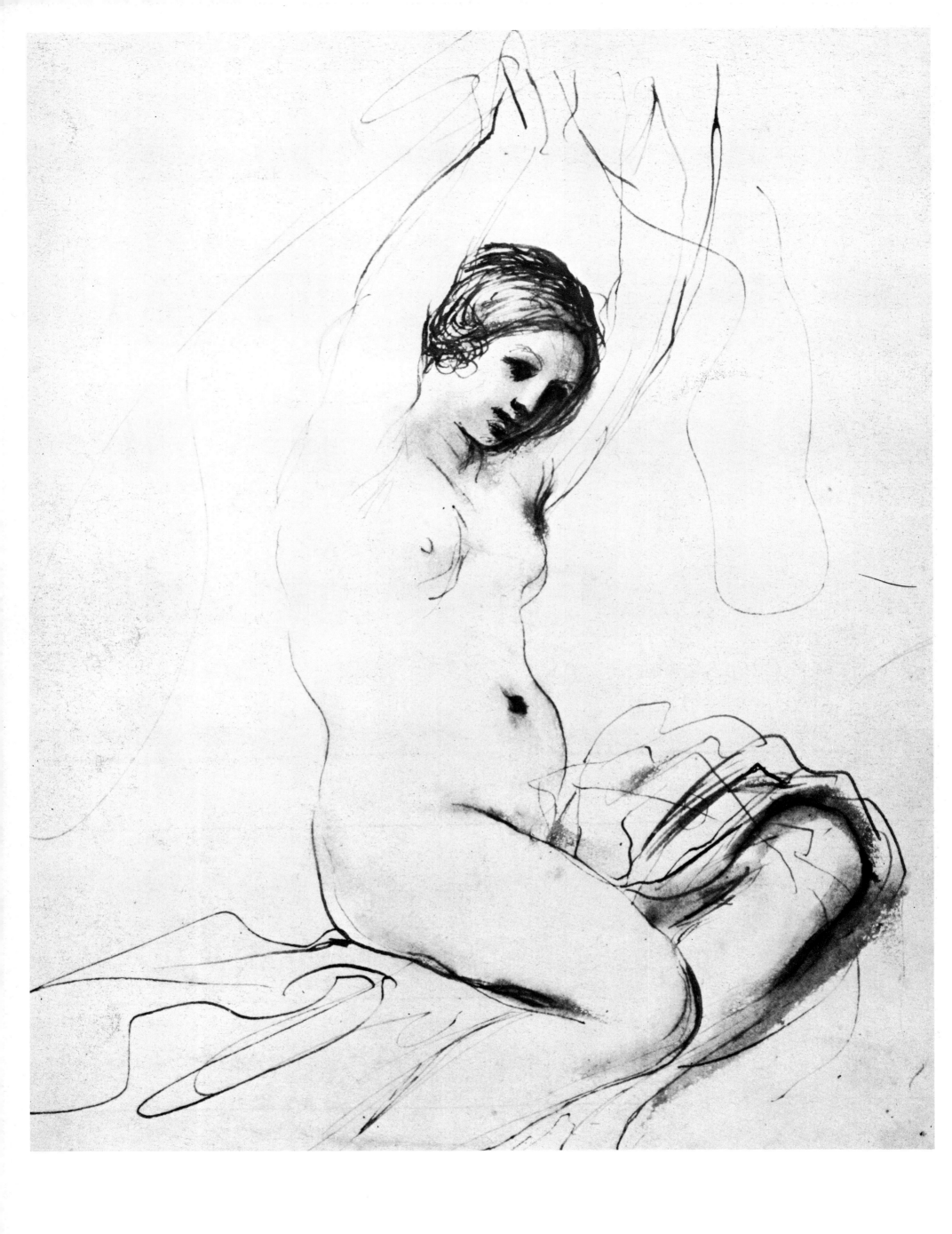

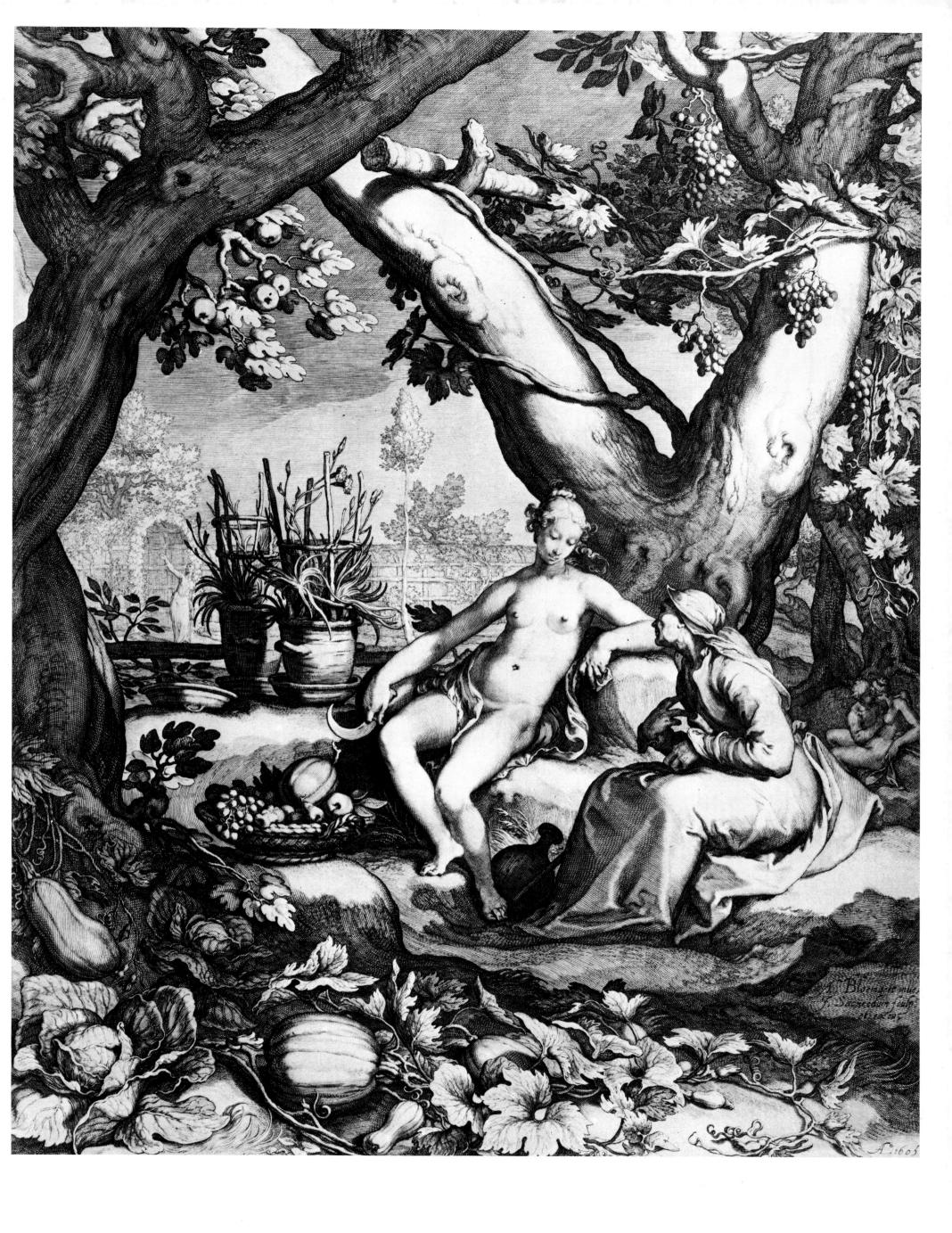

31

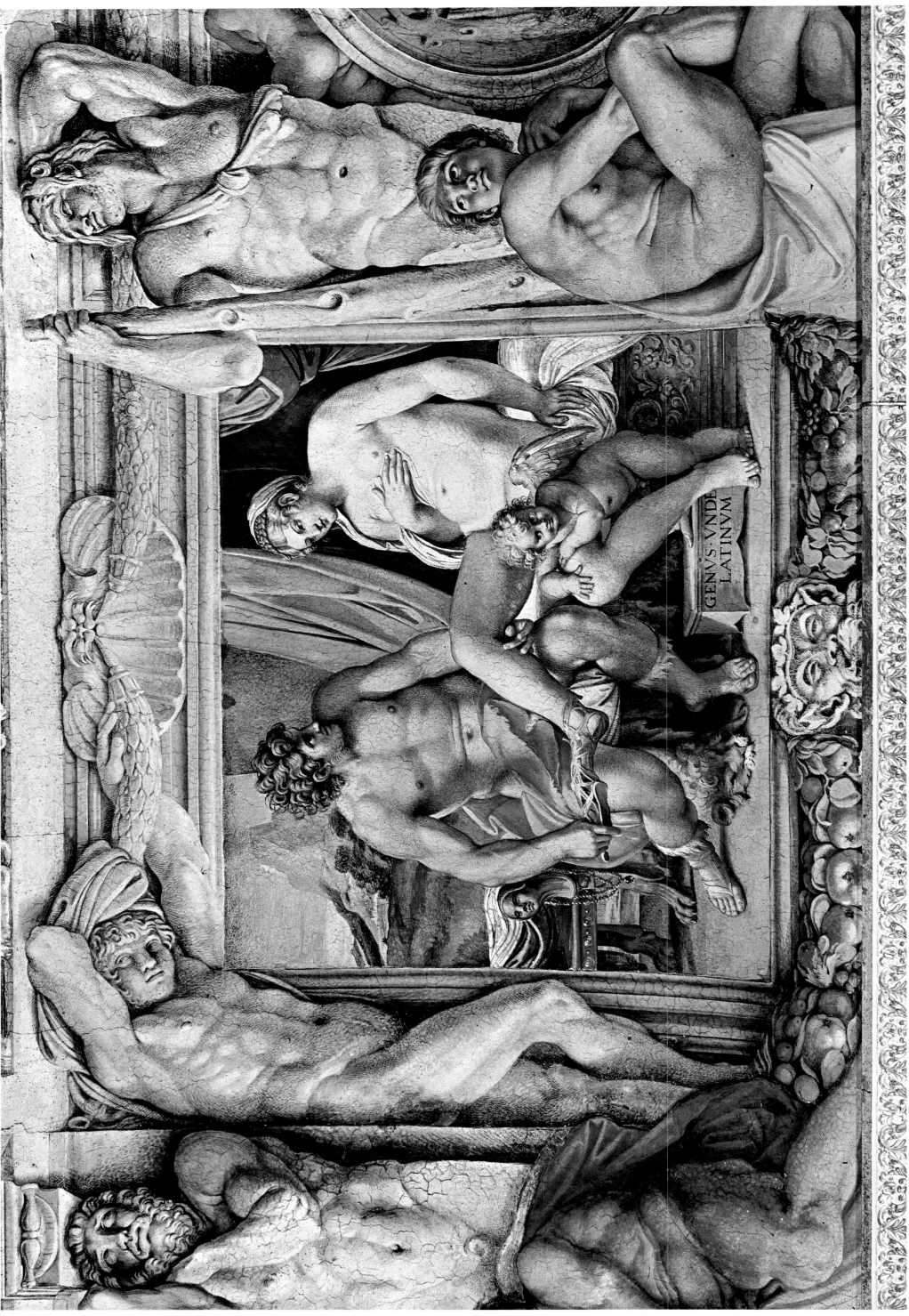

32

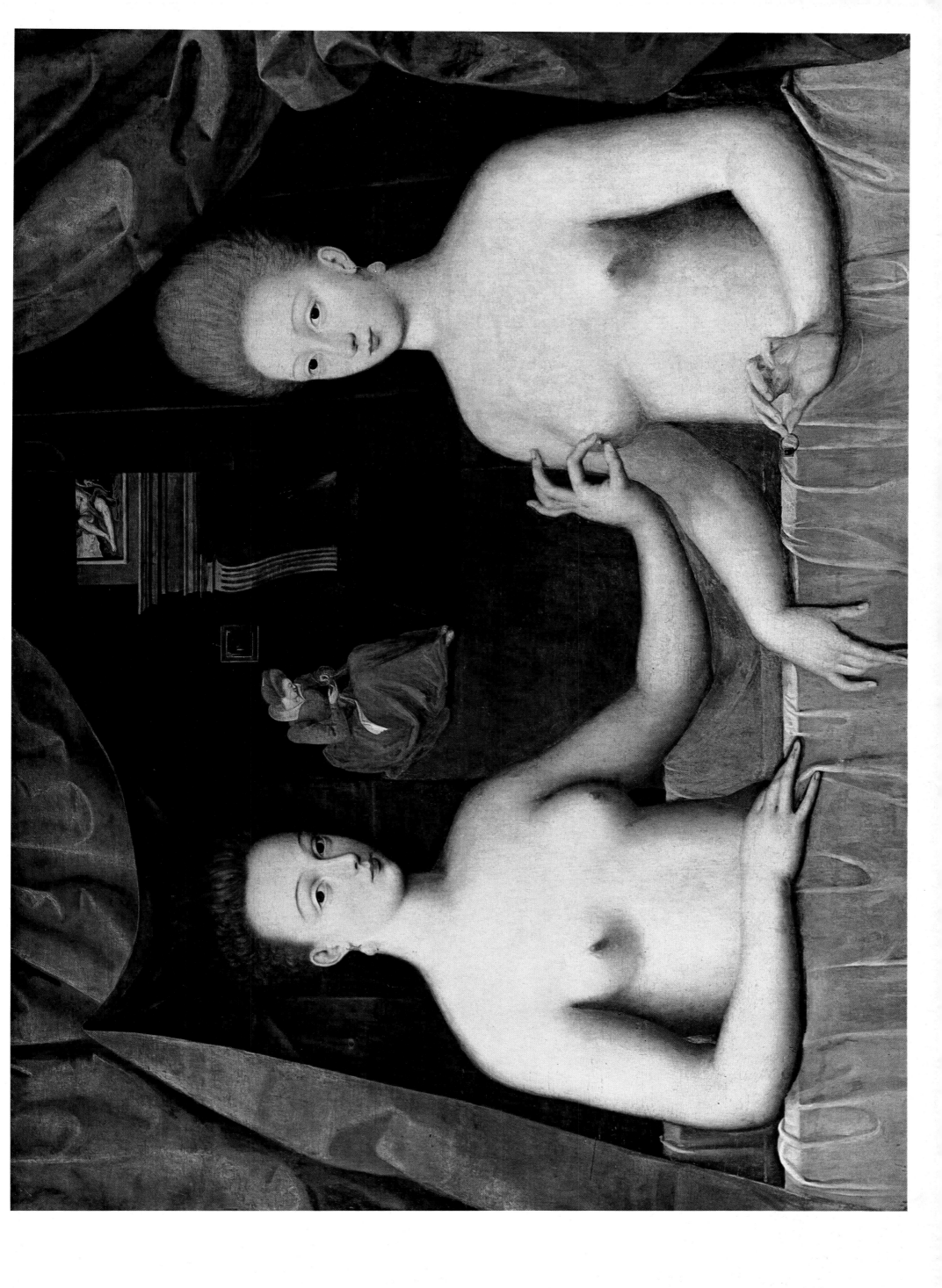

33

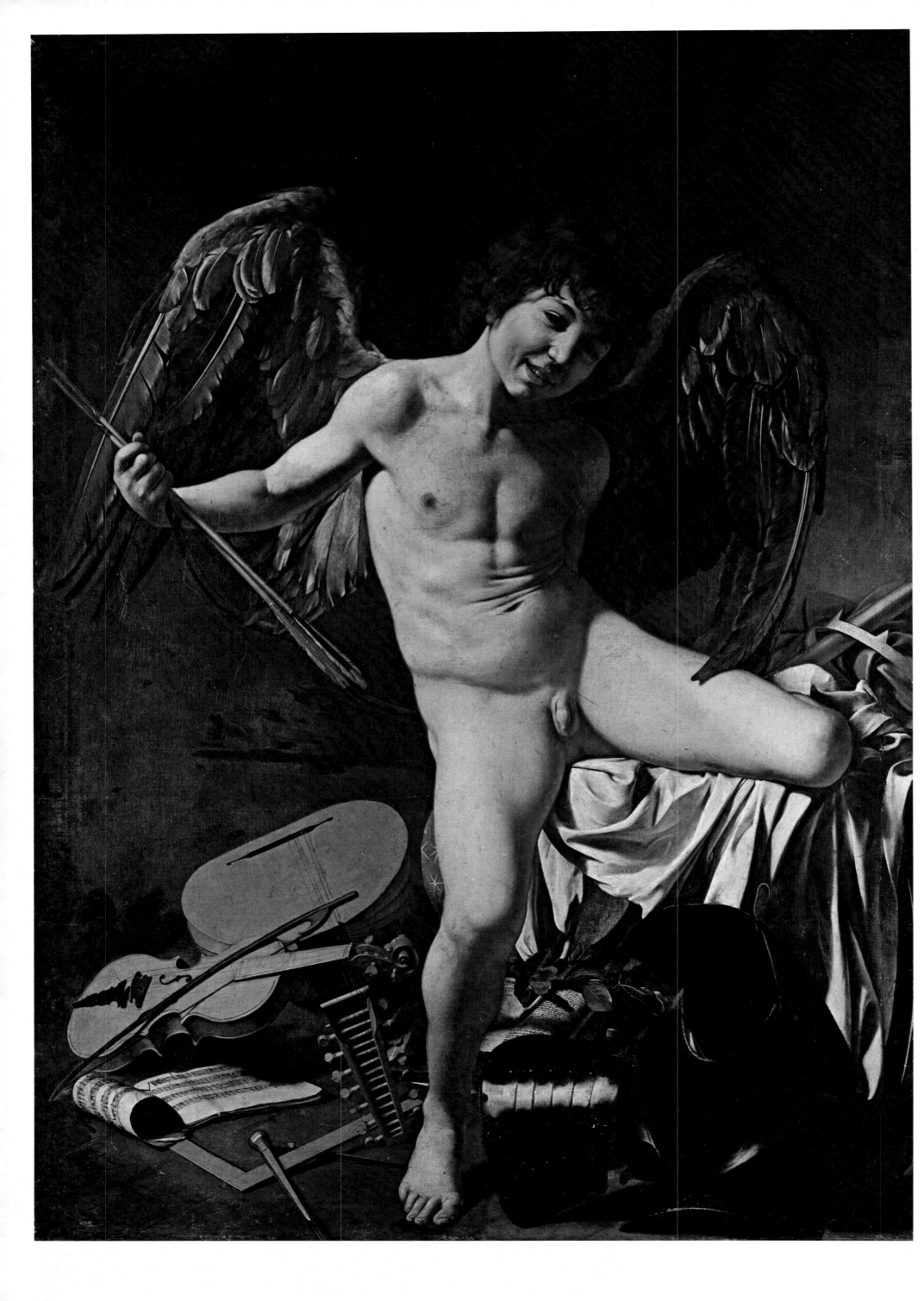

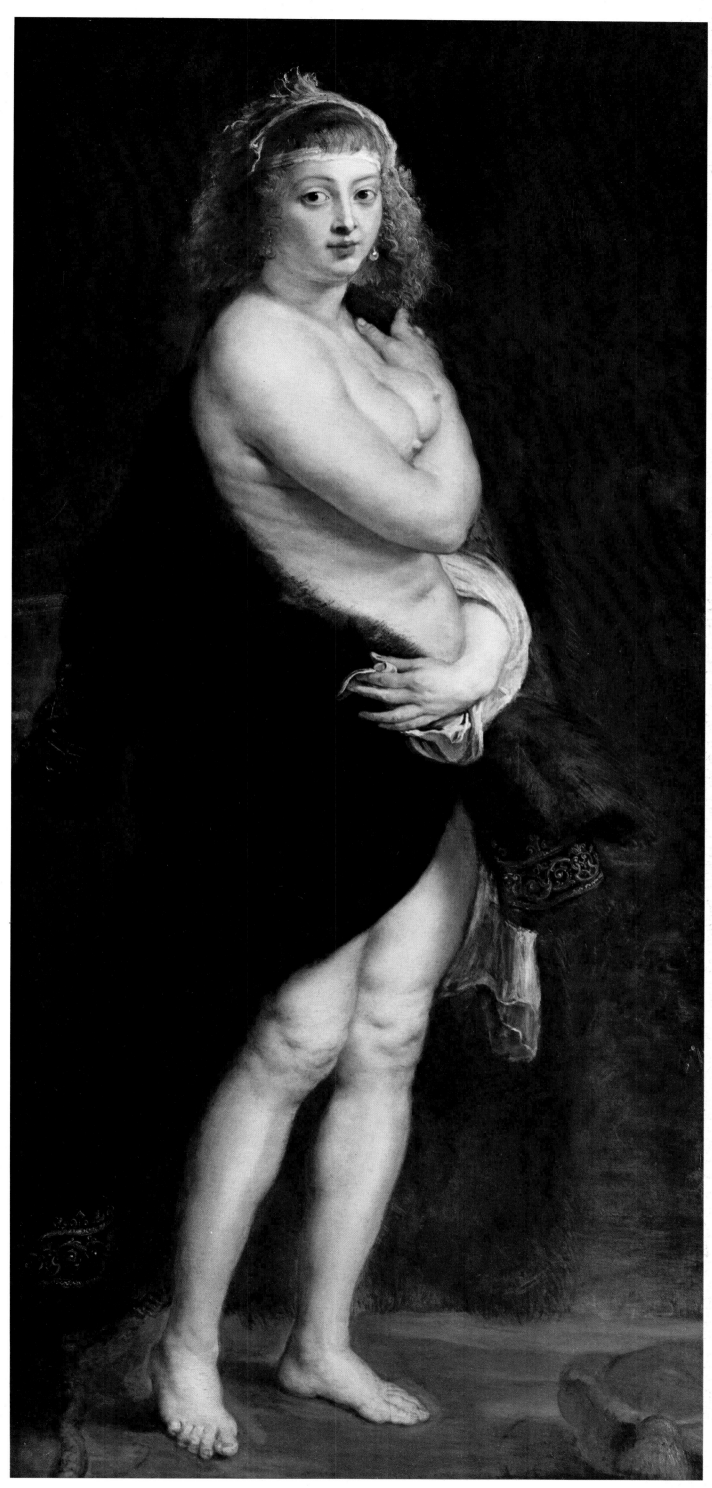

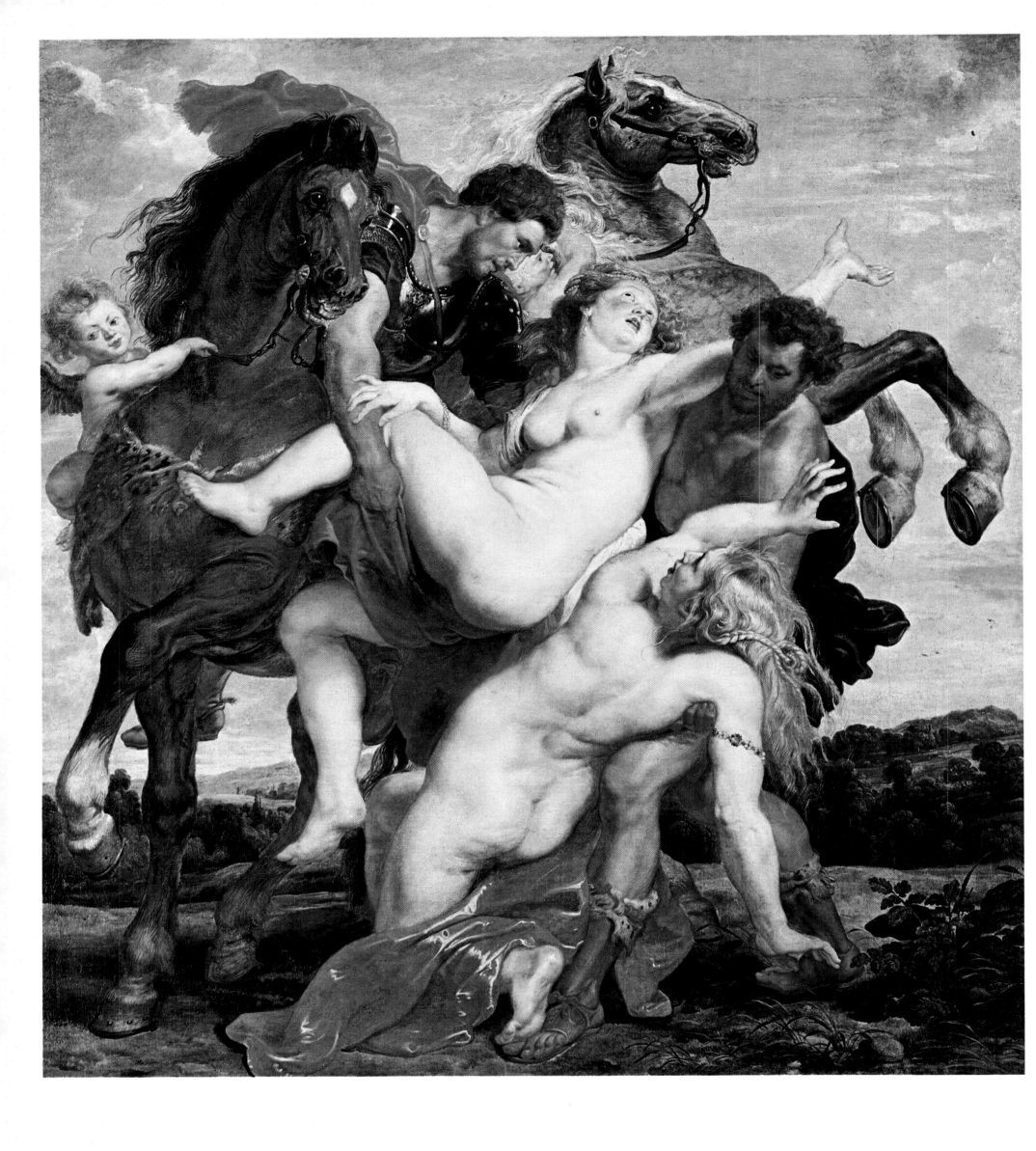

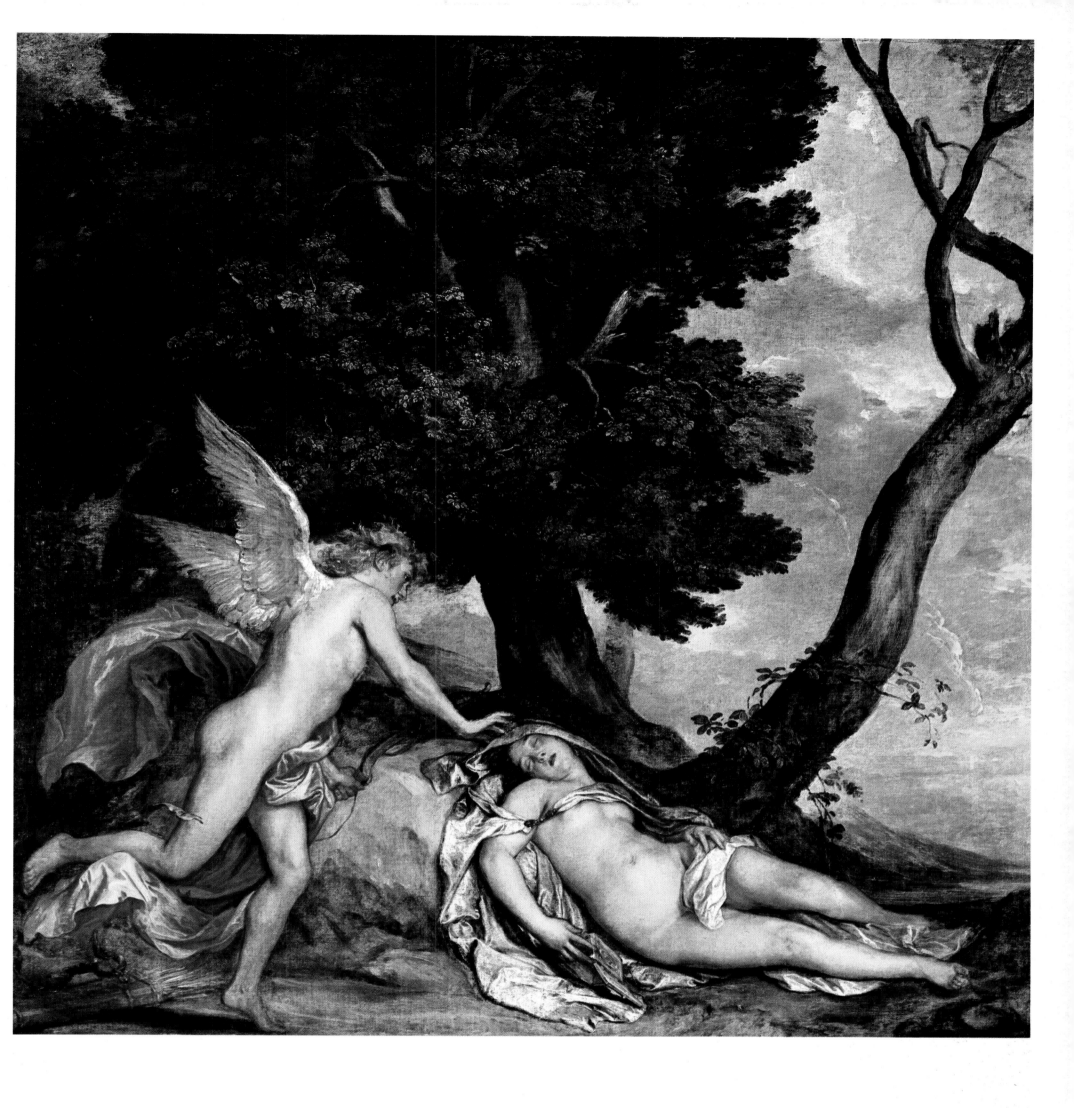

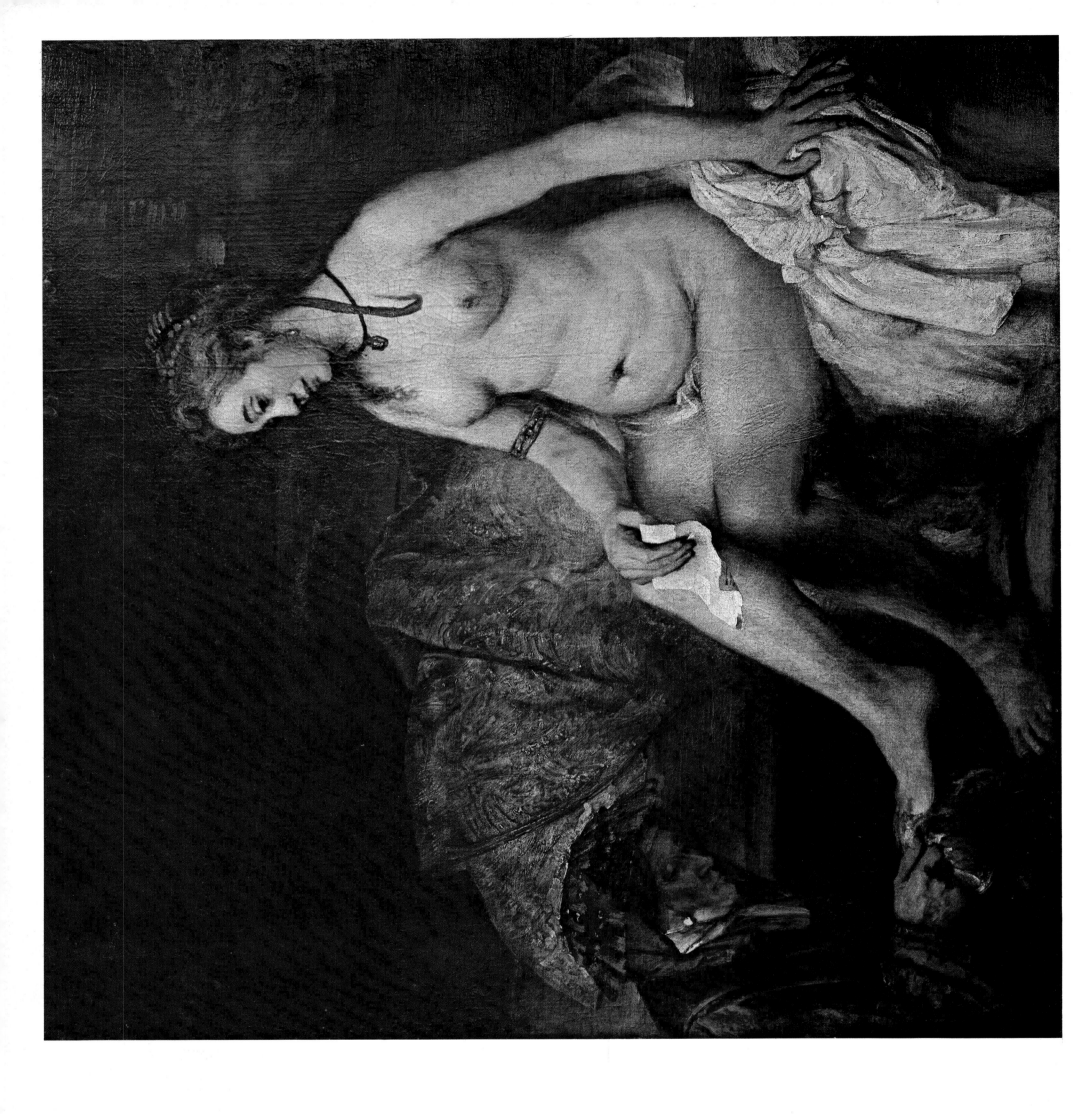

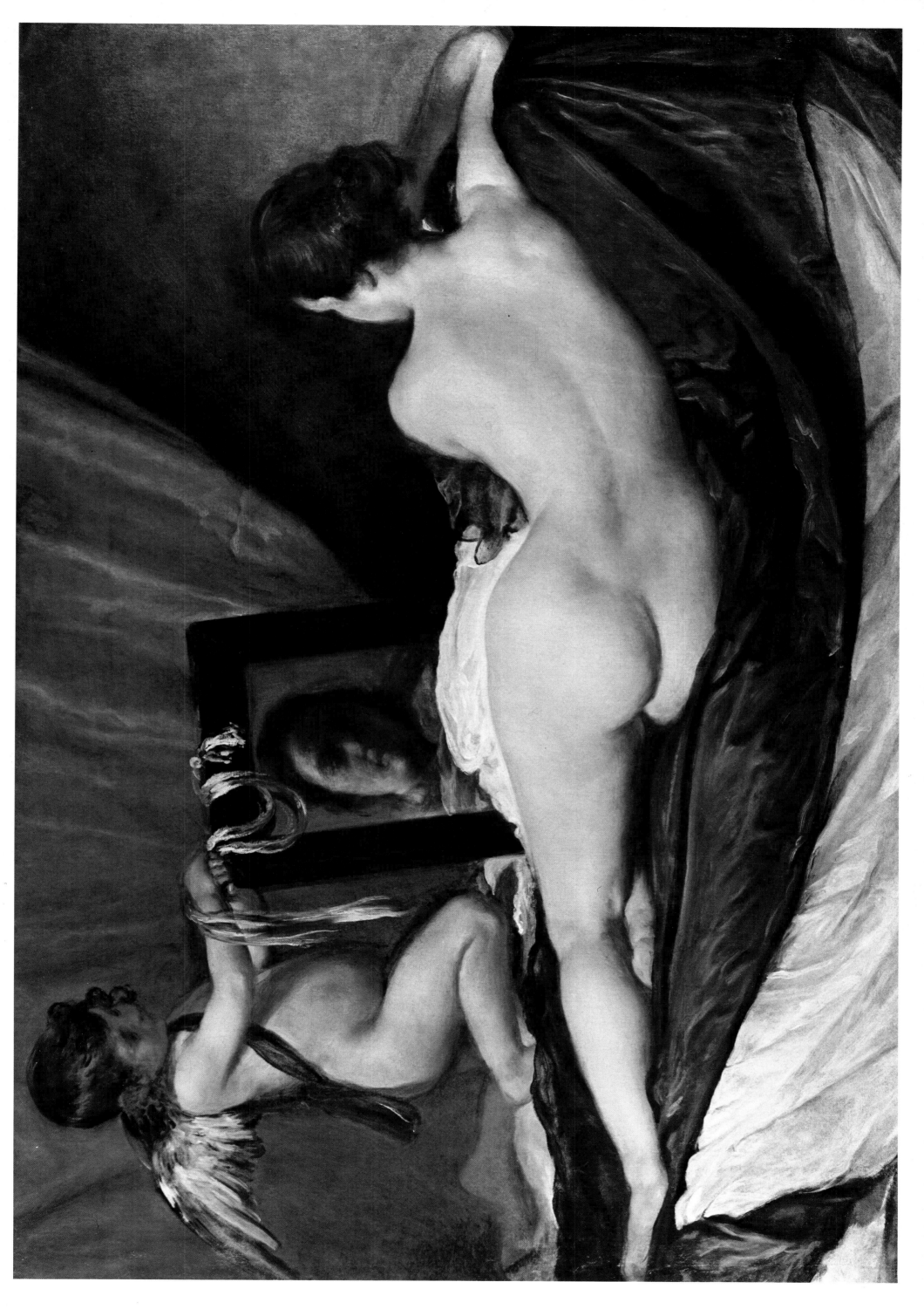

39

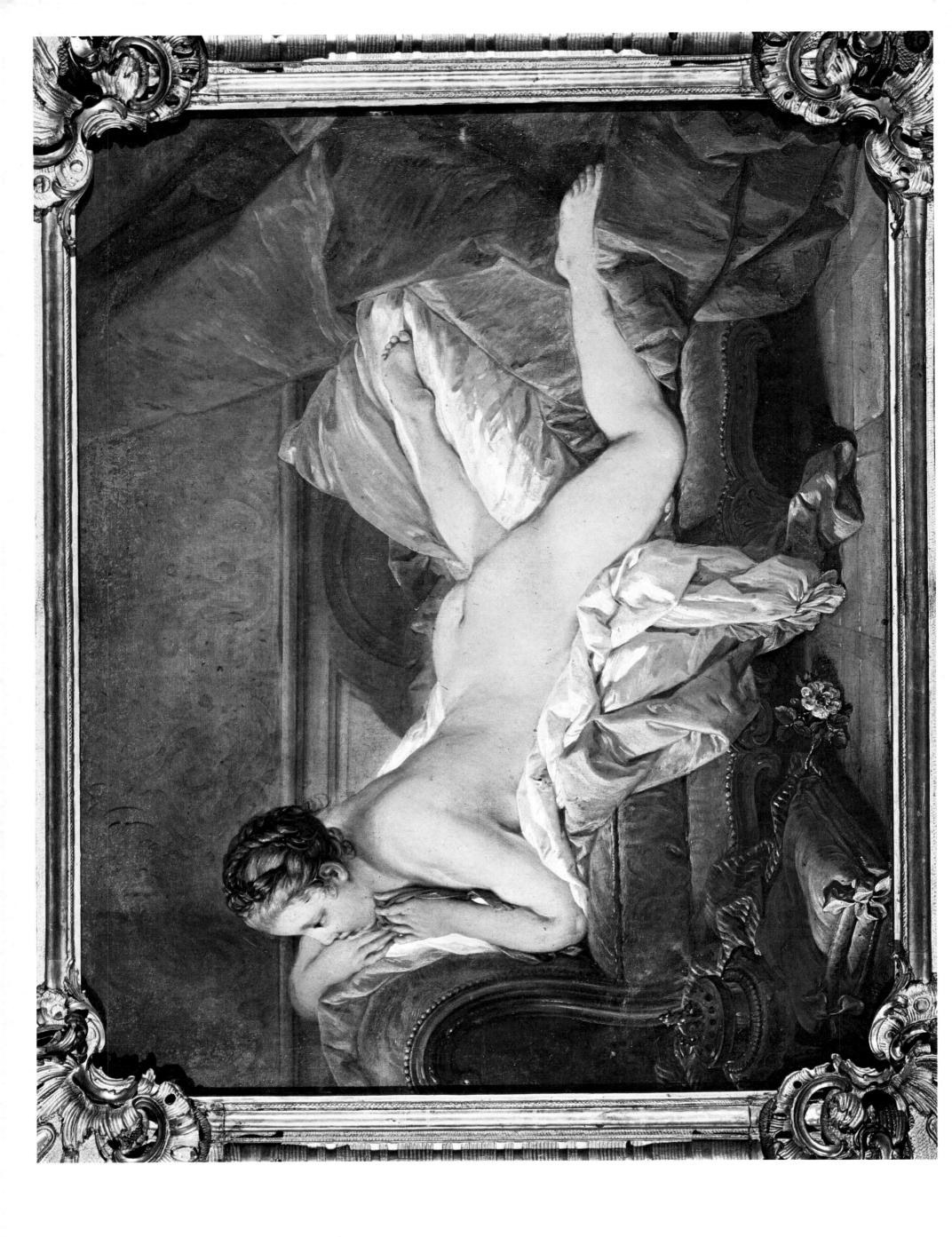

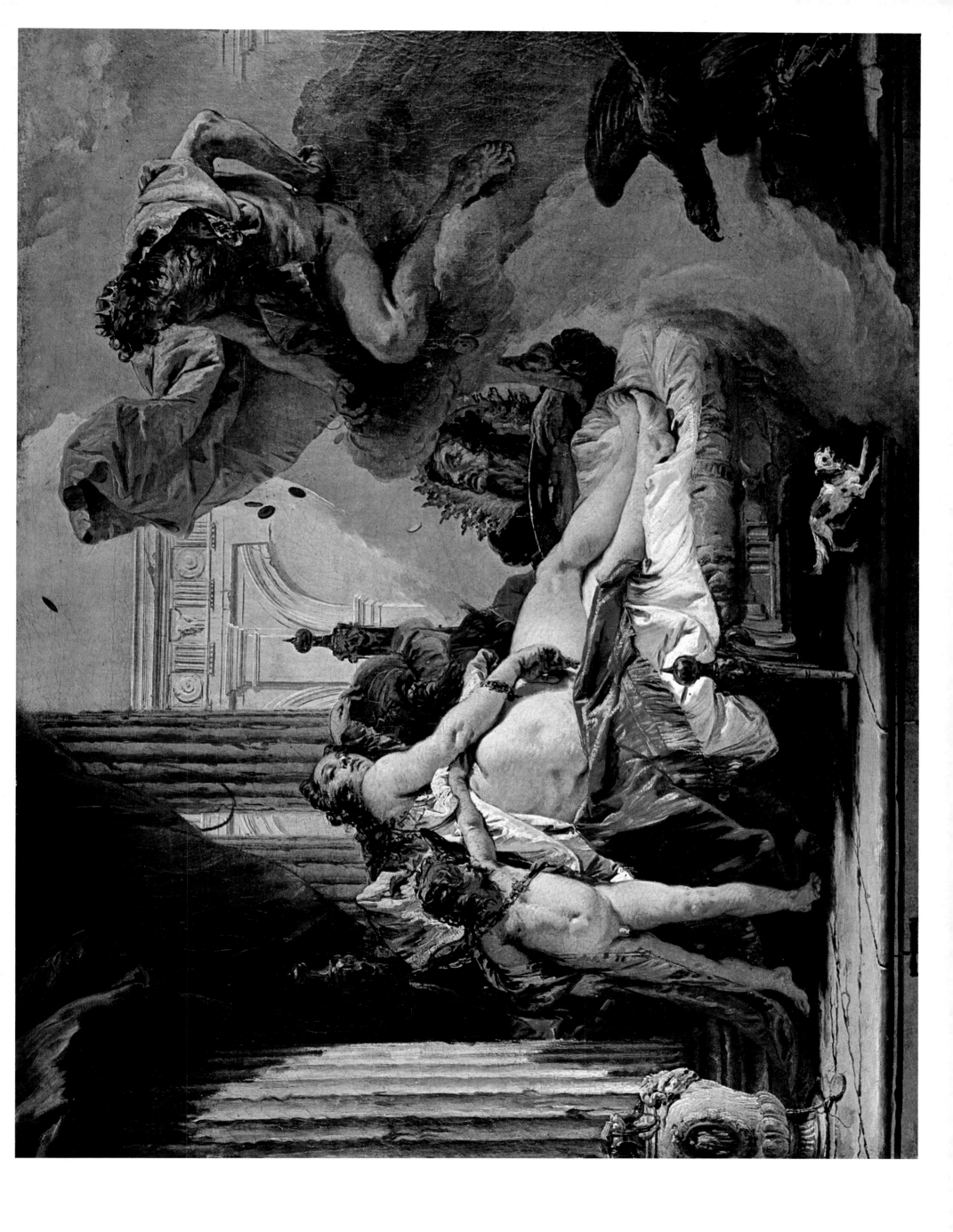

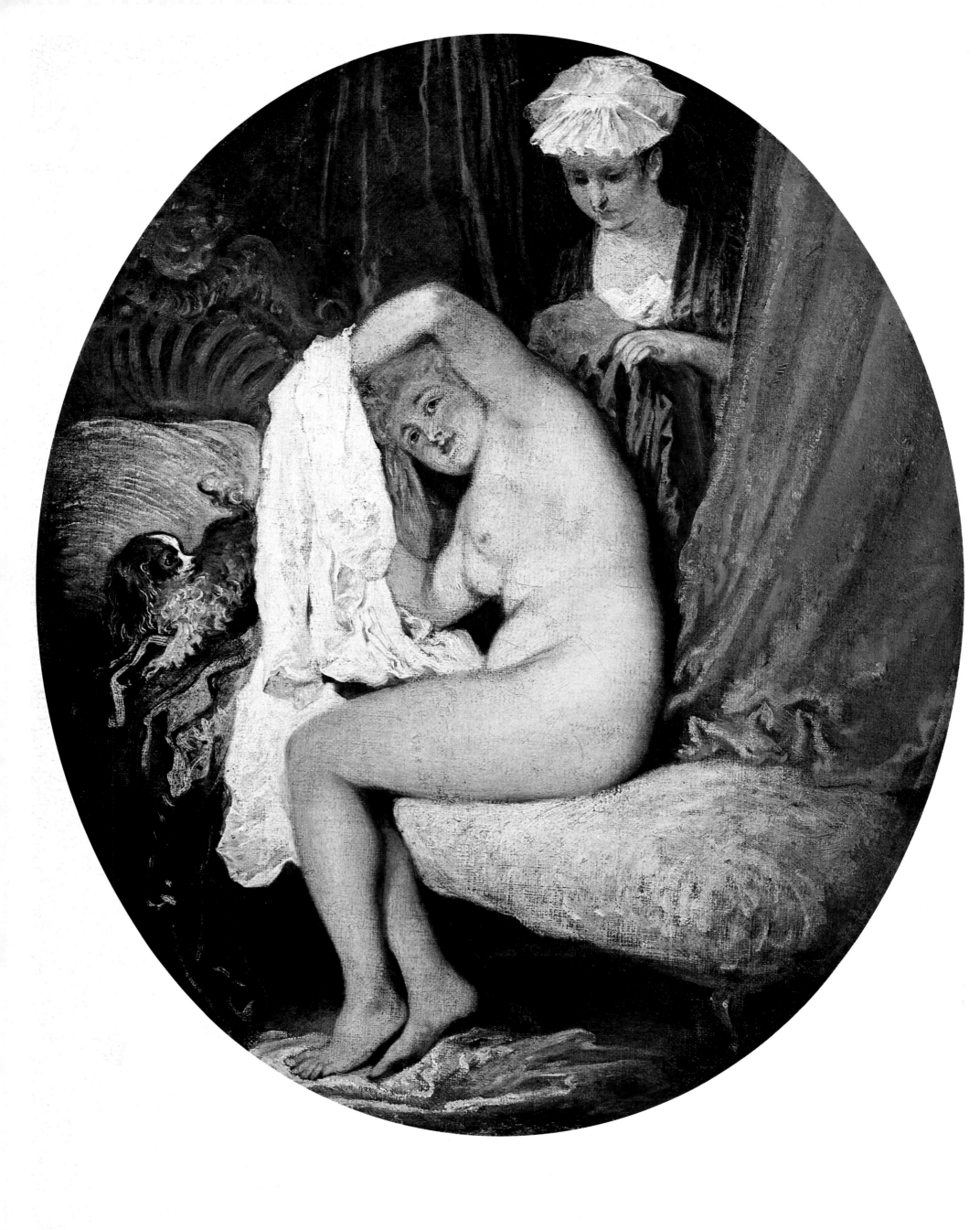

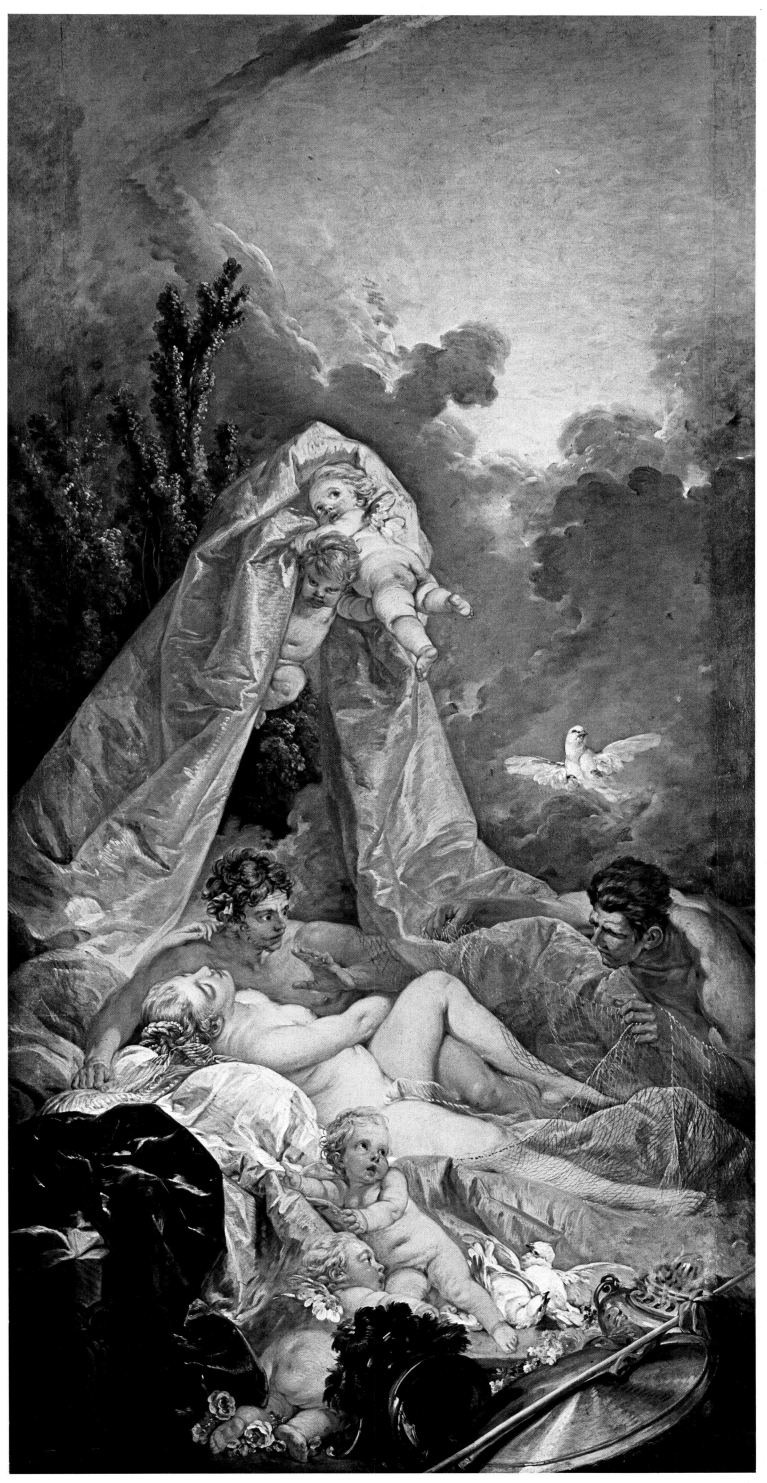

43

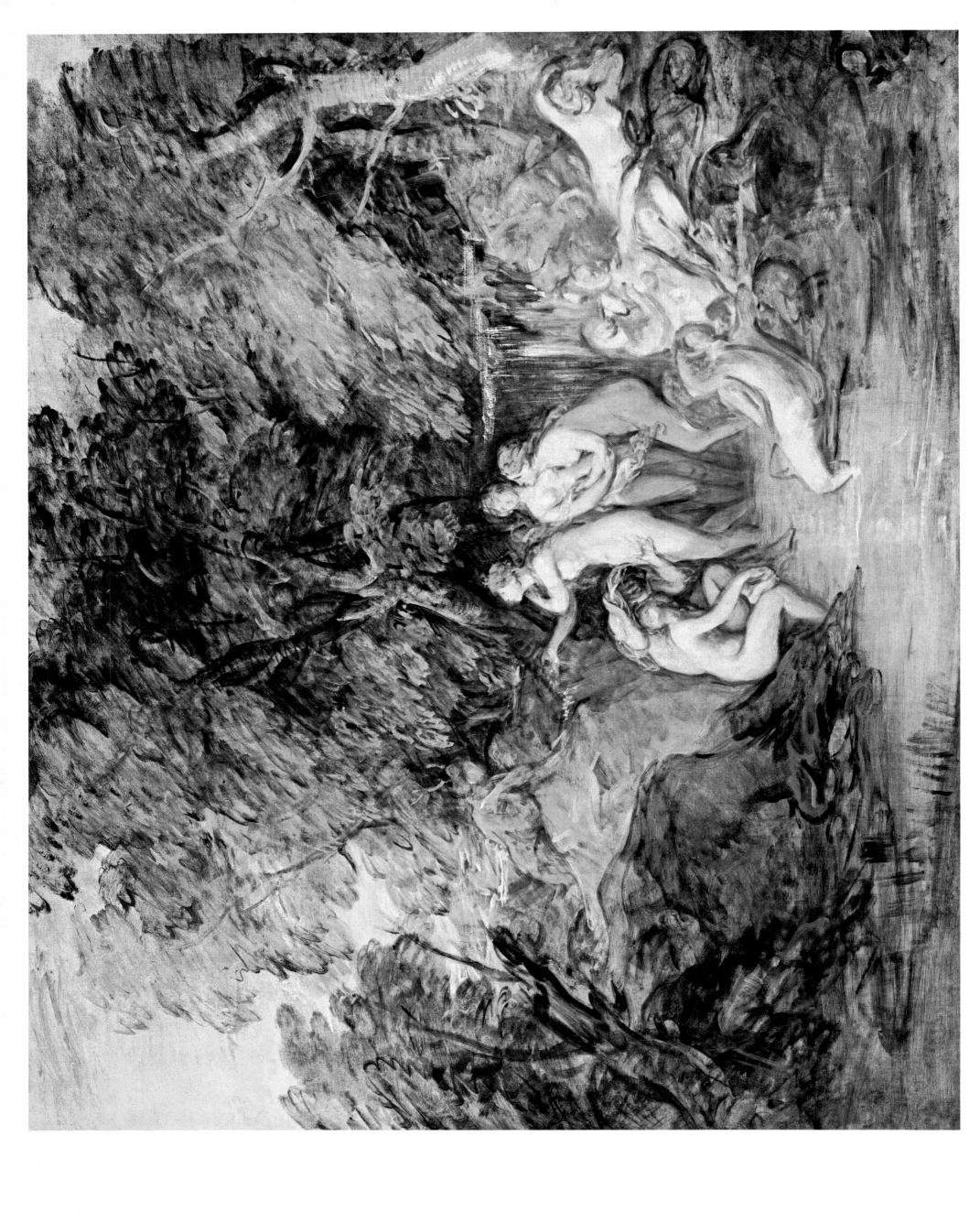

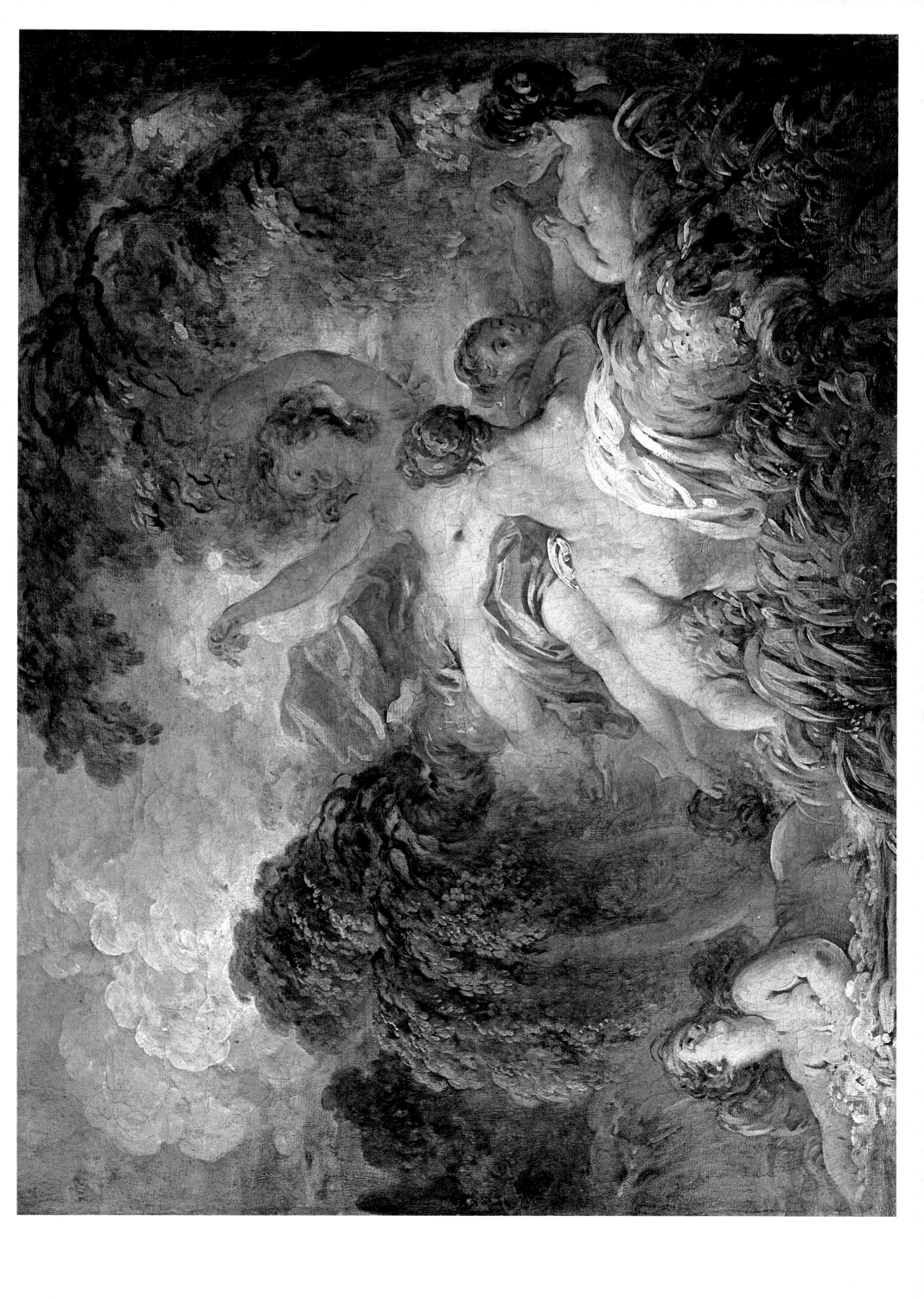

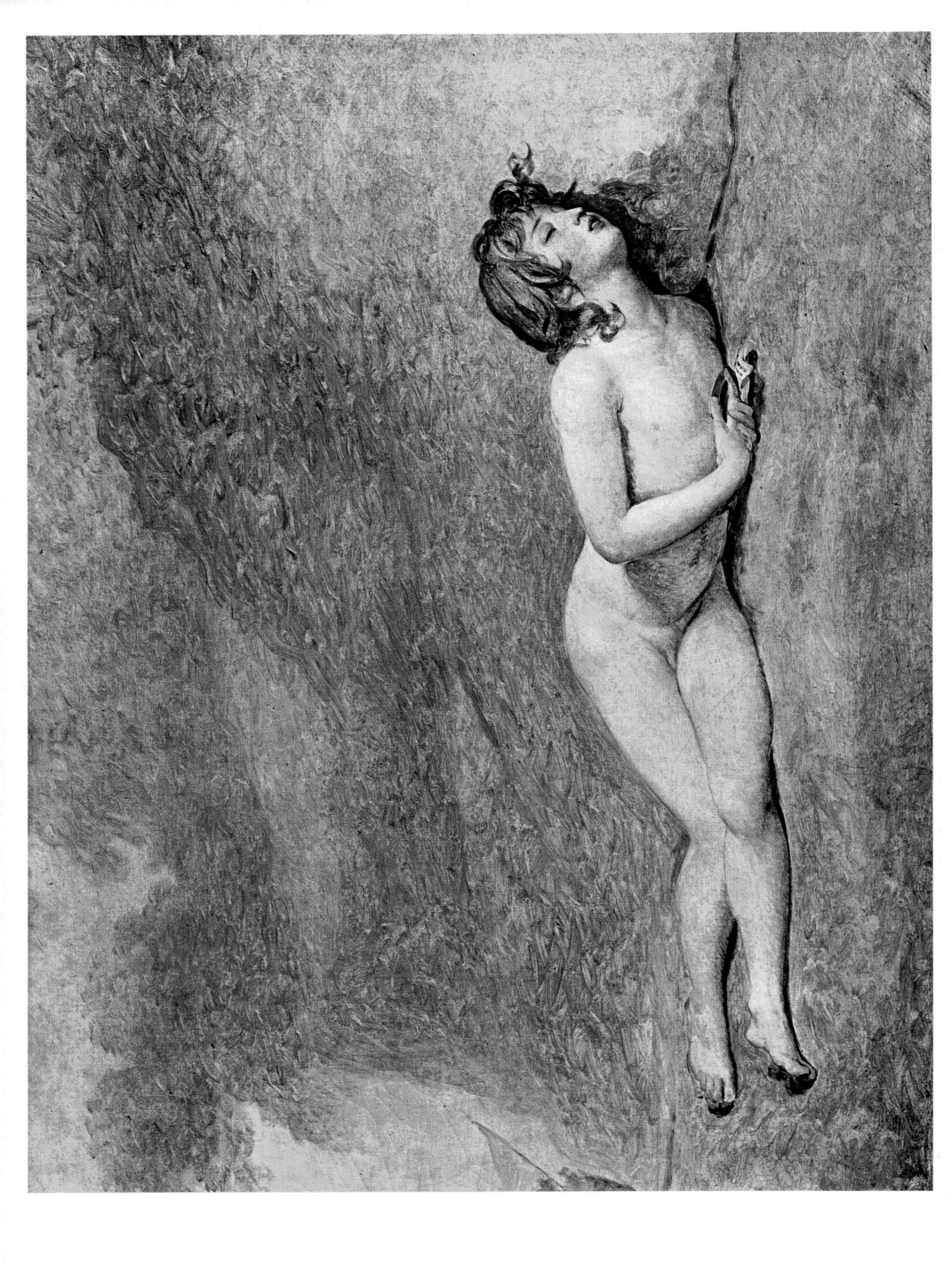

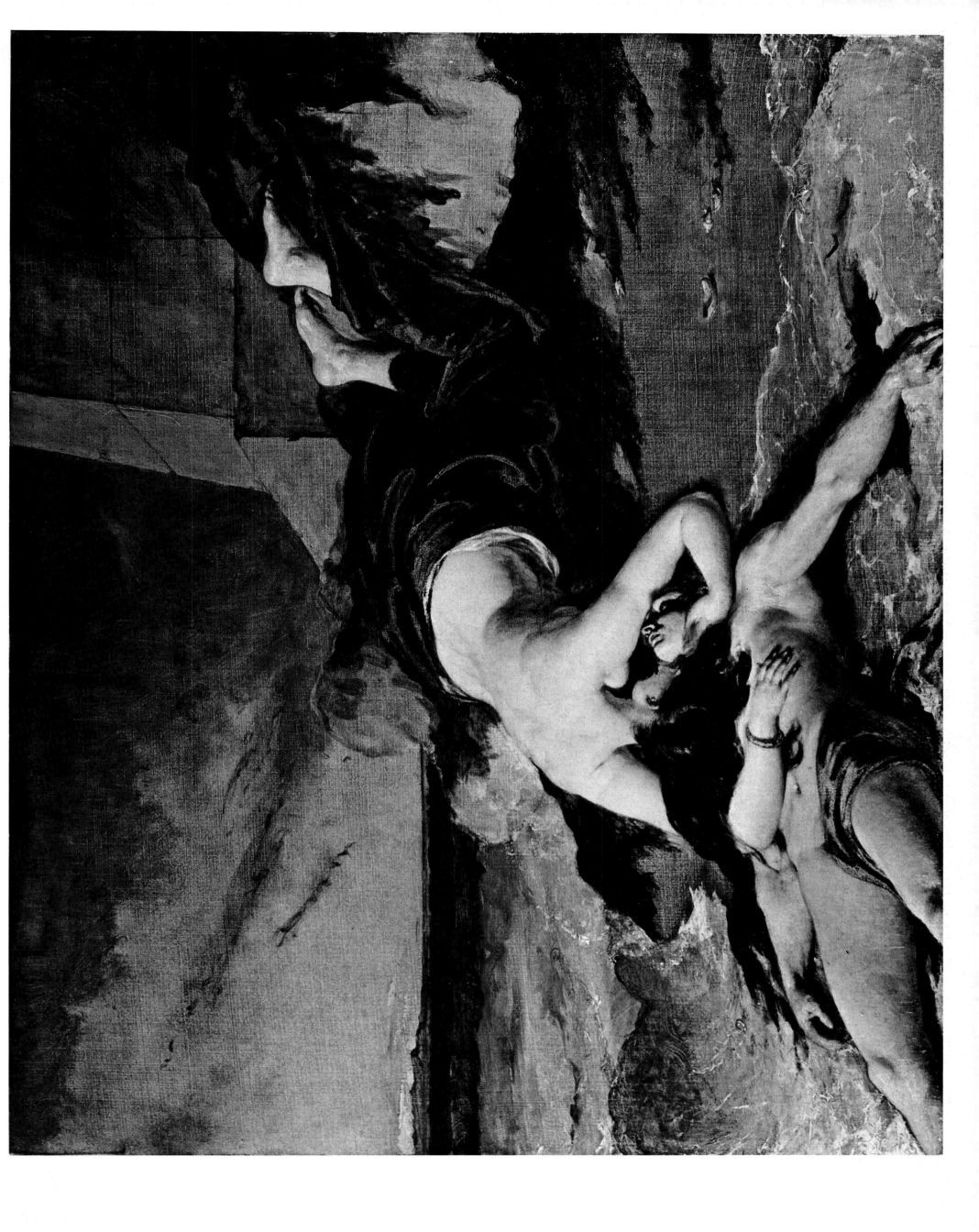

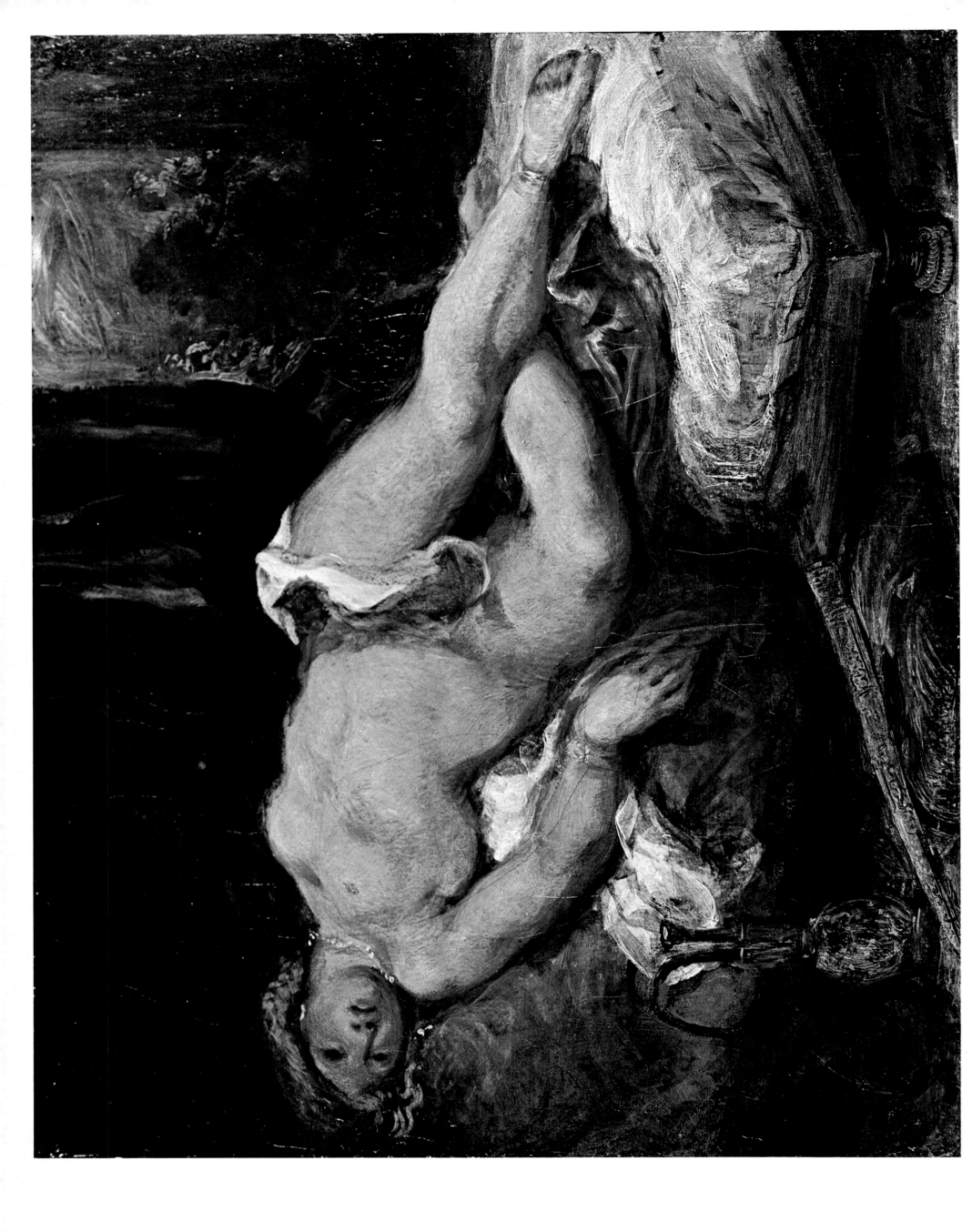

48

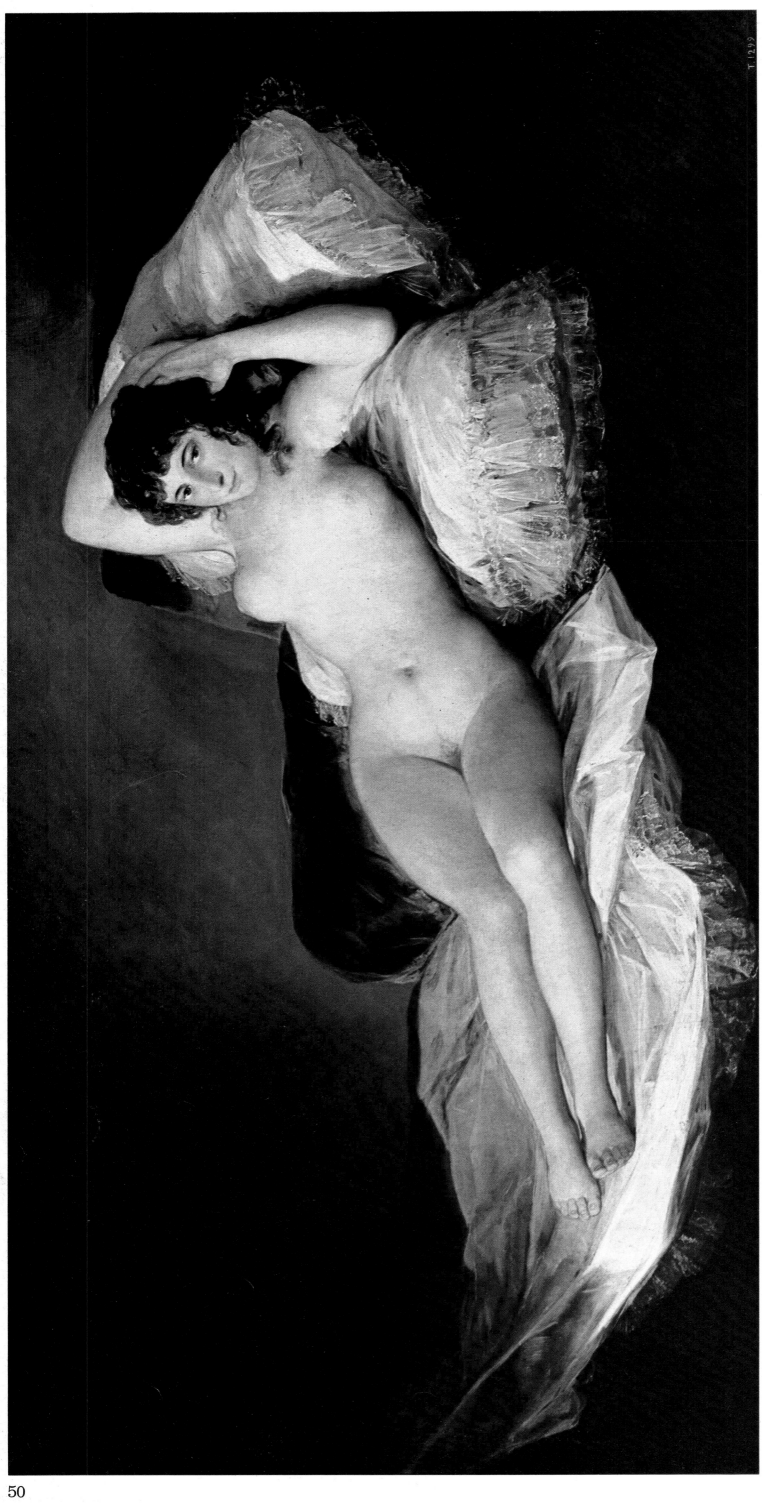

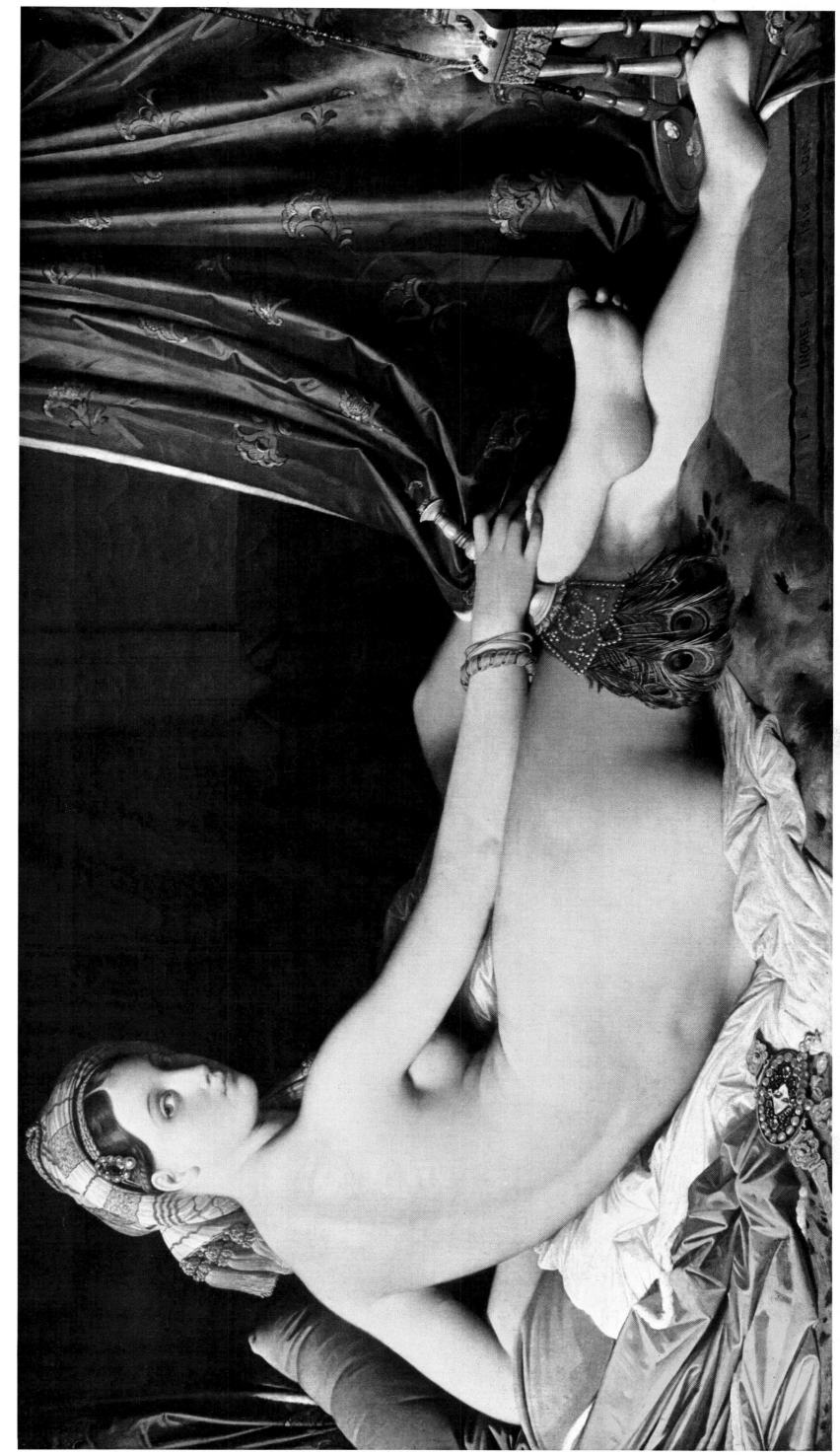

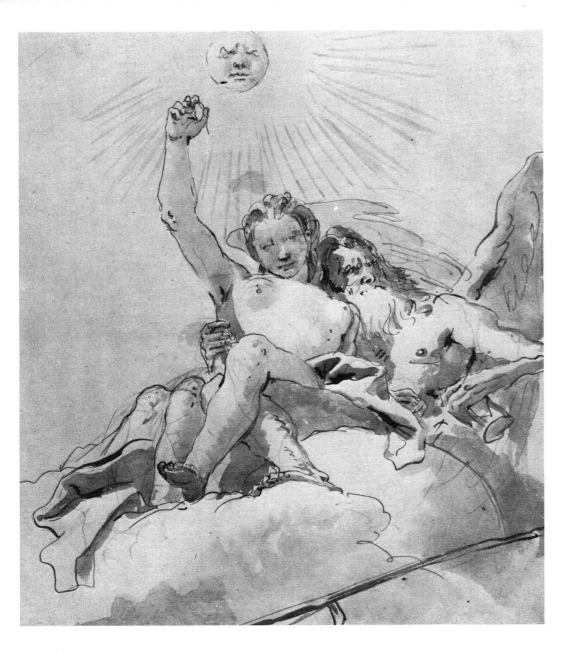

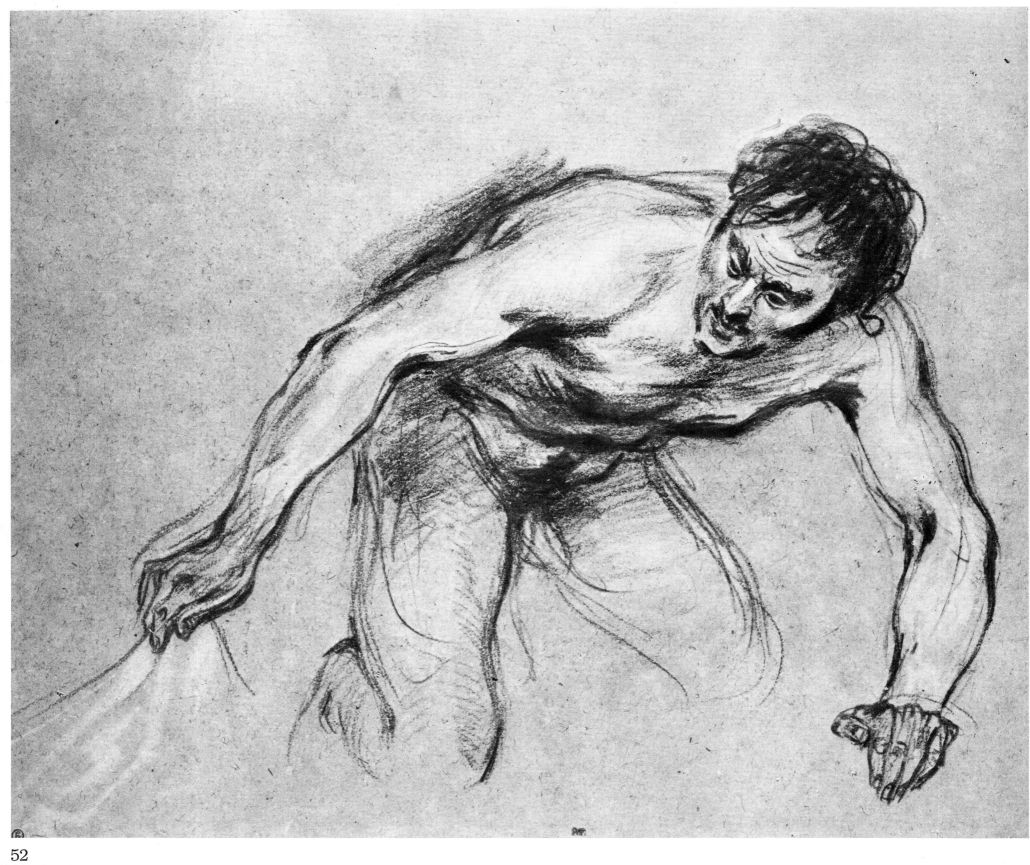

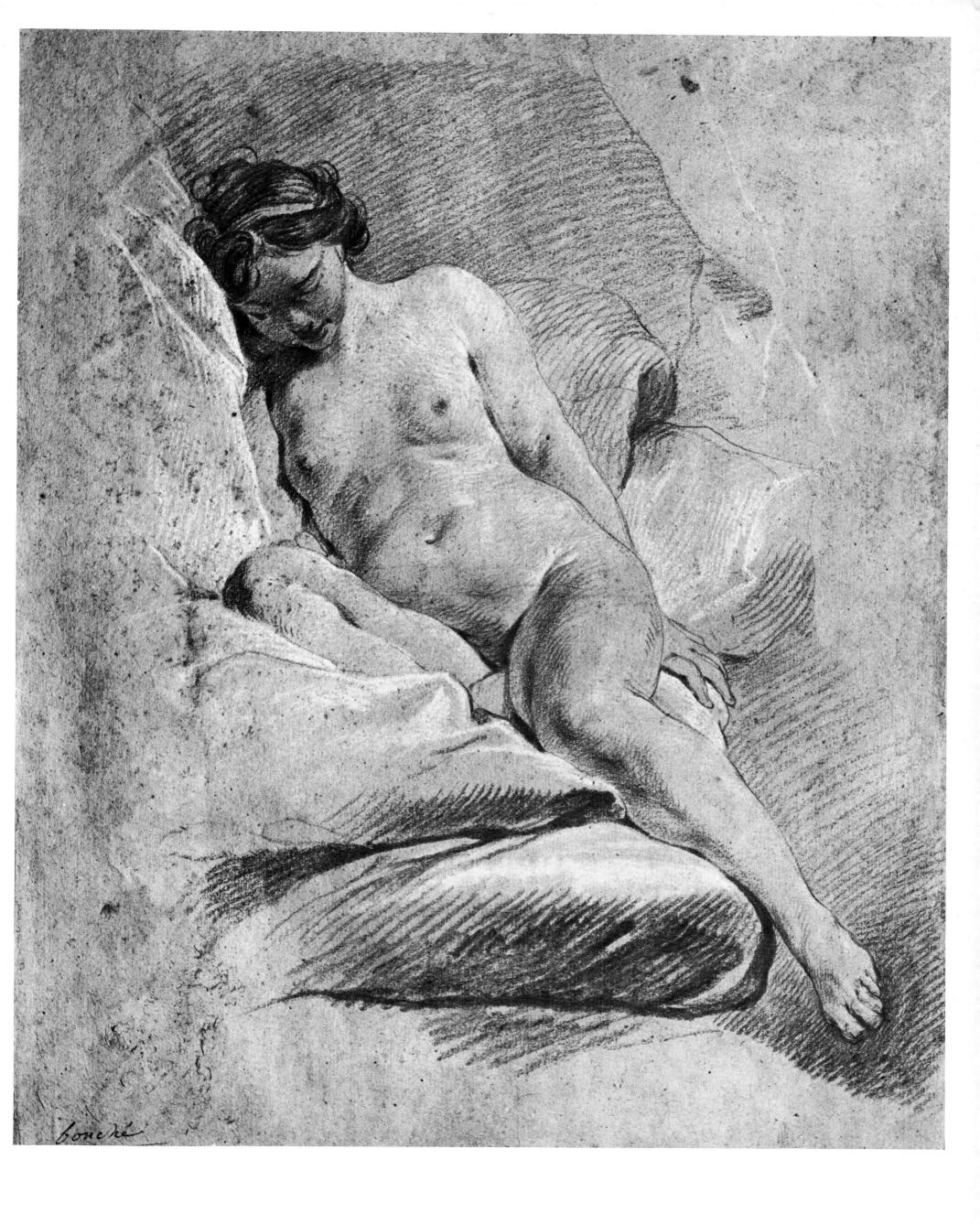

53

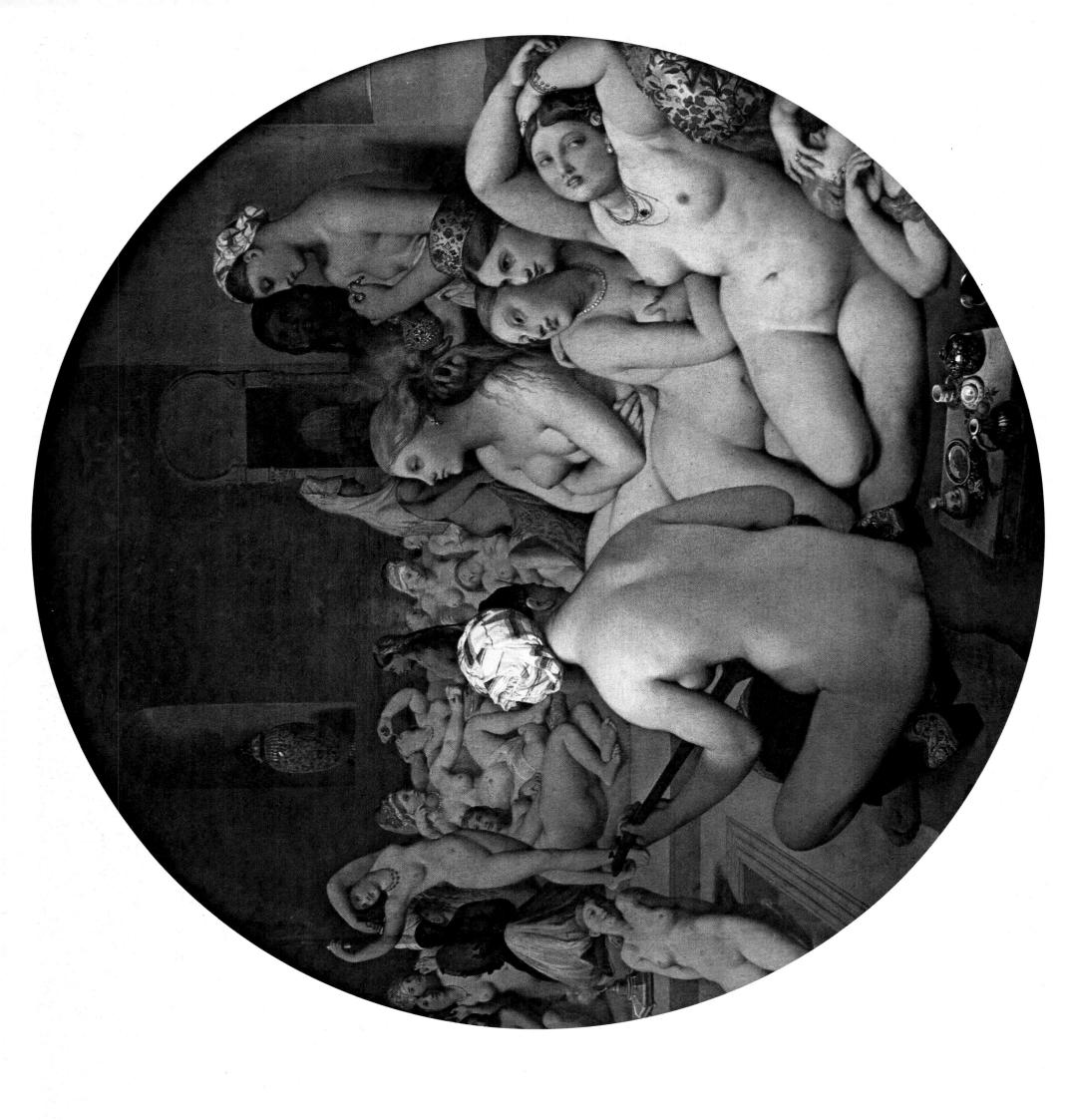

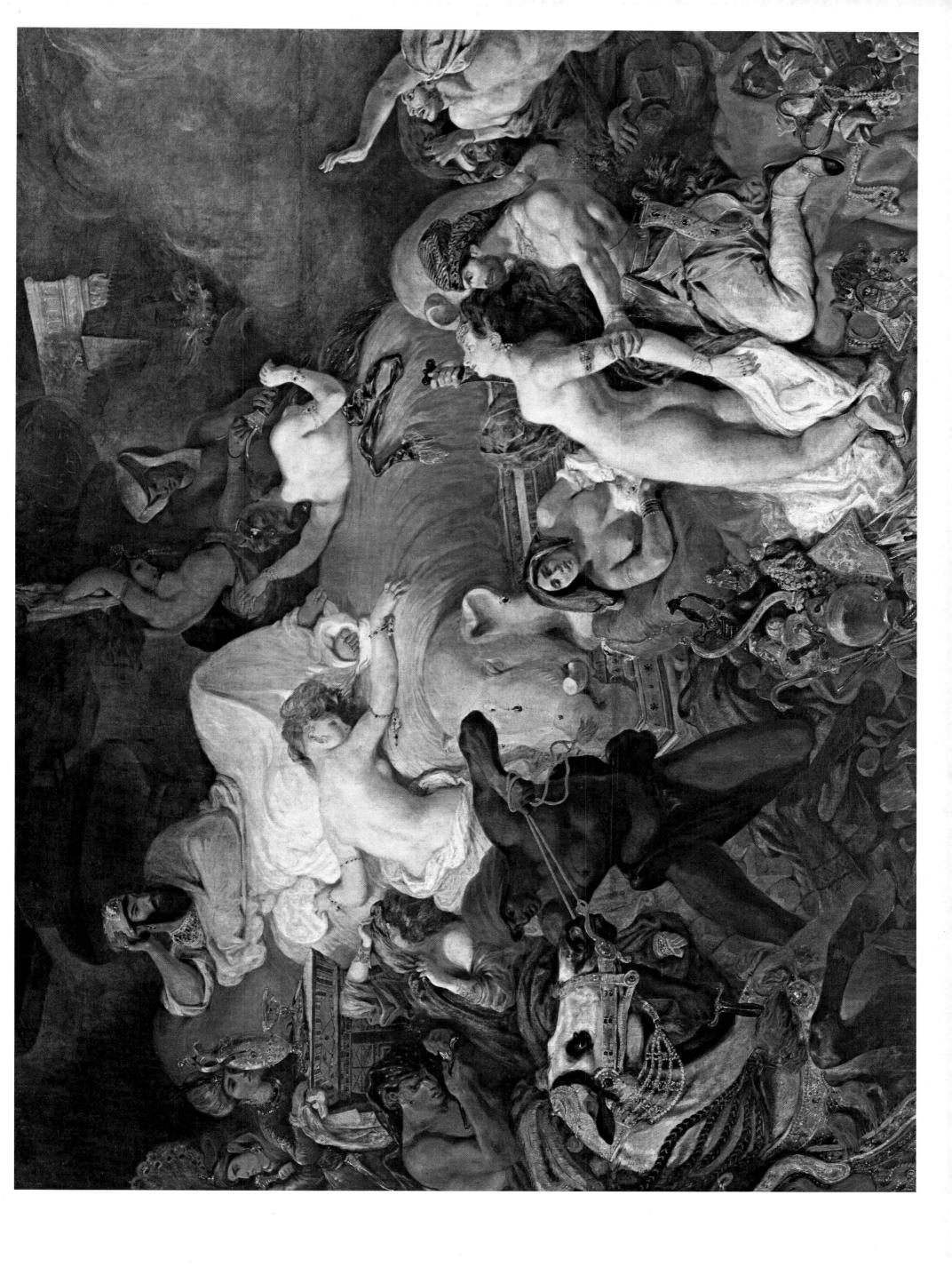

COLLECTION INGRES HARO

56

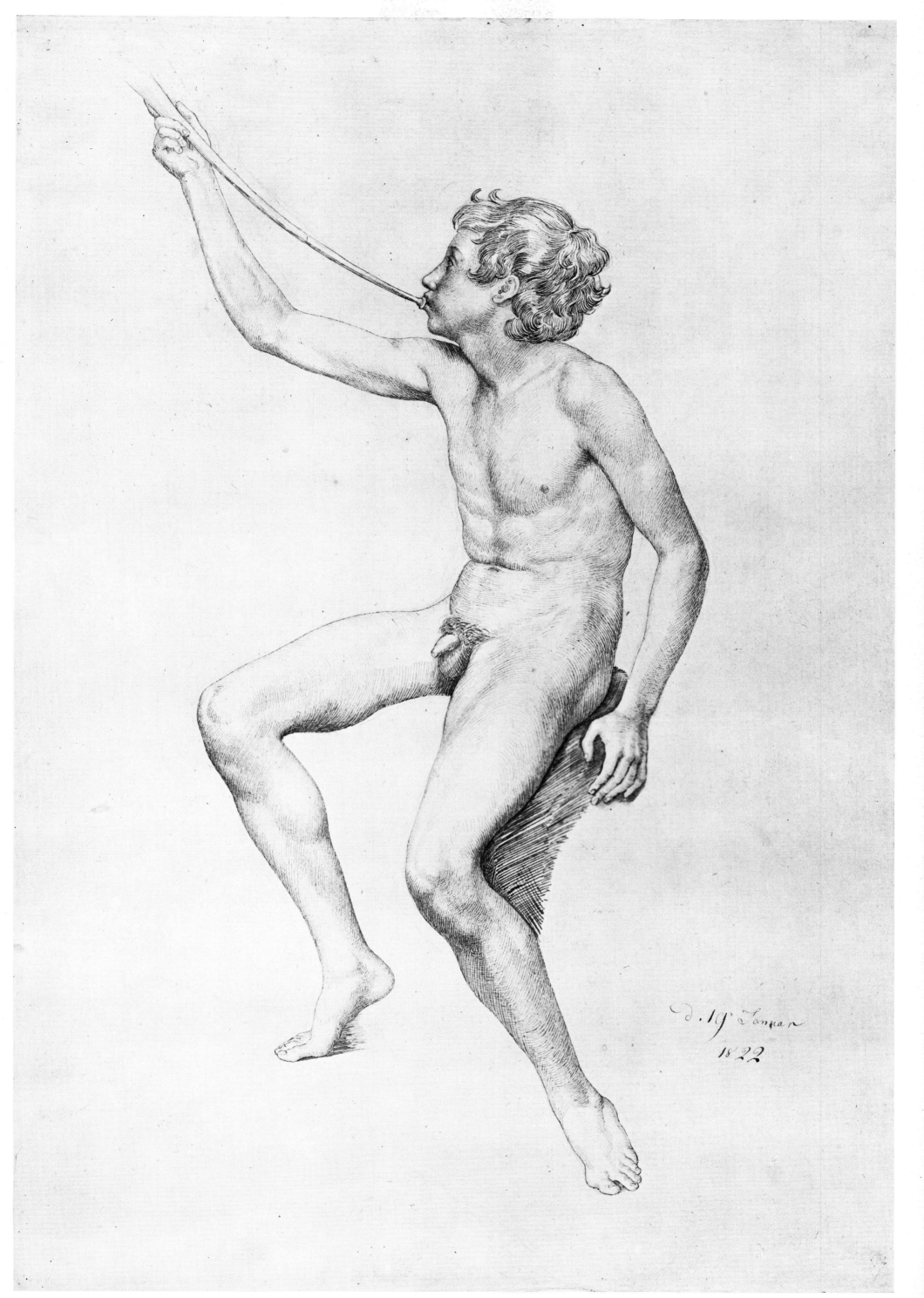

57

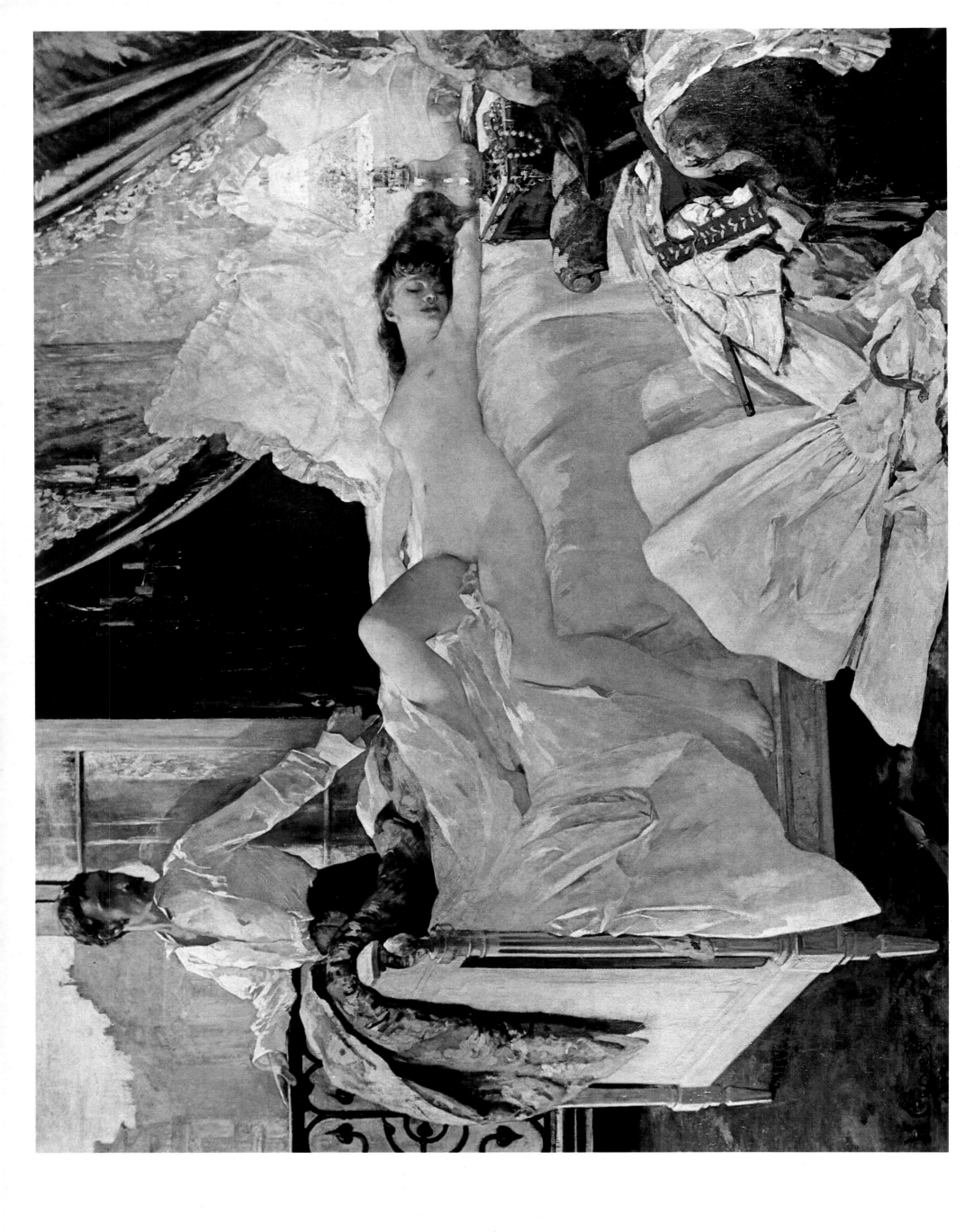

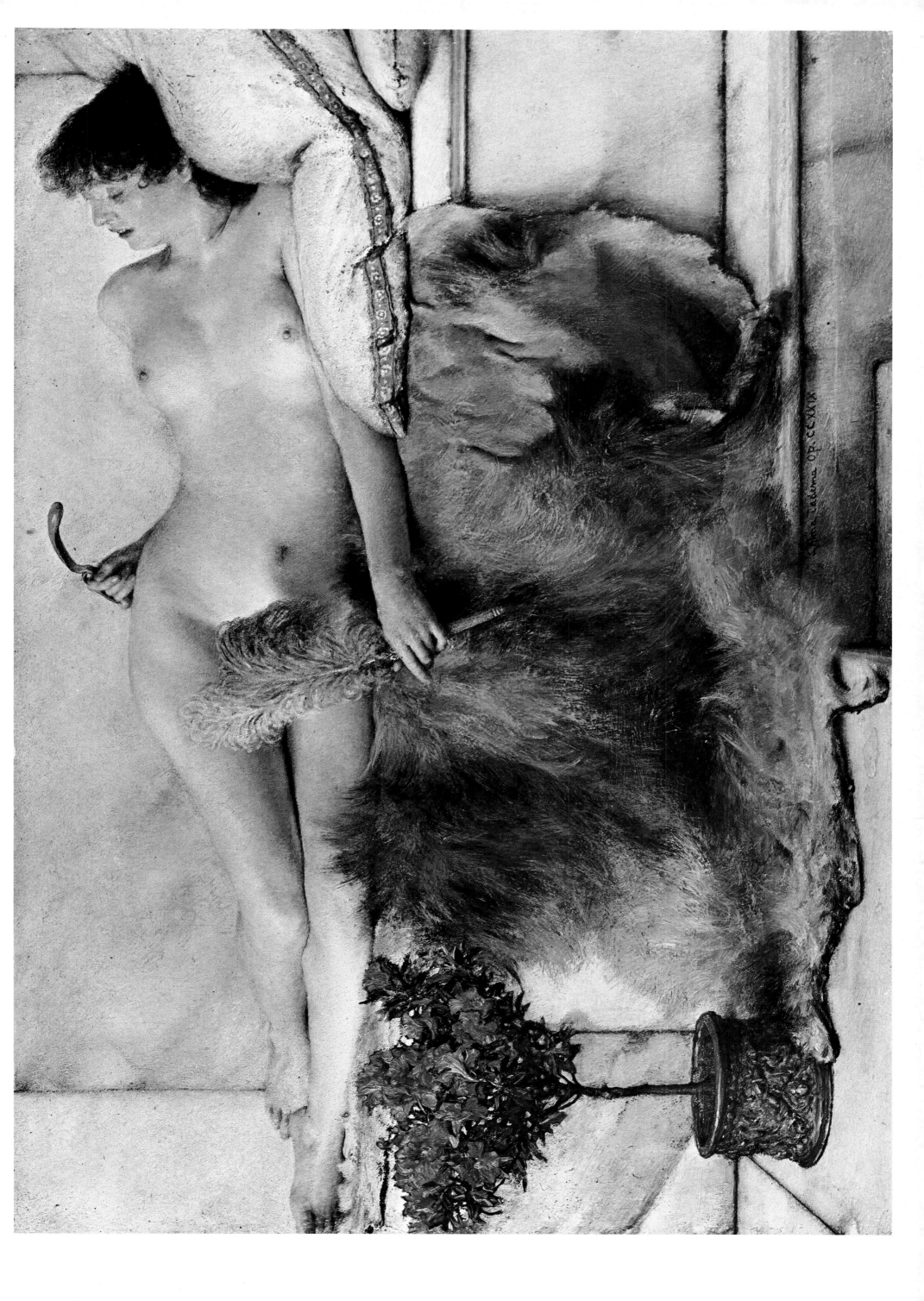

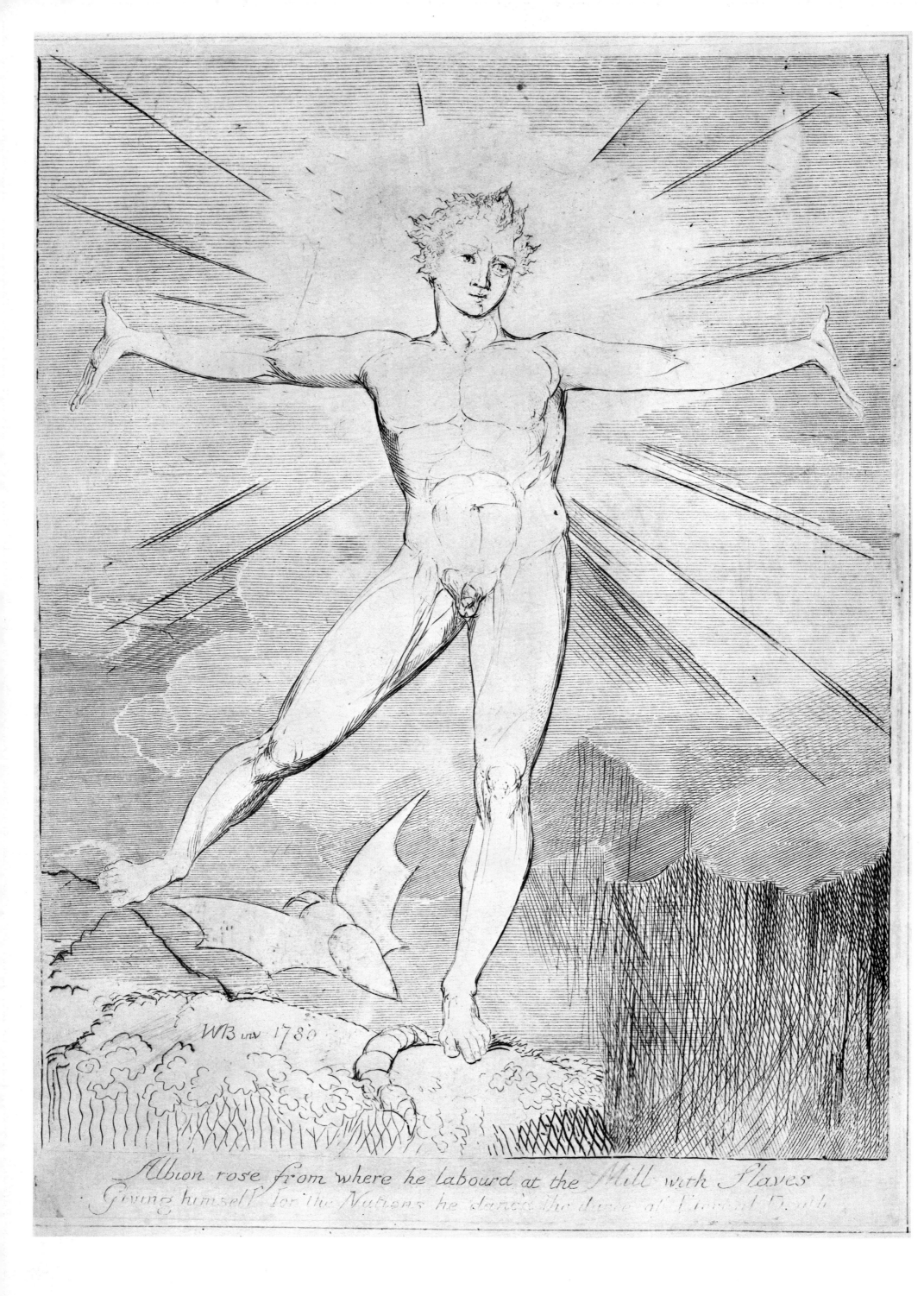

Albion rose from where he labourd at the Mill with Slaves
Giving himself for the Nations he danc'd the dance of Eternal Death

P. C. May. 06

Er badetes sic in dem blueot
Sin huot wart hurnin.

61

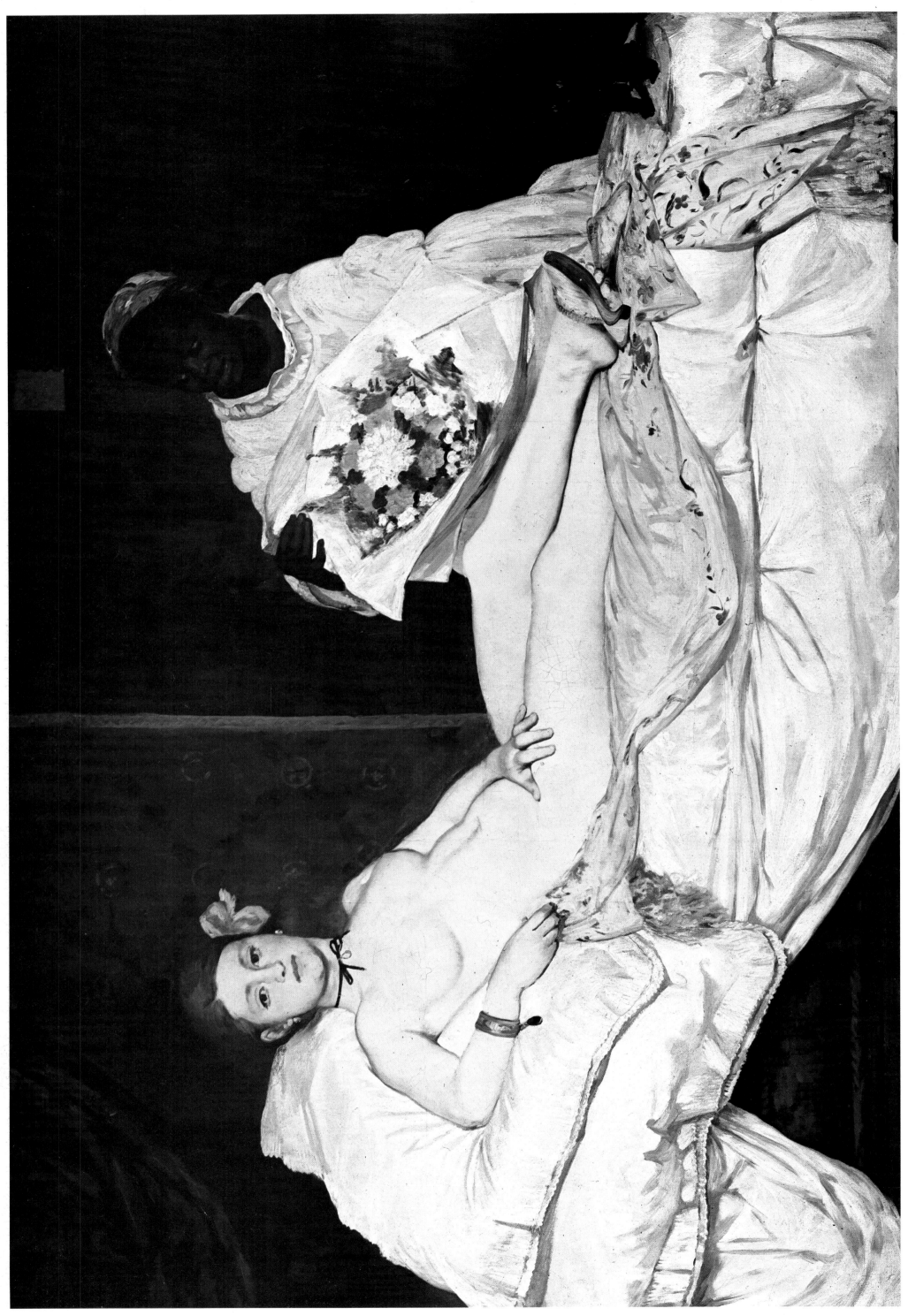

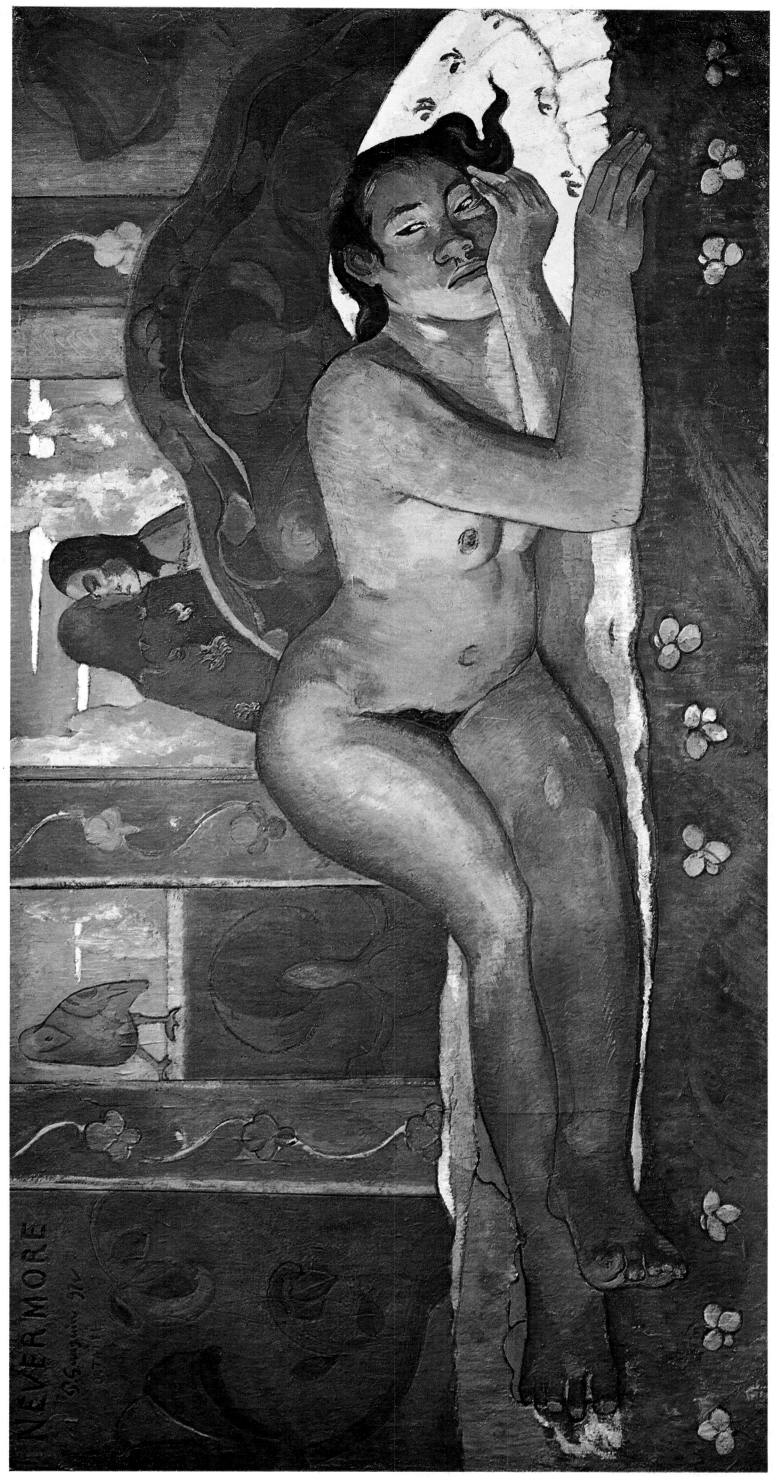

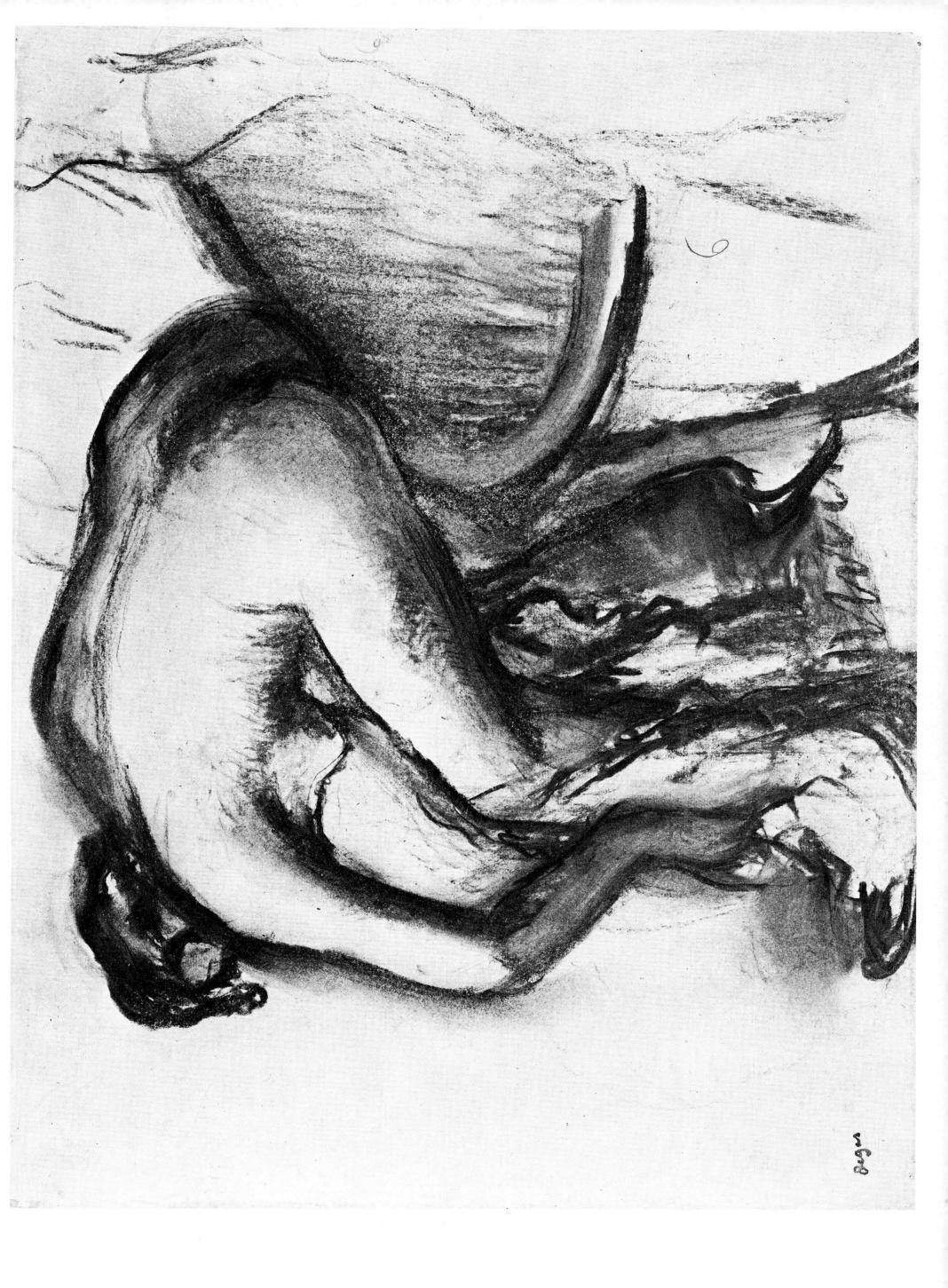

65

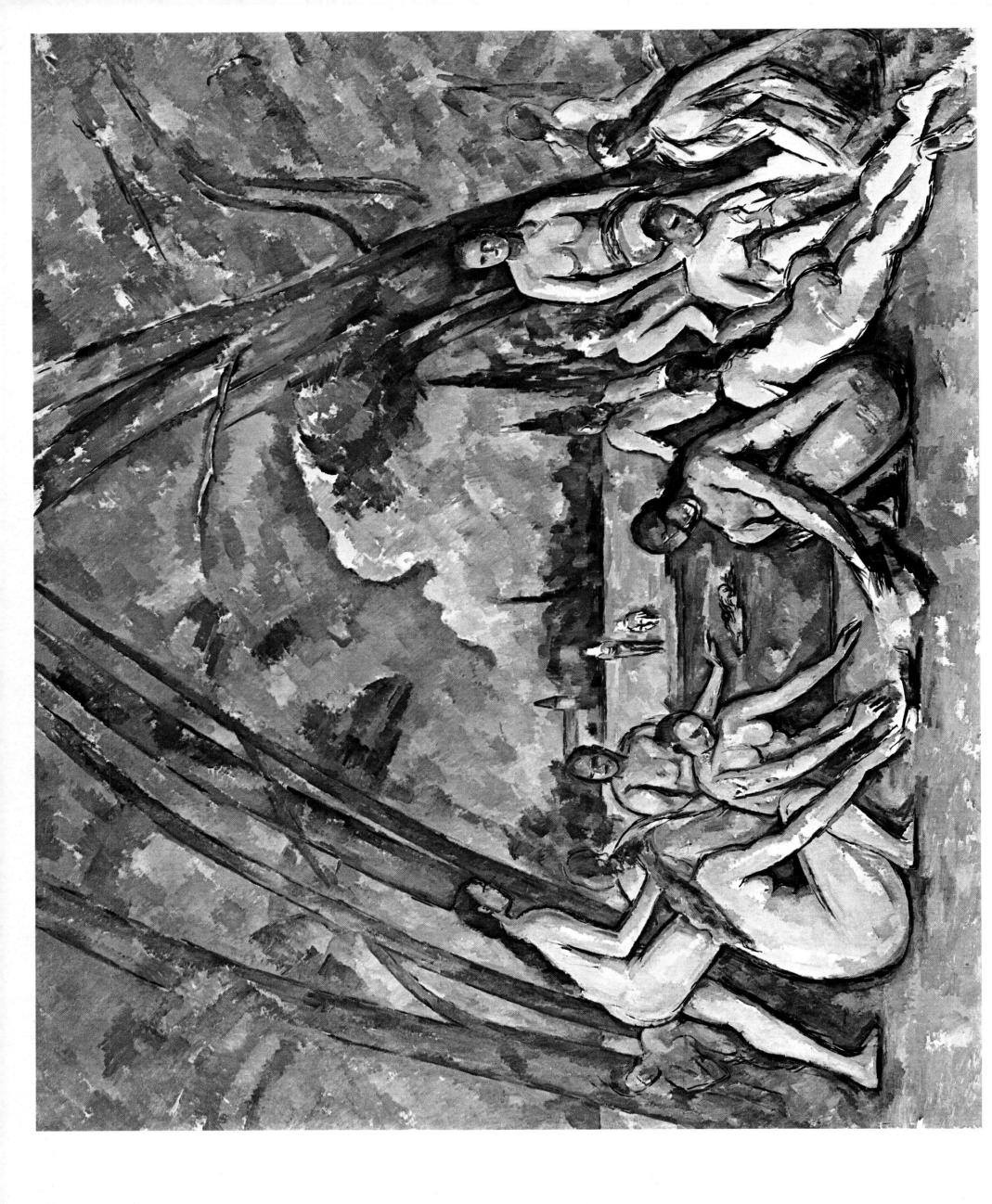

66

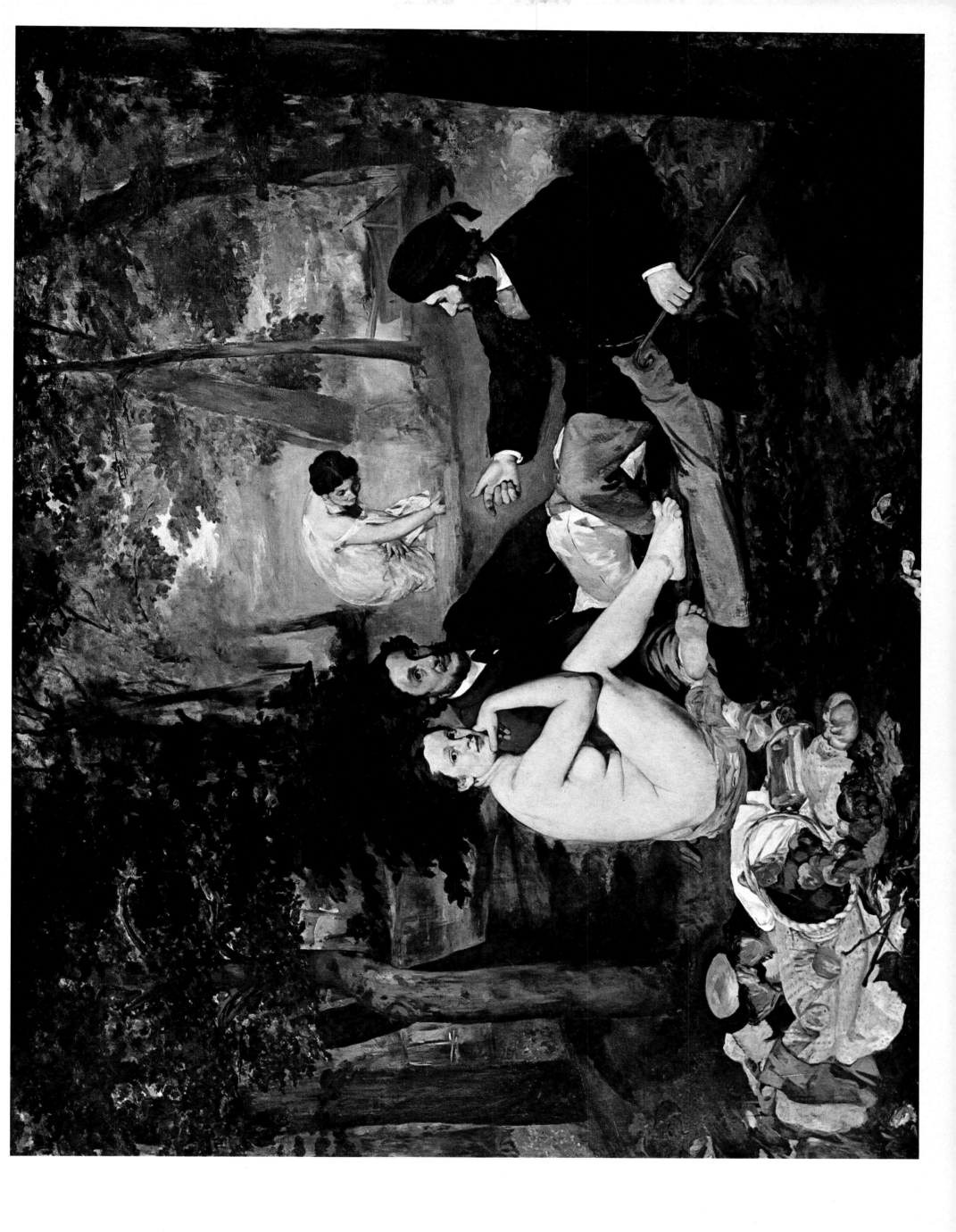

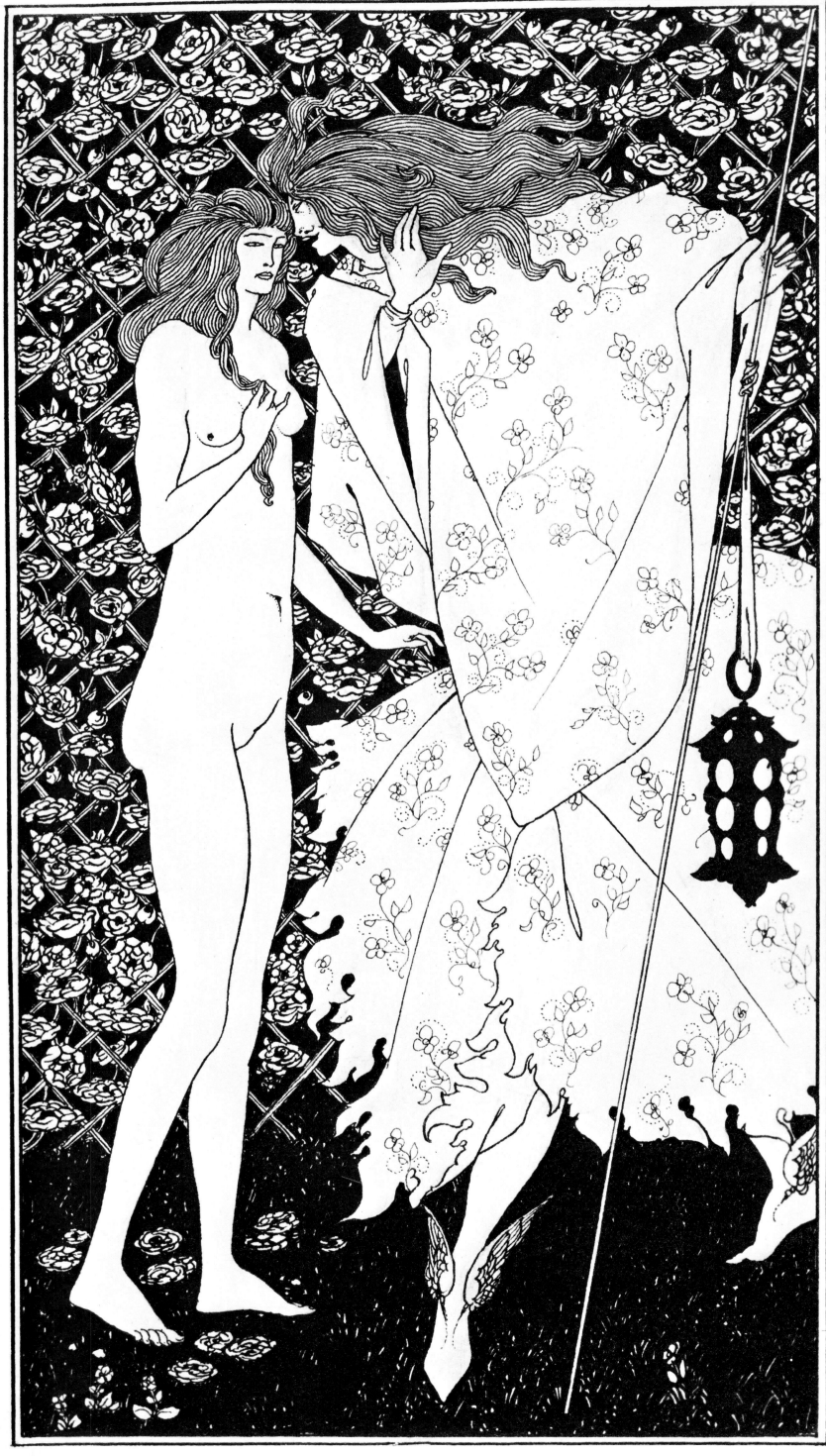

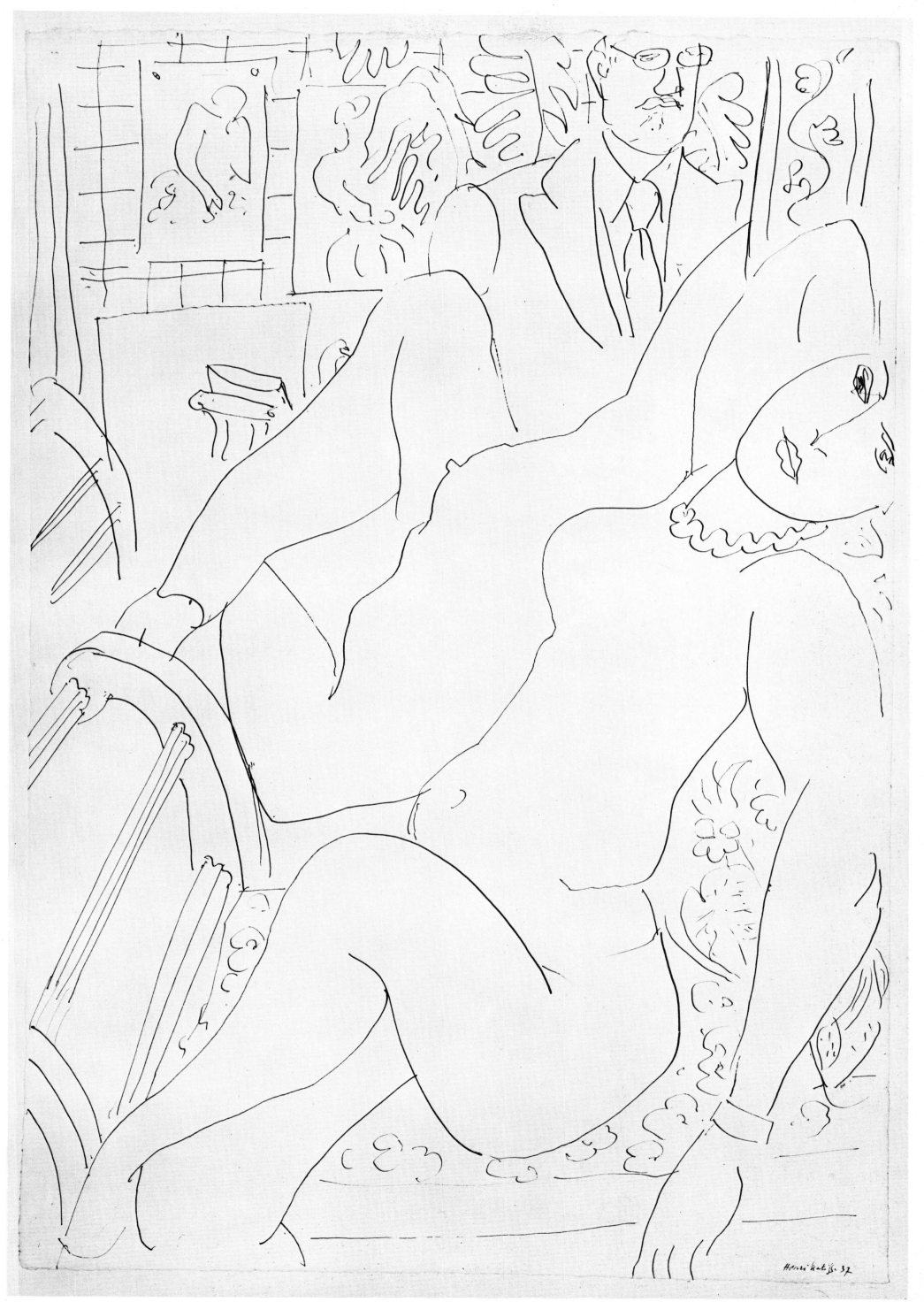

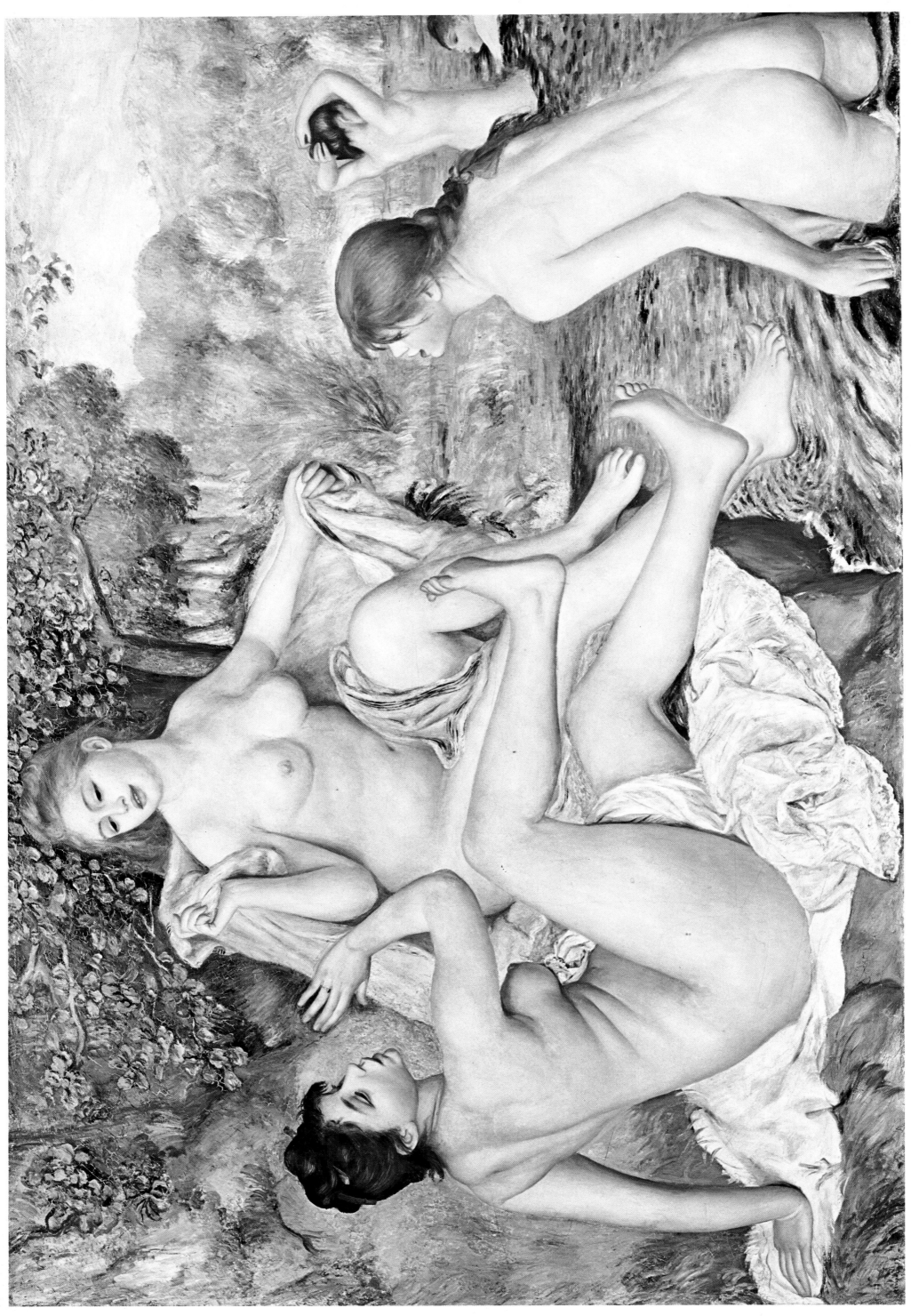

70

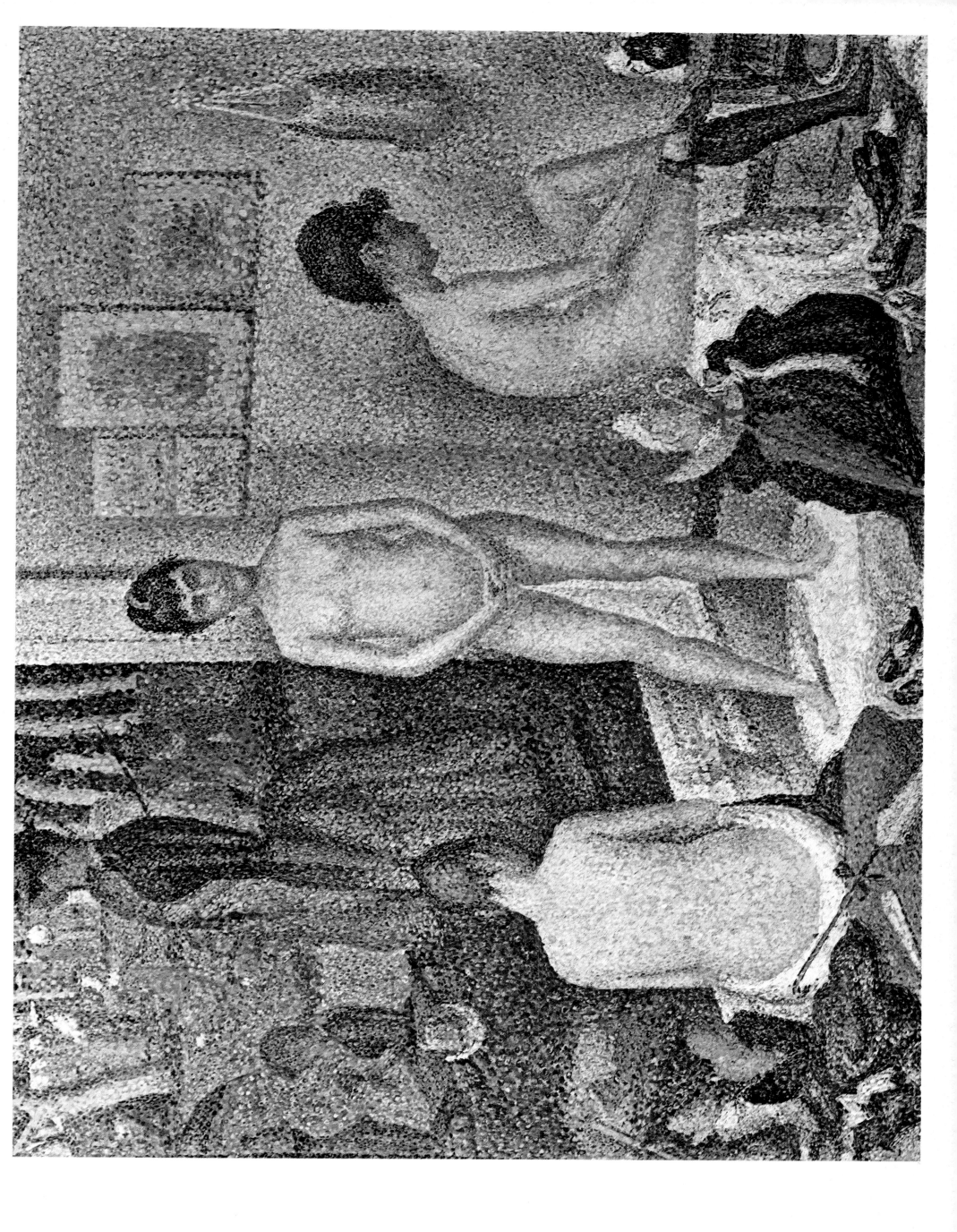

Henri-Matisse août 1909.

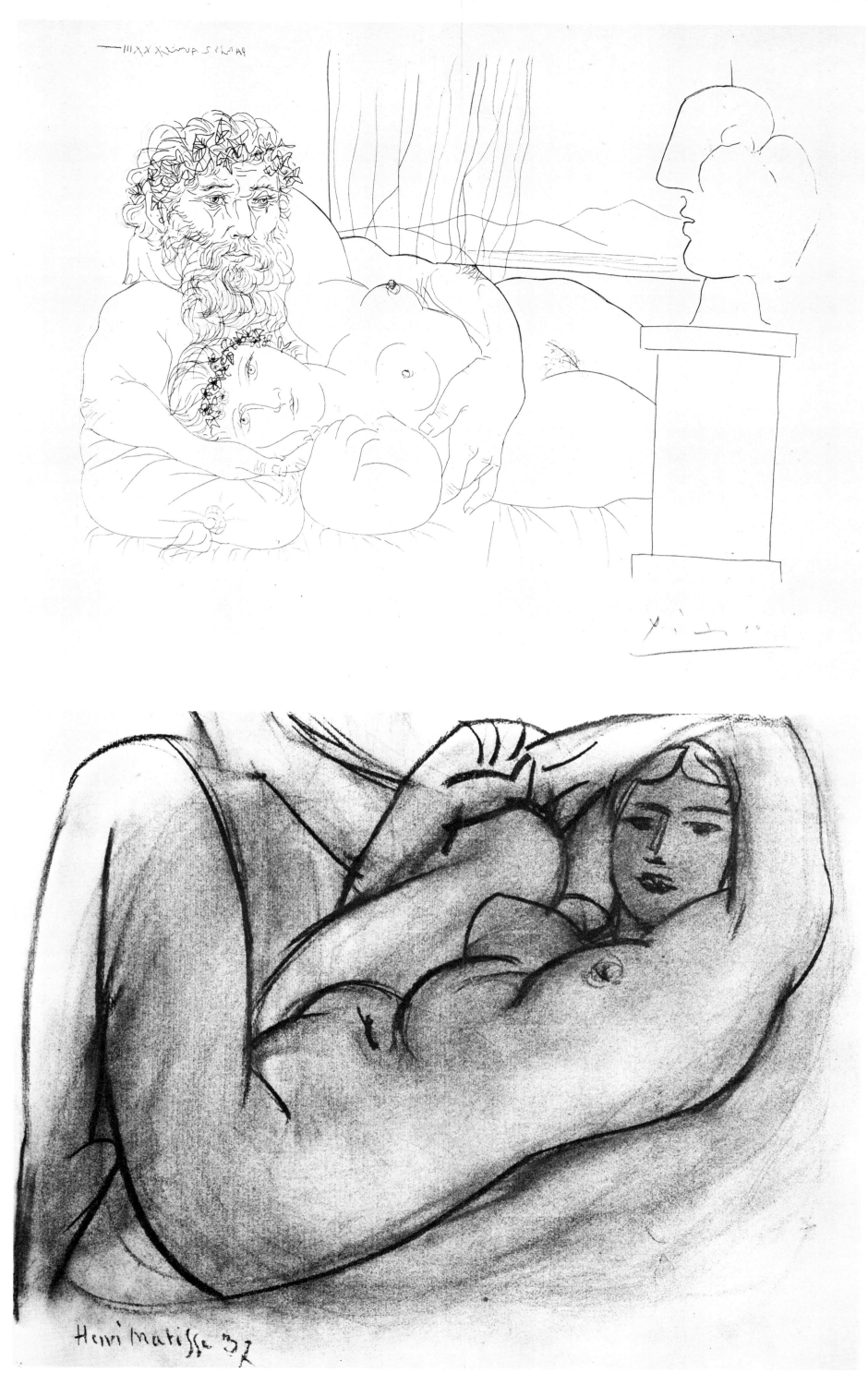

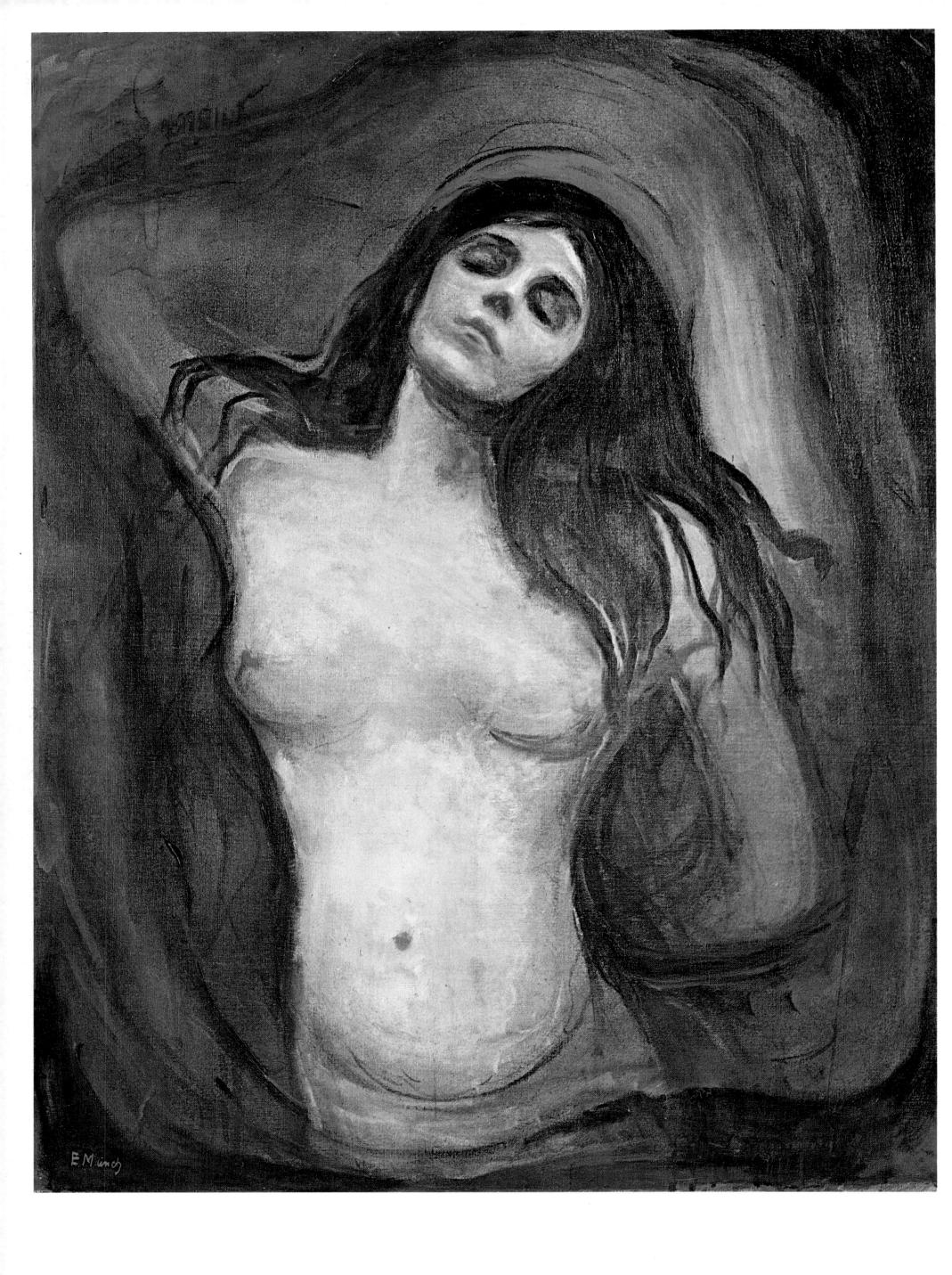

74

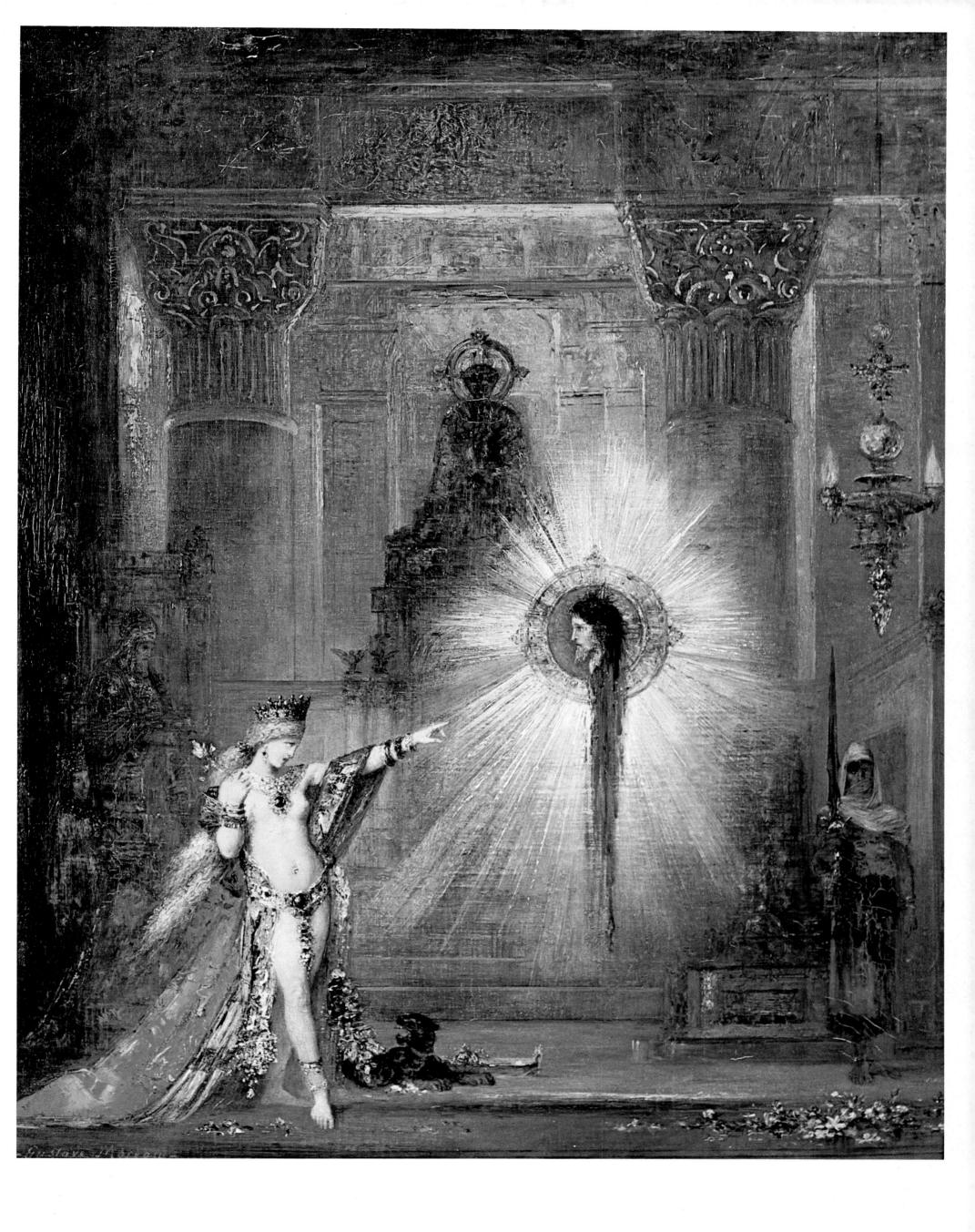

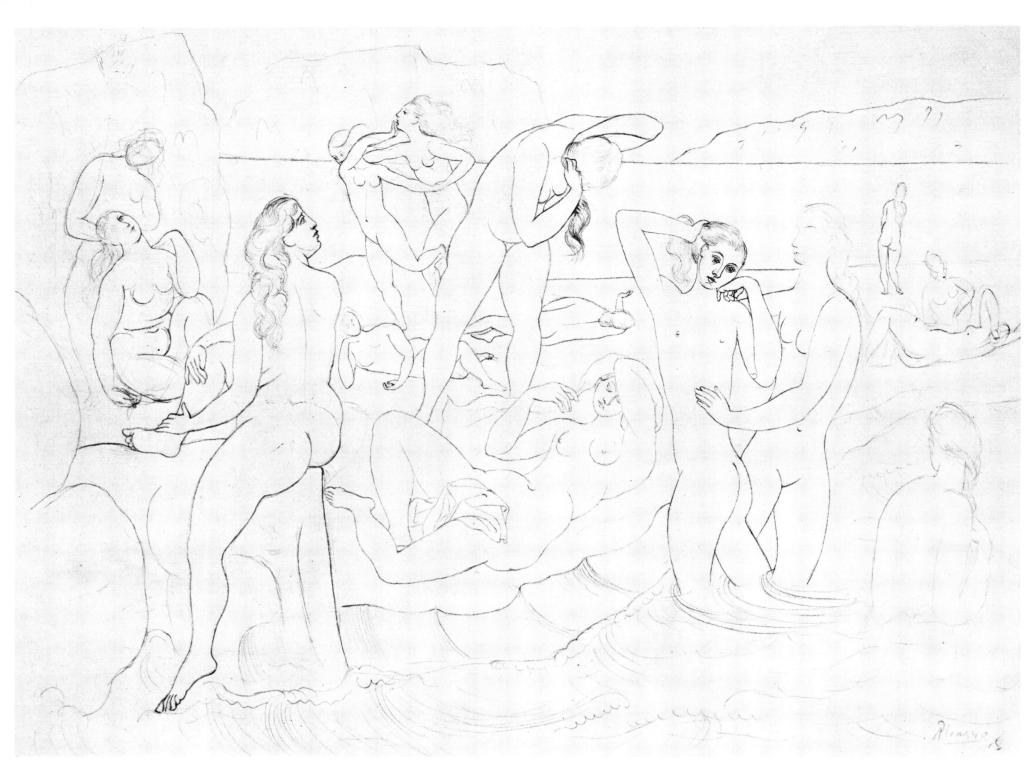

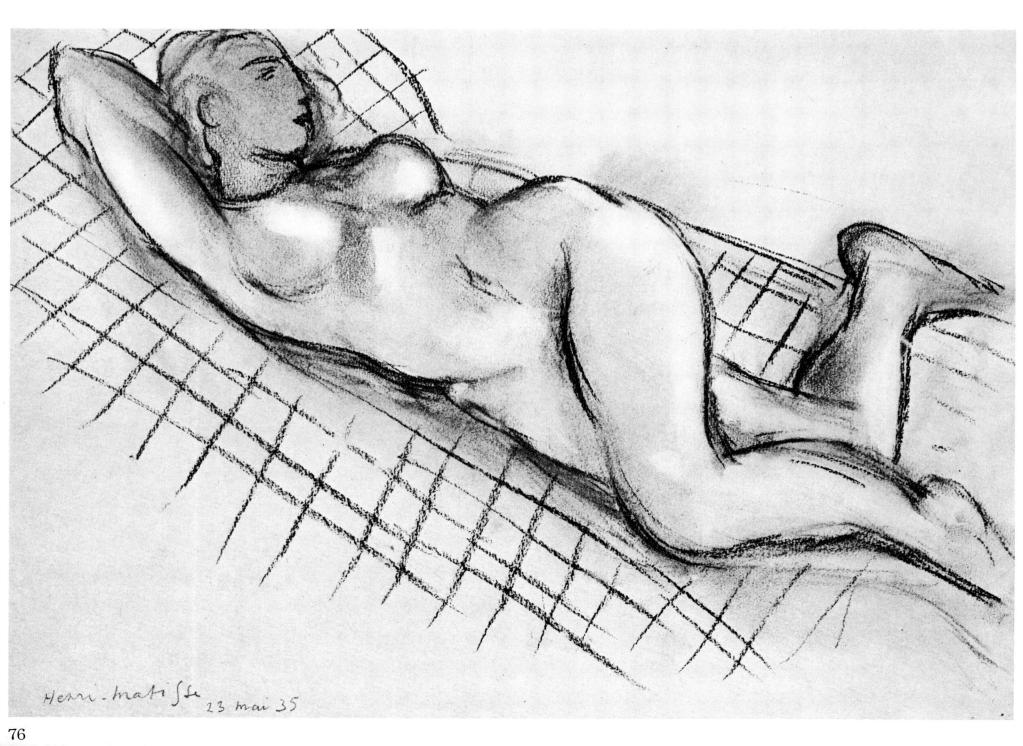

Henri-Matisse 23 mai 35

76

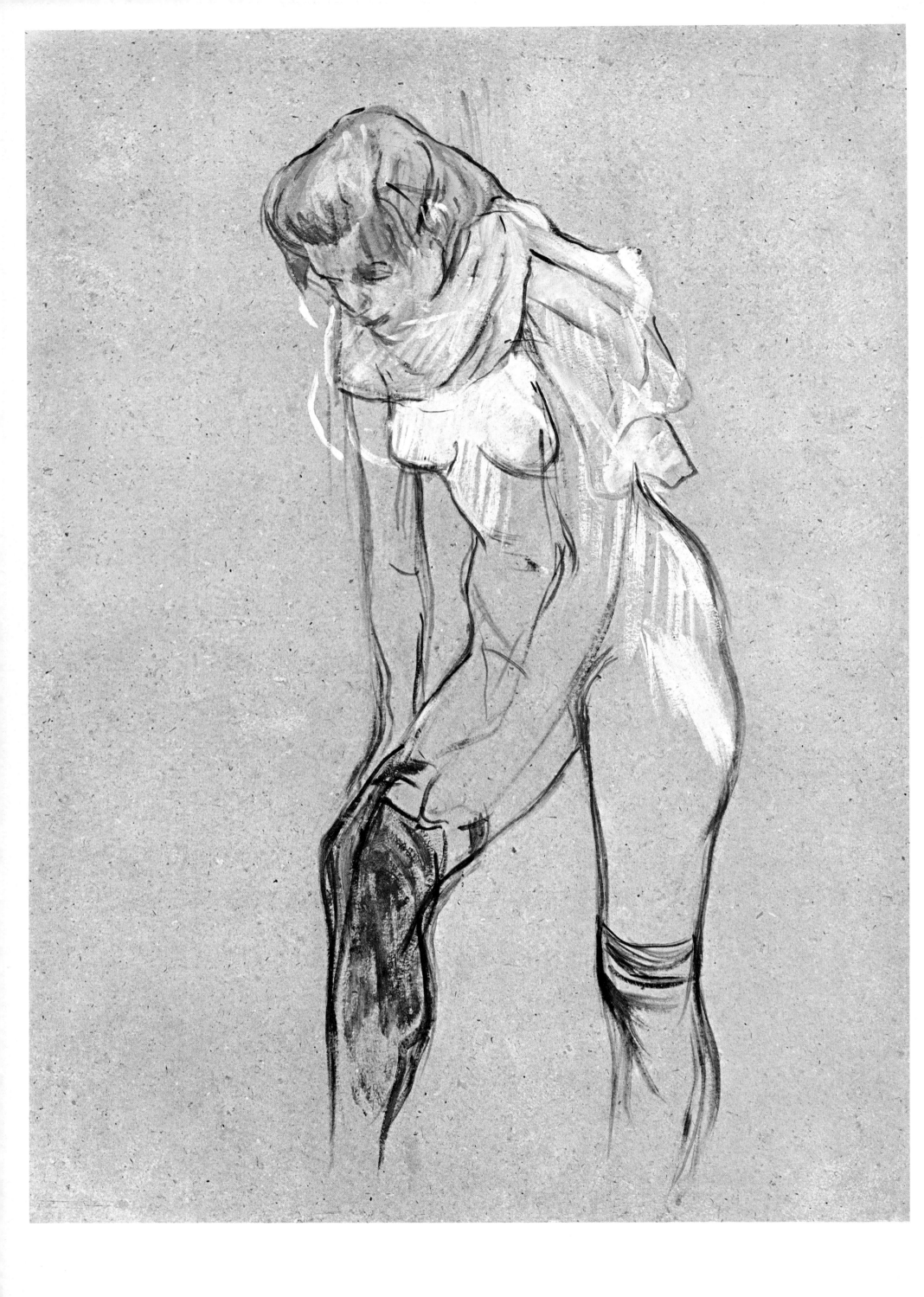

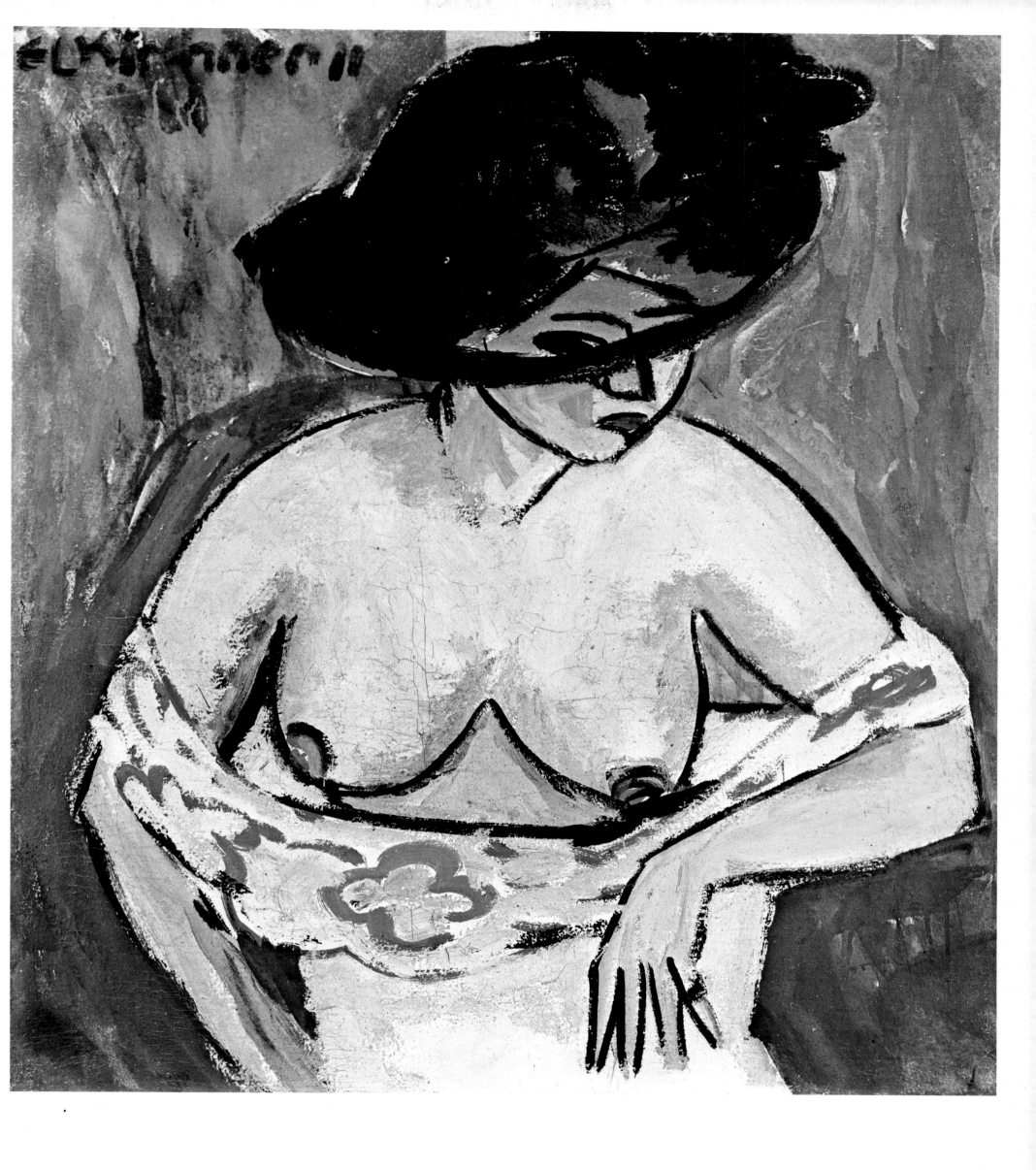

79

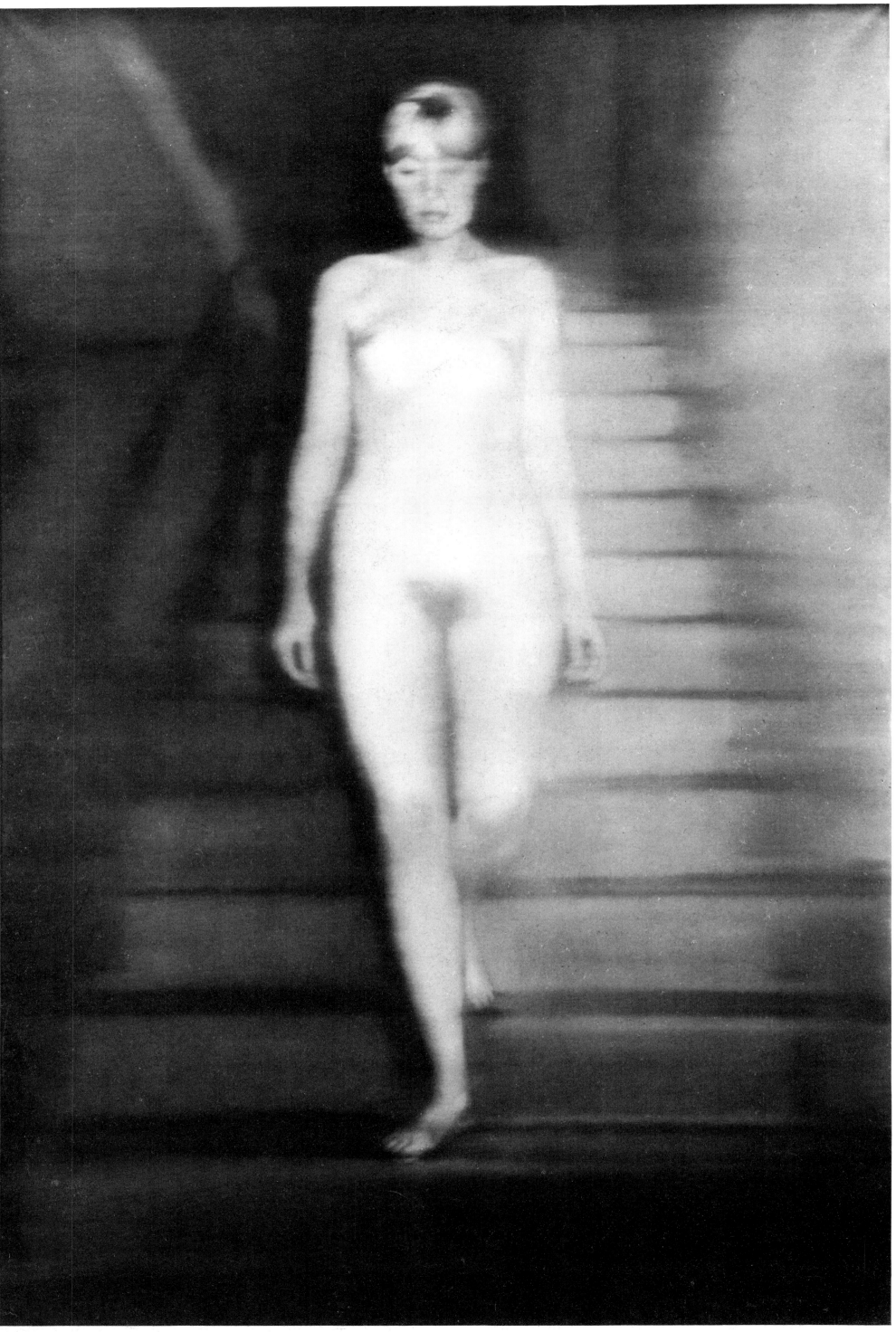

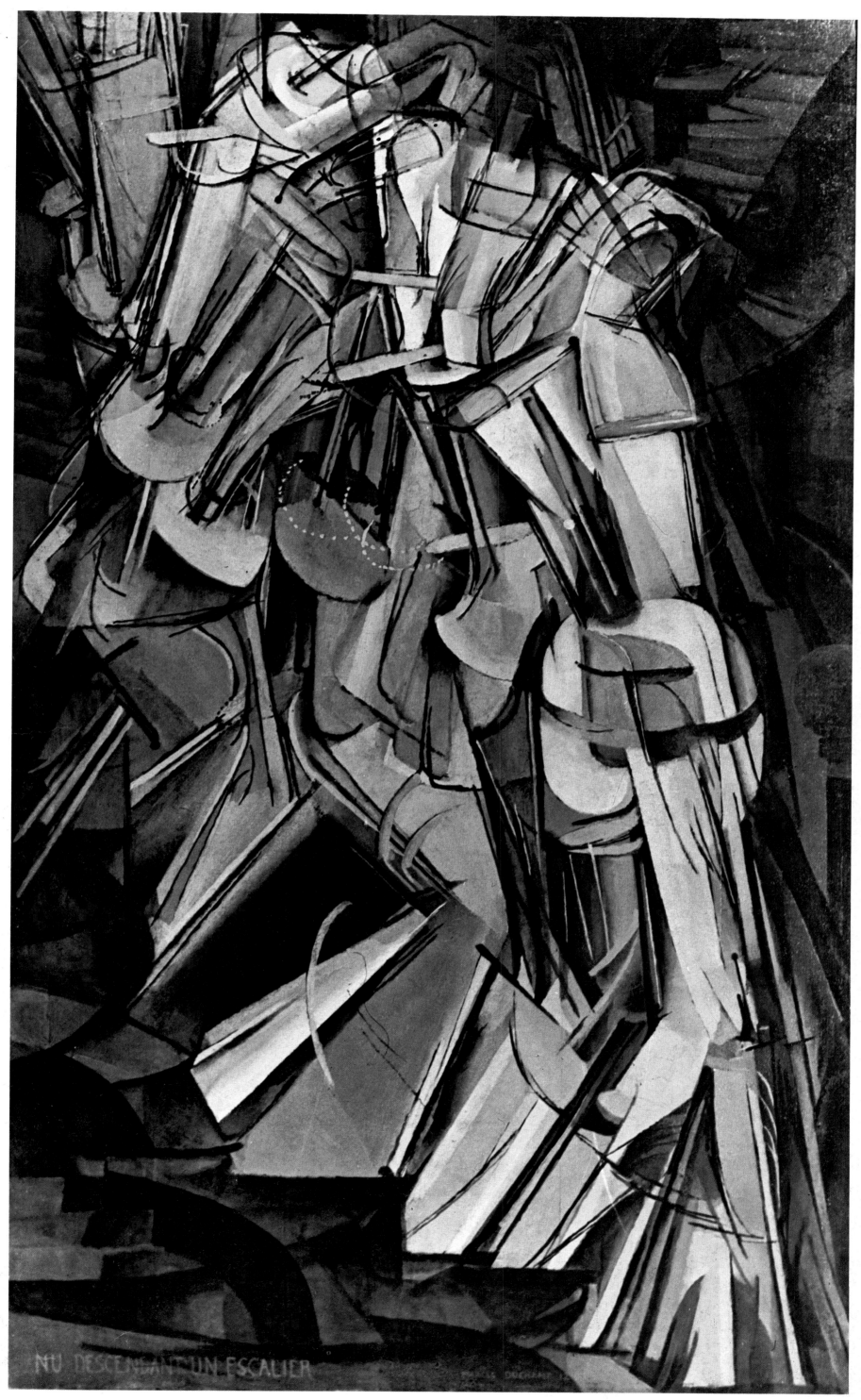

NU DESCENDANT UN ESCALIER

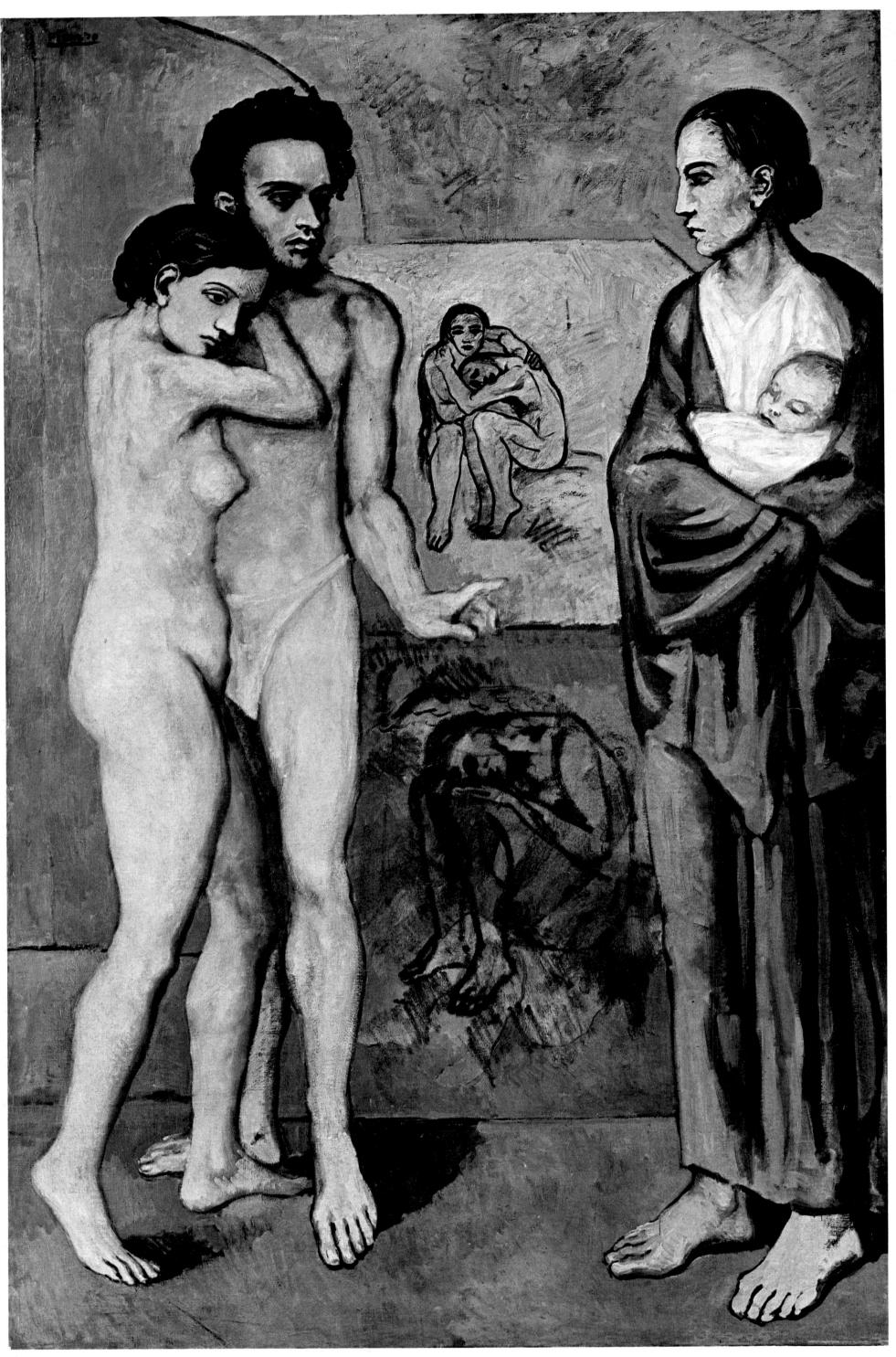

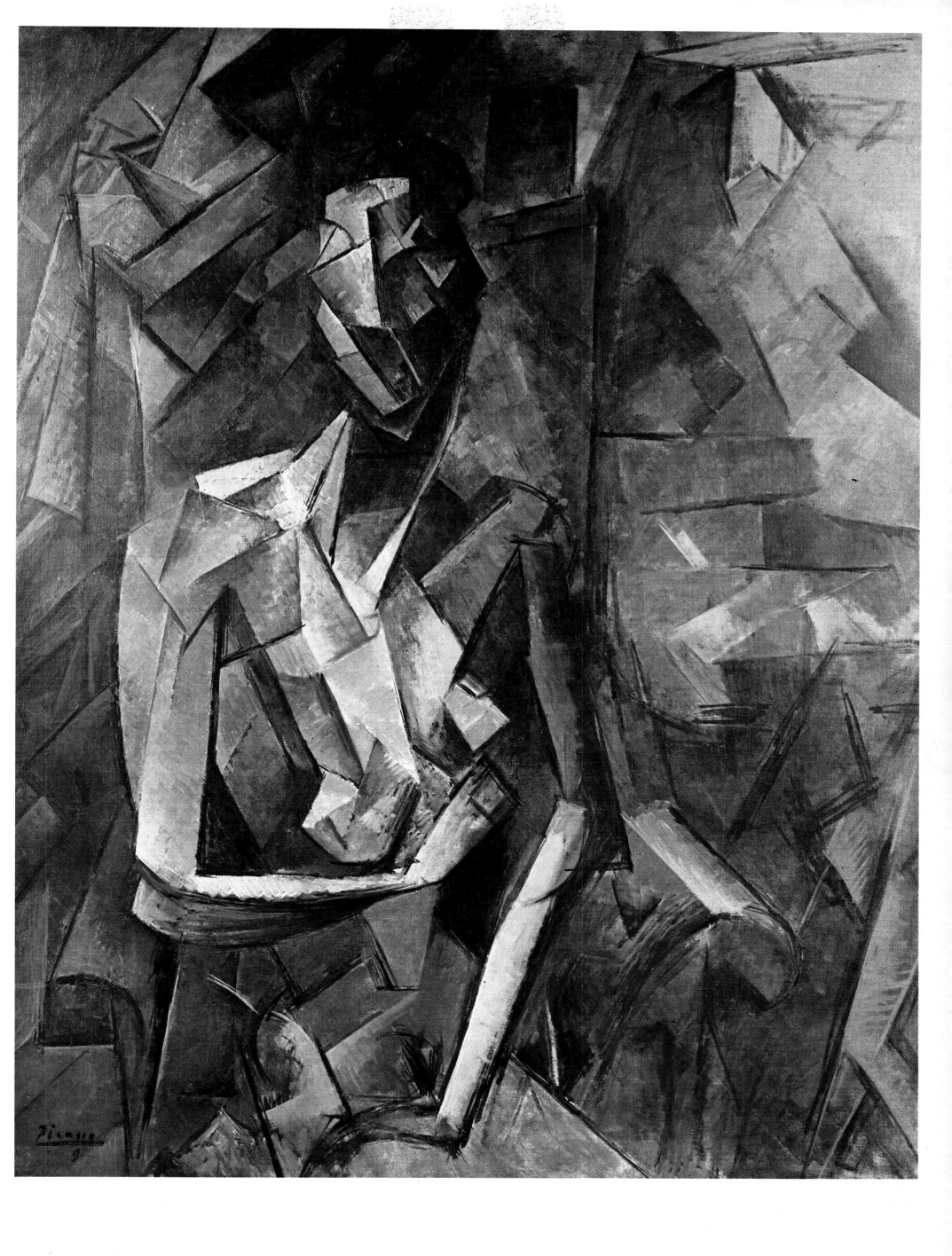

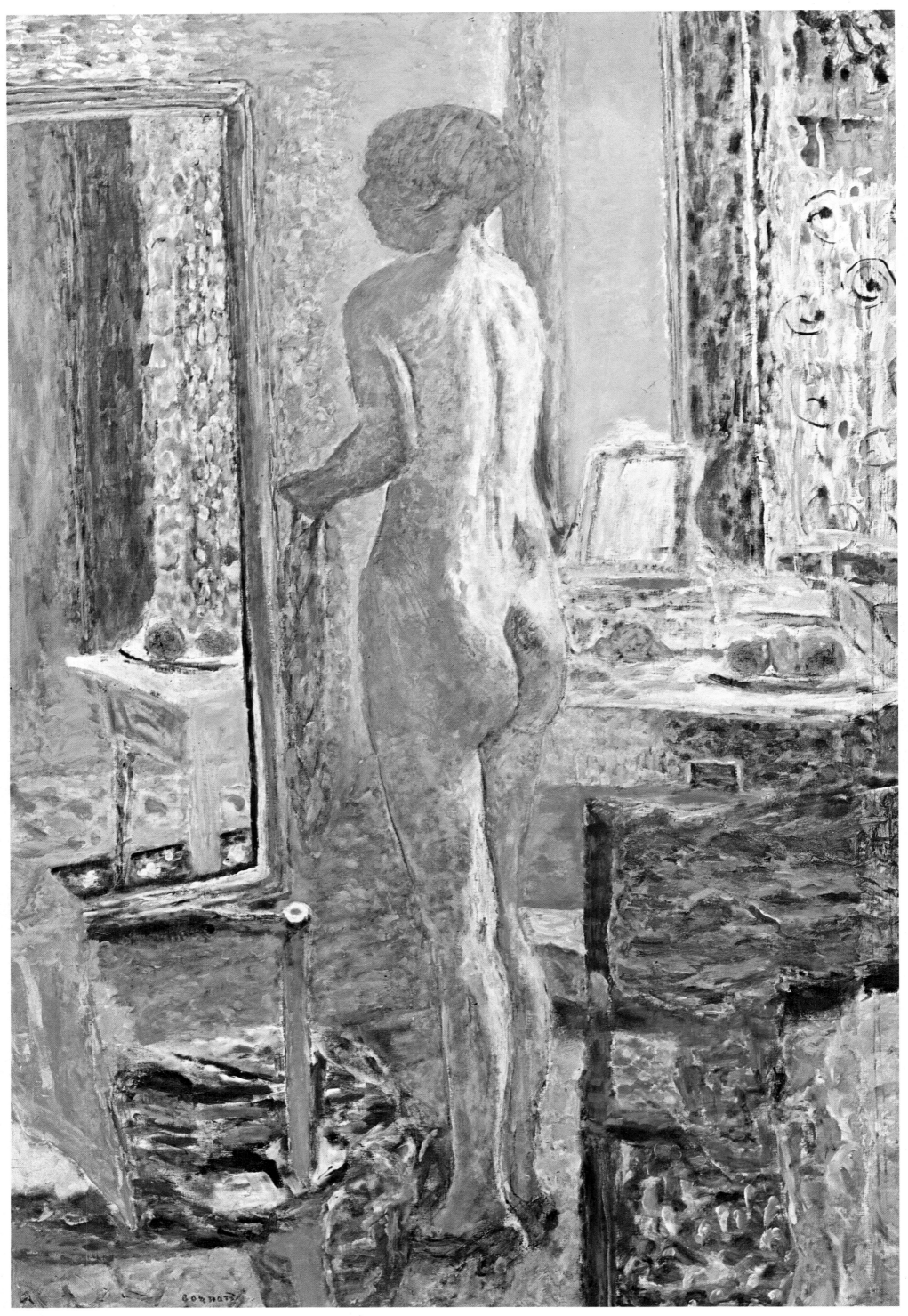

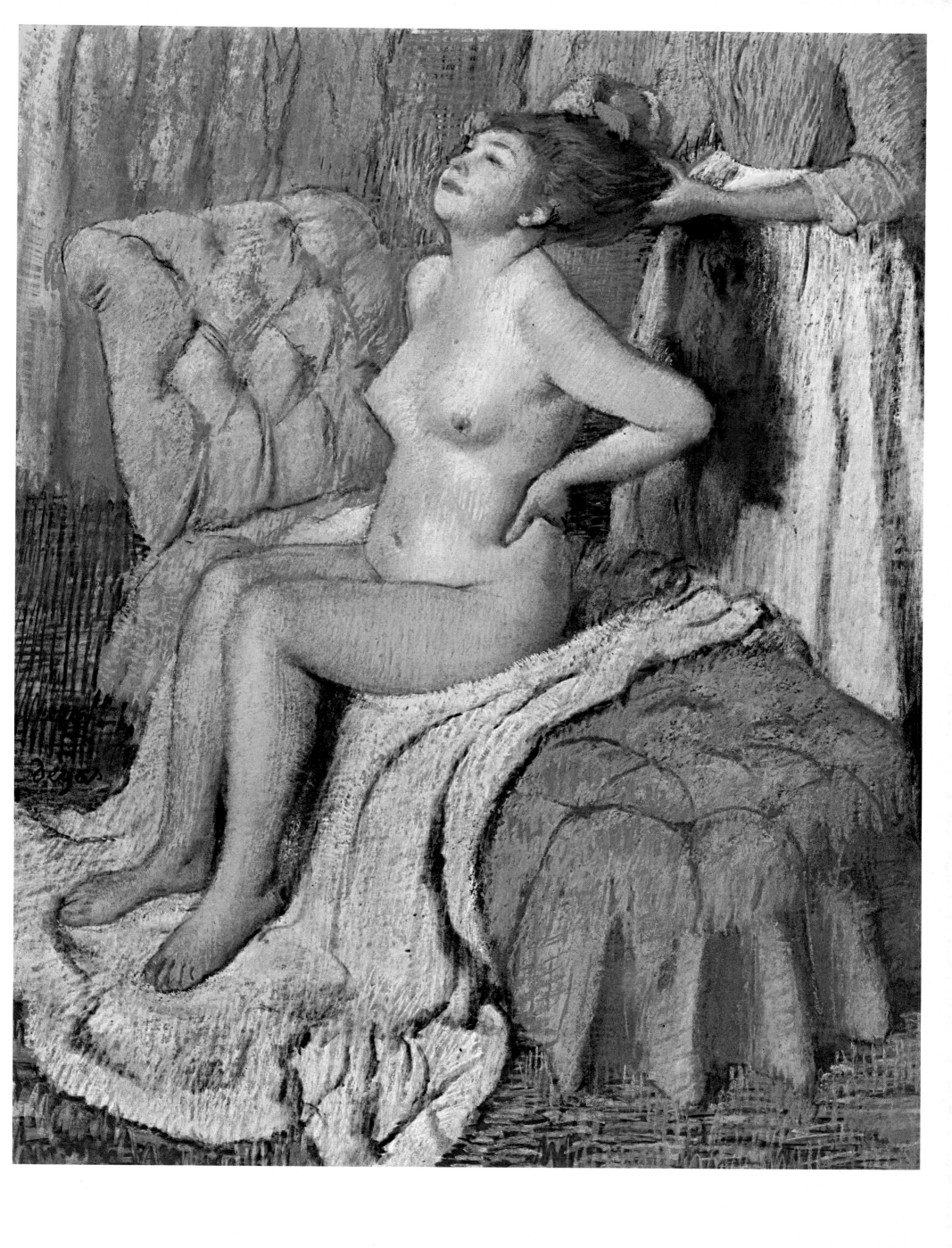

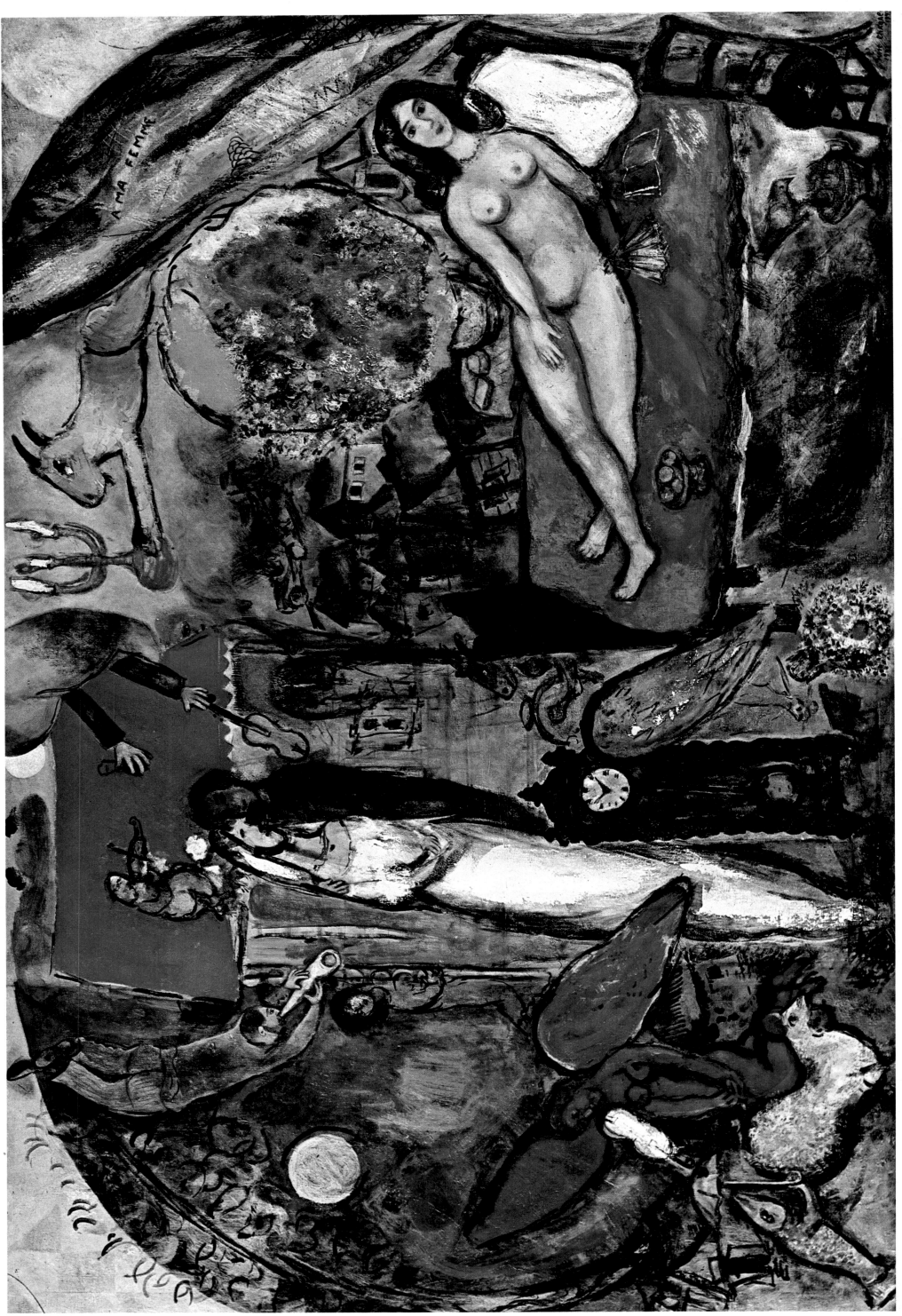

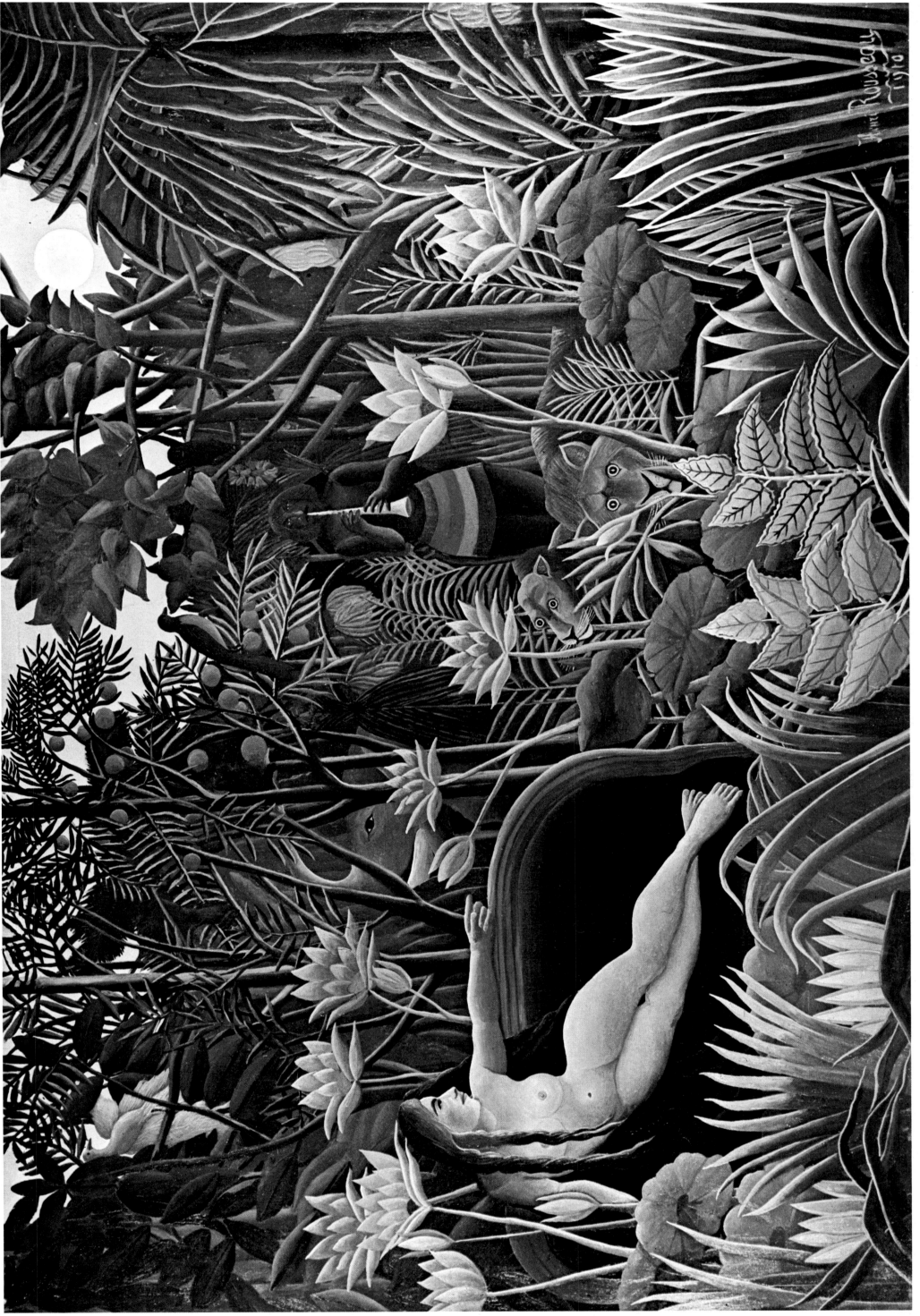

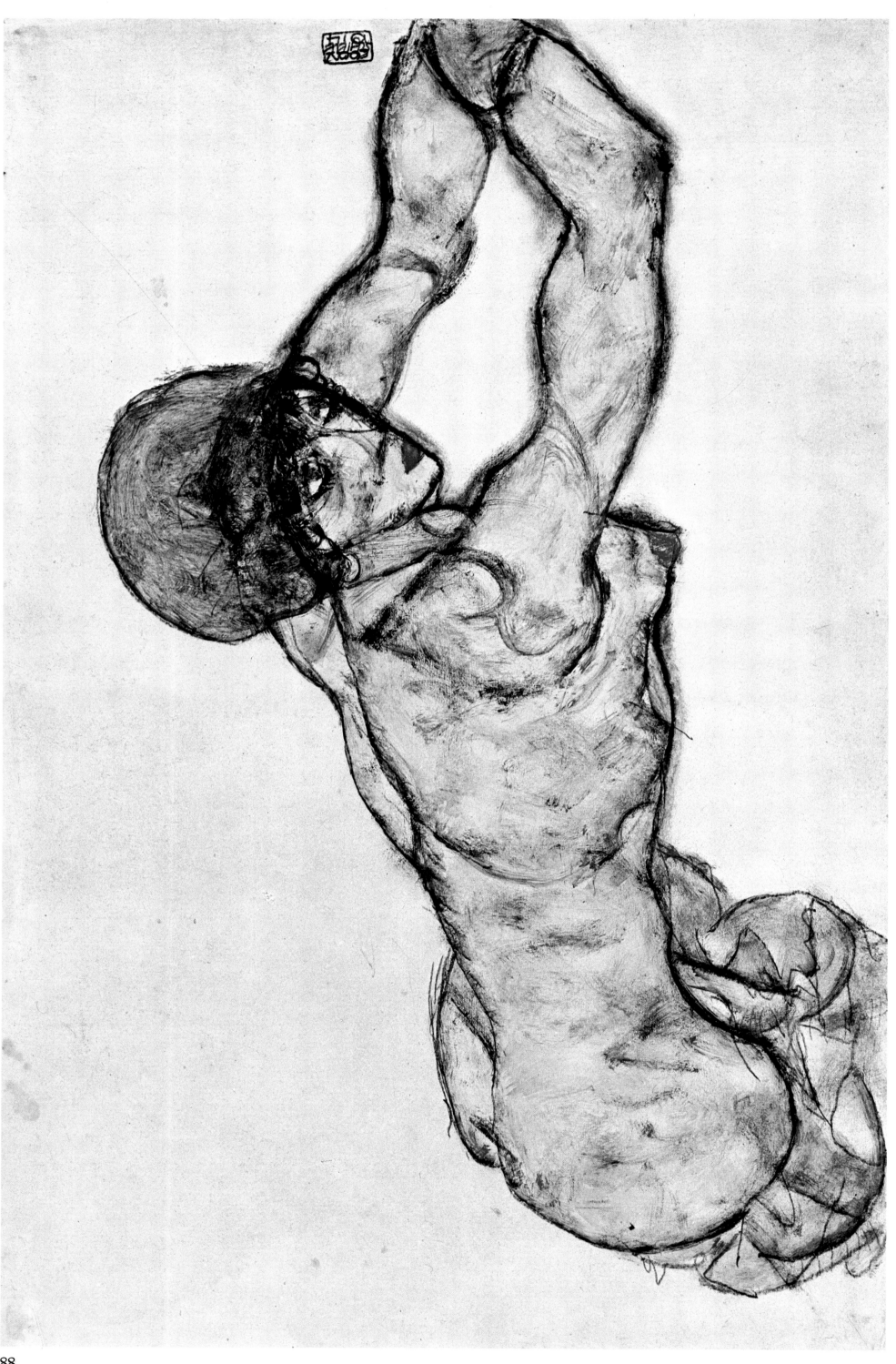

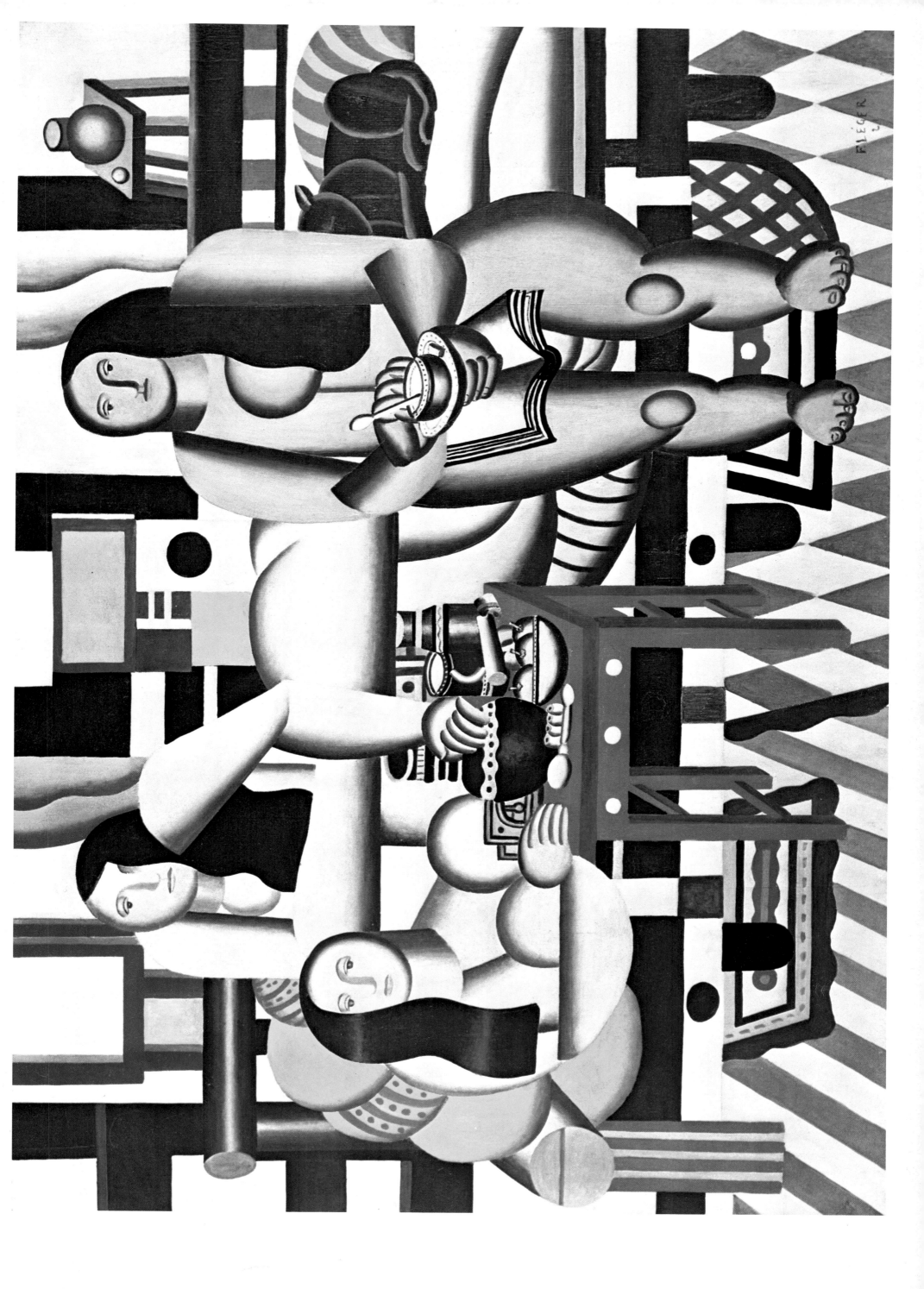

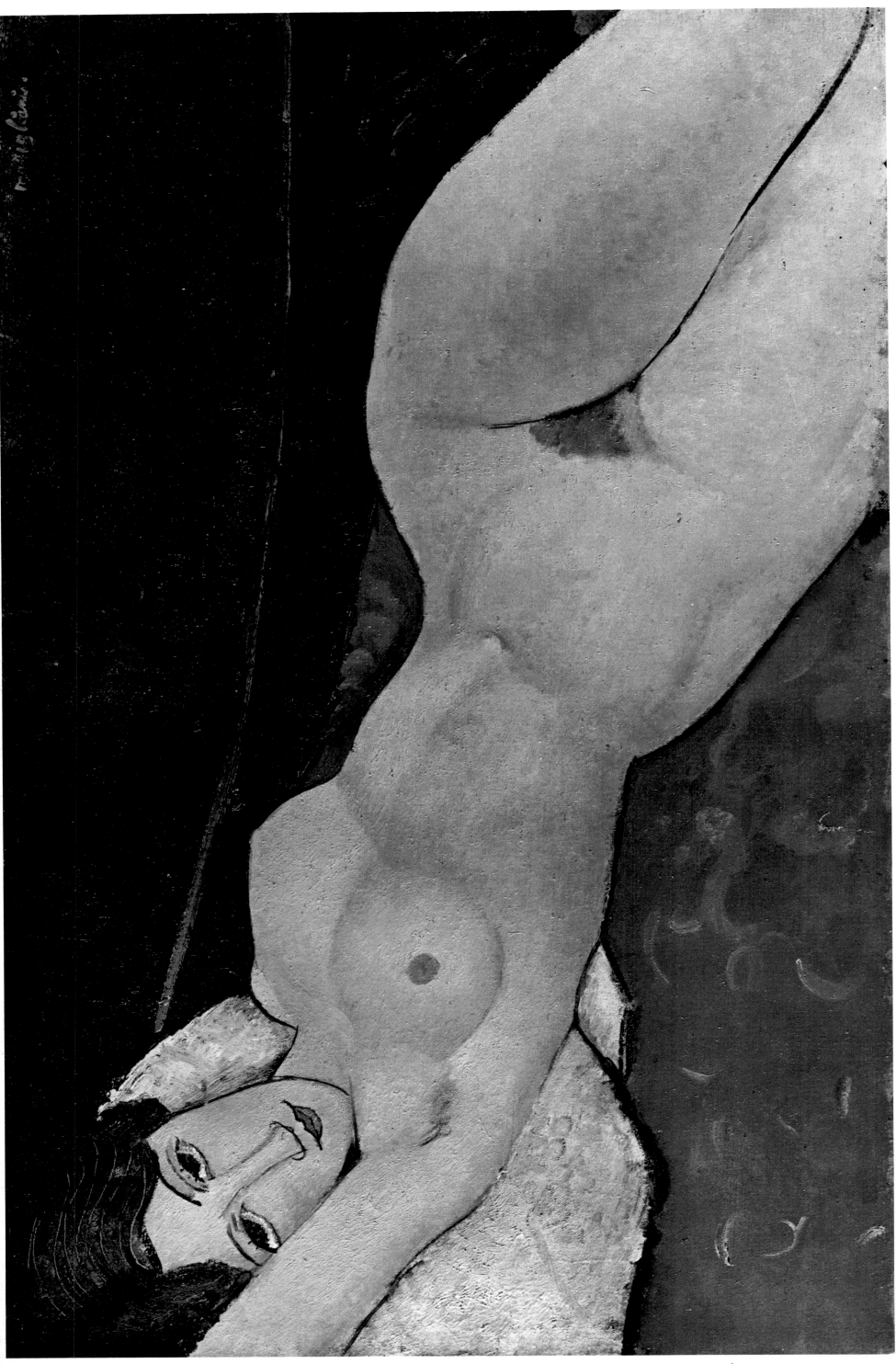

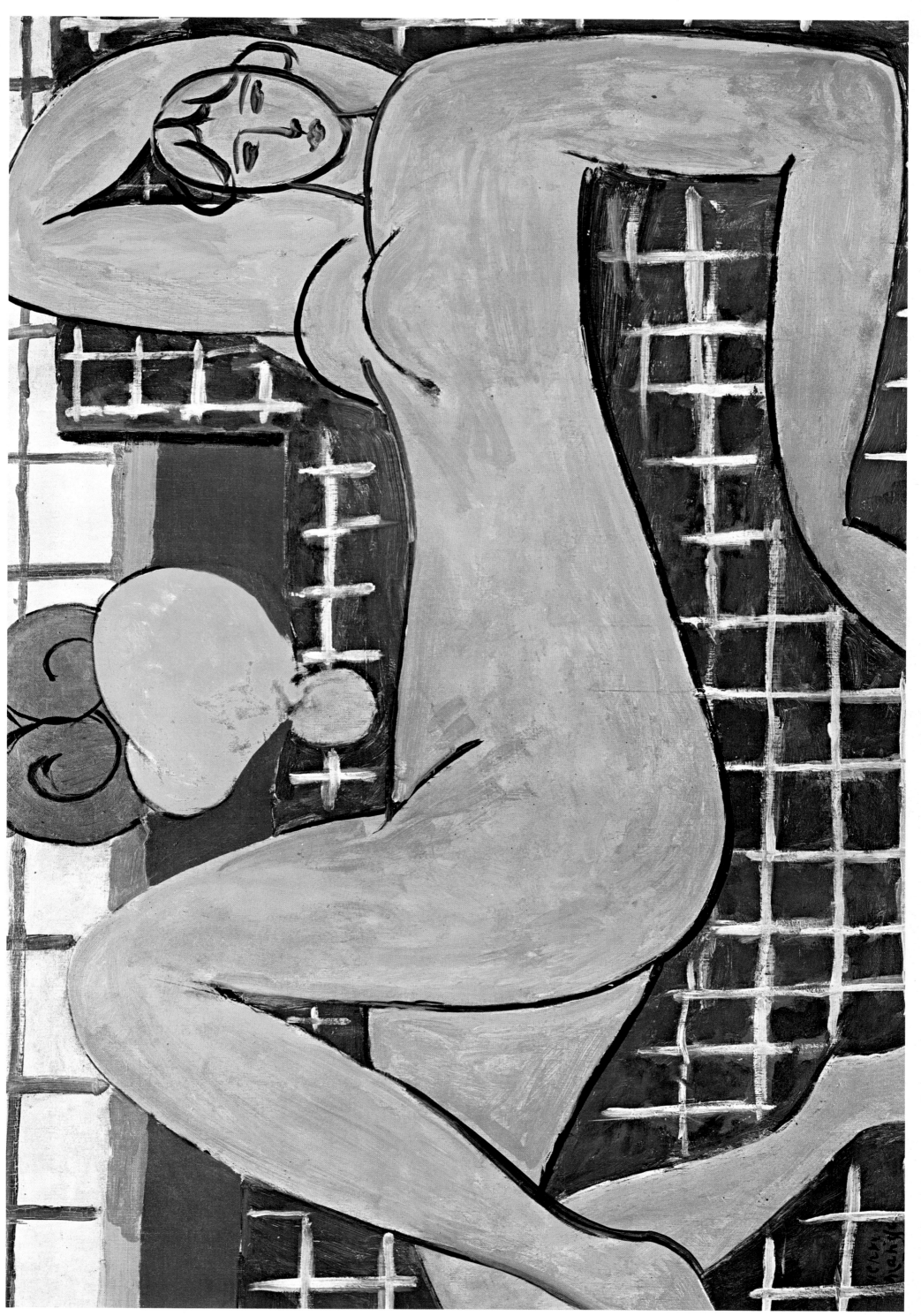

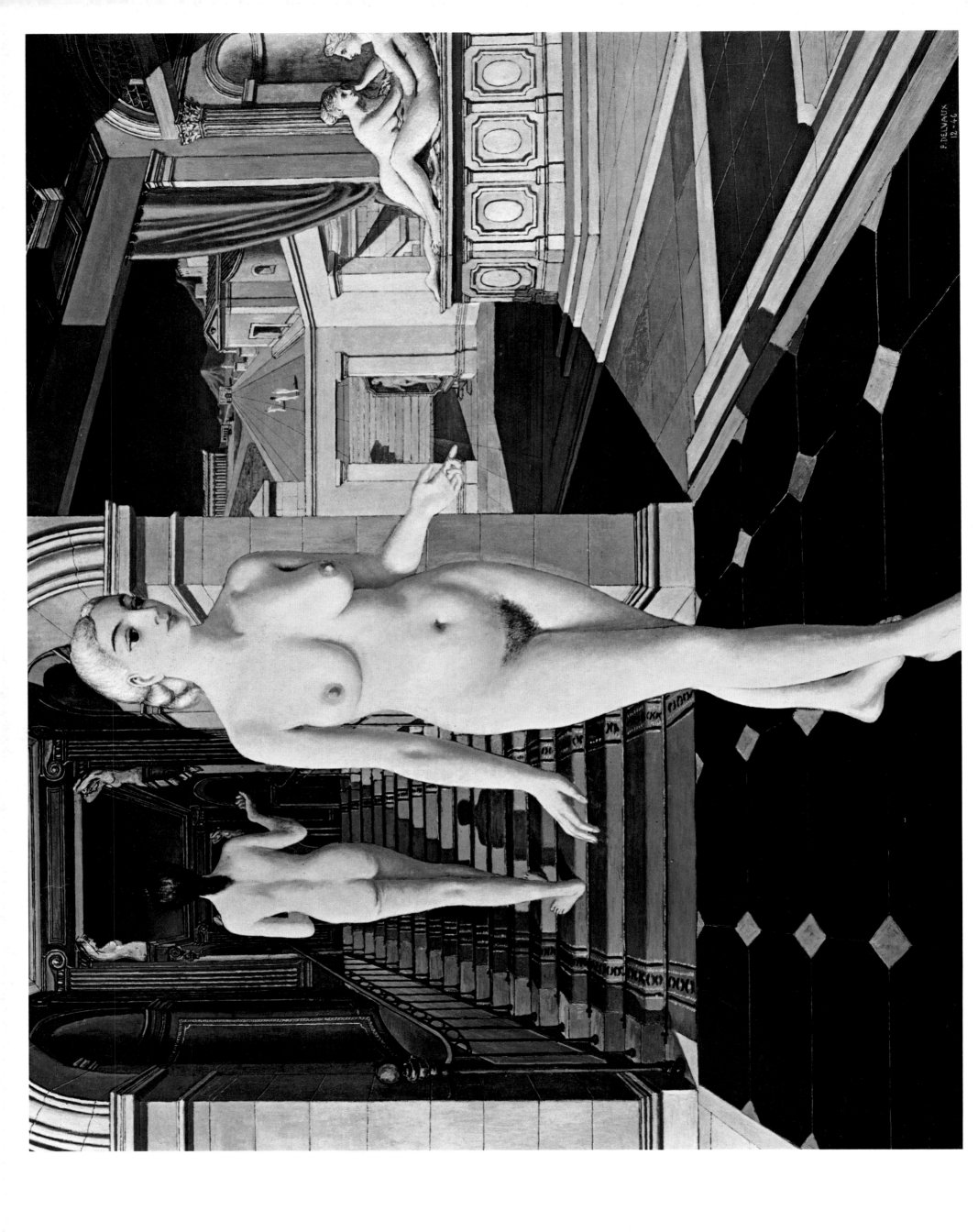

94

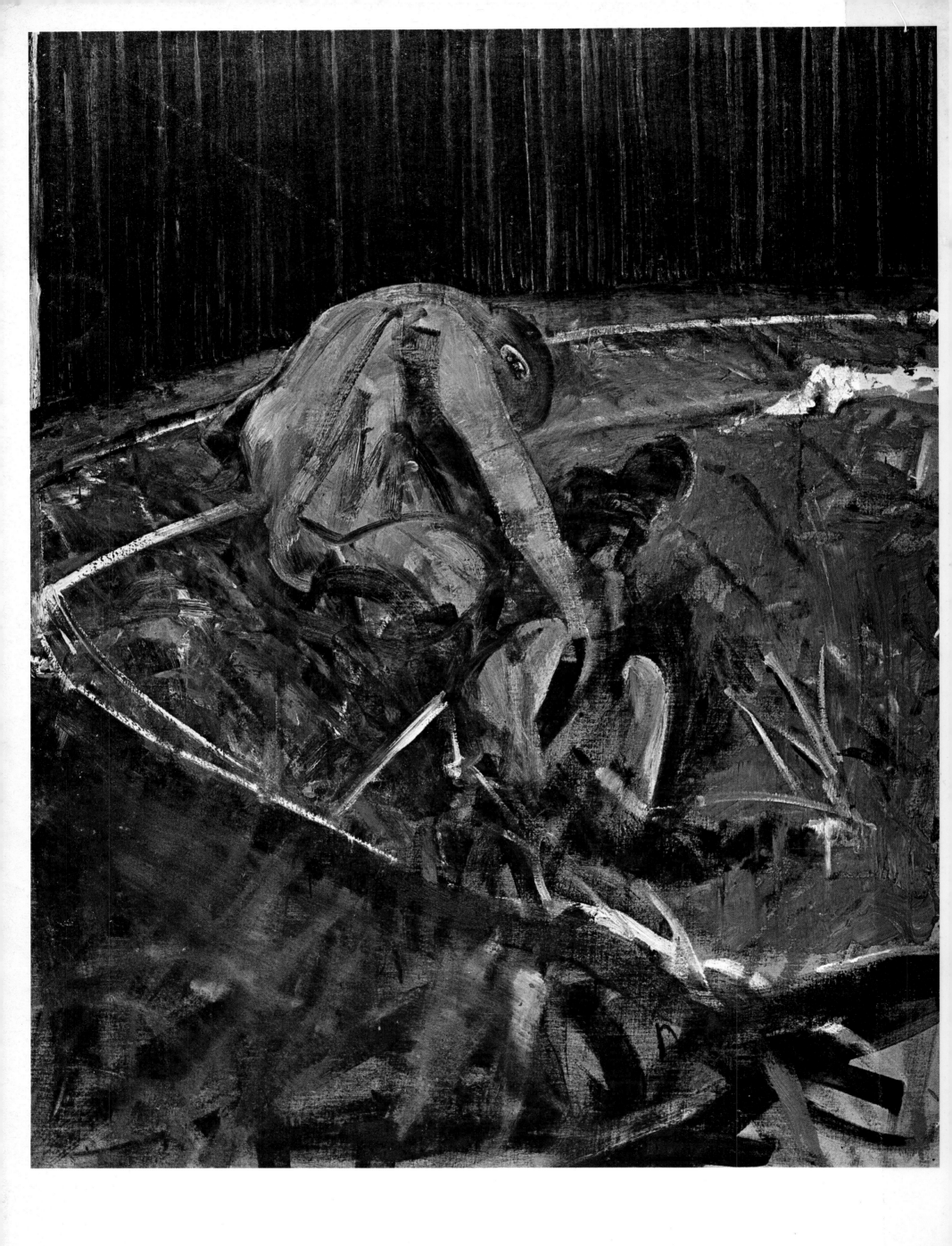